This book would not have been possible without the support of

FRESENIUS KABI

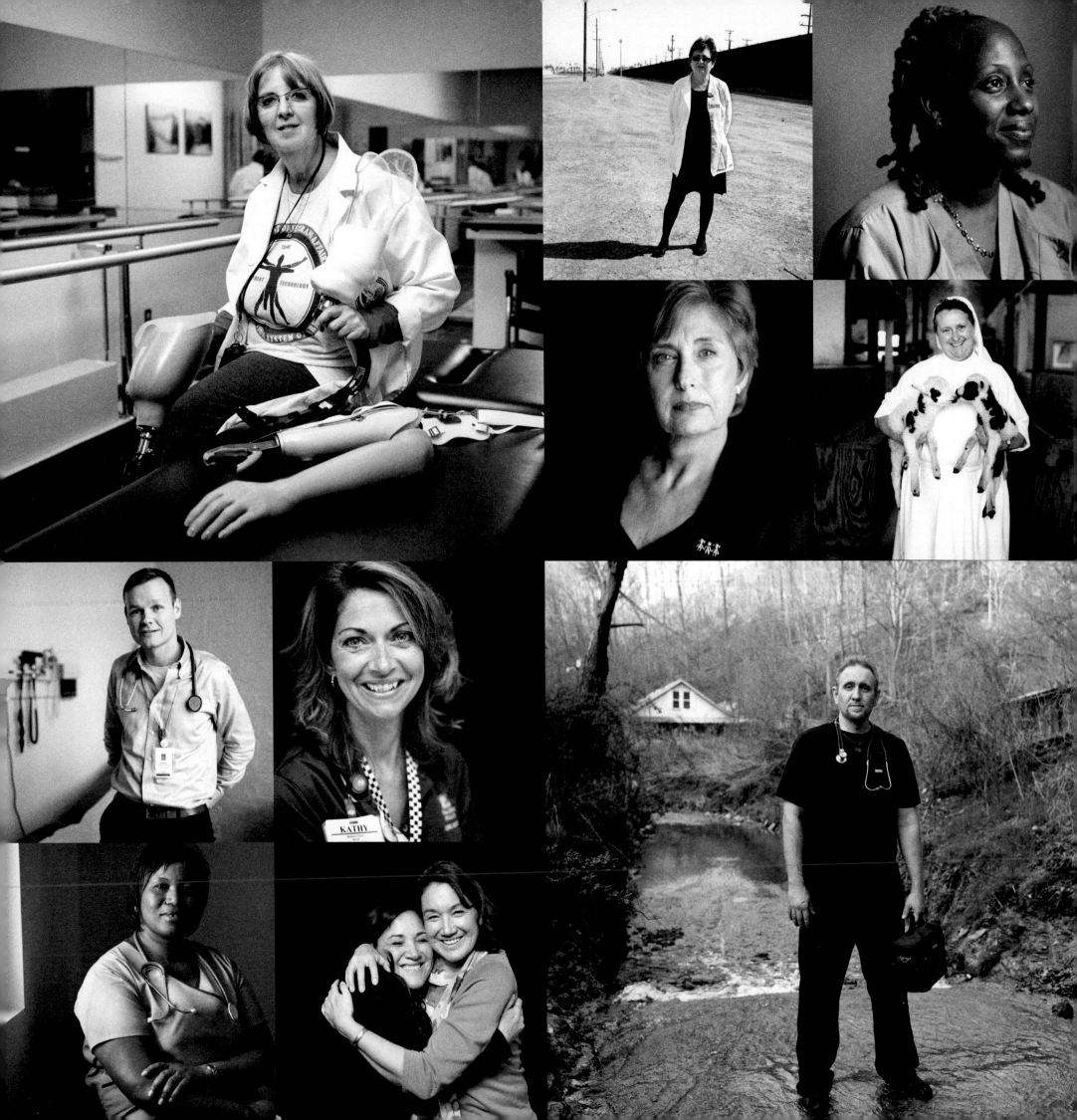

THE AMERICAN NURSE

PHOTOGRAPHS AND INTERVIEWS

BY CAROLYN JONES

welcome
BOOKS
NEW YORK

CONTENTS

INTRODUCTION

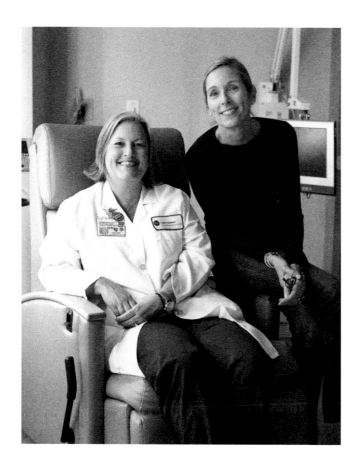

The author photographed with Joanne Staha, the nurse who administered her chemotherapy treatments in 2005.

THERE ARE SOME EXPERIENCES IN LIFE THAT TRANSFORM YOU.

I started this project at the request of a nurse, Rhonda Collins, a woman who has devoted her life to nursing and making nursing conditions better. I thought I was making a book that would celebrate nurses. I ended up gaining a better understanding of the country through the lens of the American nurse. I have altered my thinking about religion; I have completely changed my feelings about end-of-life. I have a new compassion for coal miners; a better understanding of the health-care system—and how complicated the solutions might be. I know how funny nuns can be. I've learned that nurses are like the cobbler's children; they can take care of everyone else, but they're not always so great about taking care of themselves. I know what it means to love what you do, to care so much that you would do anything to help your fellow human being. I've learned what someone's home can smell like when life has deteriorated. I've seen a man actually drive up a creek to get to his patient whose driveway is impassable because of mountaintop-removal mining.

And I found the nurse that got me through chemotherapy seven years ago when I was recovering from breast cancer.

Our goal as we began this project was to give a voice to the American Nurse. With my team we mapped a trip across America that would take us to parts of the country where we would have the chance to meet nurses dealing with some of the issues that face our nation, poverty, returning-war veterans, a rapidly aging population, black lung disease, prison life. We chose places where we would find those nurses and patients. We asked hospitals and facilities to nominate nurses that would best represent their organization and region. In this way, I was able to talk to some of the best nurses in the country.

In the beginning, I thought a nurse was a nurse. I thought I would talk to nurses about the job itself, but instead I had conversations that lead to other conversations about things that matter to all people.

This journey wasn't neat and tidy. There were times when I had to stop an interview just to feel the story. We hugged. Nurses hug a lot. Touch has the power to heal, and it's a huge part of what they do. Nurses spoke of being honored and privileged to have much intimacy with their patients. To be with patients and their families during times of illness or death is to see people at their most vulnerable. I often felt that intimacy in the interviews—it's home base for them. The nurses I met were comfortable showing me who they are.

I started my journey in the Bronx where I met Mohamed Yasin, who grew up in Guyana in South America. His father was considered a healer whom the villagers would visit, an honorable position that inspired his son to become a nurse. His father would use a warm breath to heal villagers, and Mohamed learned the power of the smallest gestures from his dad.

Joan O'Brien started the first AIDS unit at her hospital while simultaneously dealing with the first gay men she had met in her Irish Catholic life. Those were the early days of HIV/AIDS, when they really didn't know much, and nurses were scared. Joan spoke of what she learned from that first patient and how much he taught her about herself.

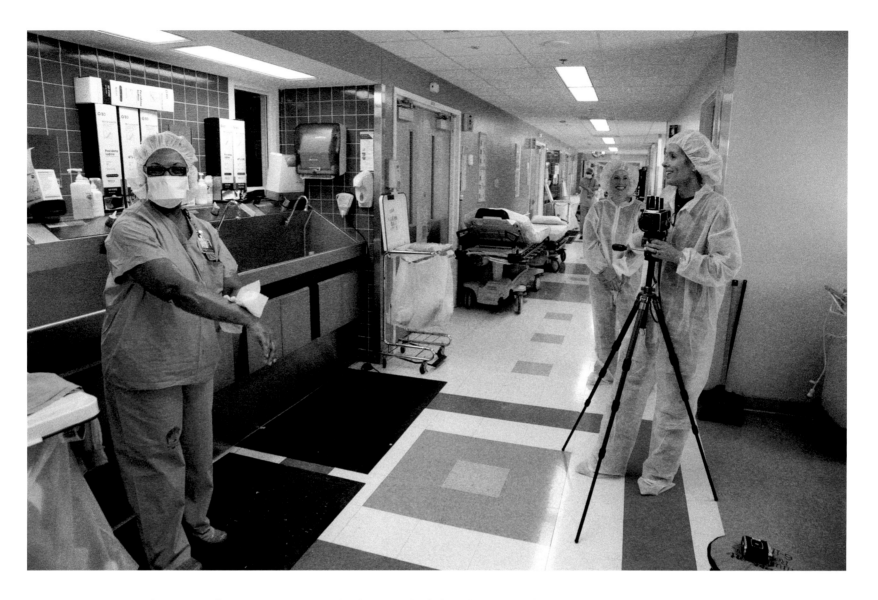

Nurse Germaine Williams shows Carolyn and producer Lisa Frank how to scrub in outside the Johns Hopkins Hospital OR.

At a clinic in New York, I met Nathan Levitt, a transgendered nurse who helps others going through the same process and conducts gender-sensitivity training for health professionals.

I met nurses who have difficulty saying the word "die." For some, we "expire." For others, we "pass on" or we are "lost." It turns out death is not easy for anyone to talk about.

At the Johns Hopkins Hospital, we had amazing access to the nurses. In the NICU, Karen Frank rocks babies when they are dying and the family cannot be there. There were days working on this project when I thought I wouldn't be able to stop crying during the interviews.

I photographed nurses in the ER while a young man was dying in the next room of a gunshot wound.

Here's one of the first things I learned: when you sit down to talk to a nurse you realize that there's very little veneer to get through. I interview a lot of people, and there's almost always something that a person holds back for protection. Not so with the nurses—there are no walls to break down. The interviews were rich because the people giving them don't have time to dance around words and feelings. They are just so raw. Saving people and watching people die makes you more human, I think.

Carolyn photographs hospice nurse Katy
Hanson at her patient's home in rural
Wyoming, forty-five minutes from the
nearest medical center.

I met Brian McMillion at the VA hospital in San Diego. He spoke of working with young men waking up
and realizing that they had lost limbs in combat and yet the first thing they would ask is "When can I go
back? I left my brothers out there." Spending time at the VA hospital showed me what sacrifice is.

I went to the Louisiana State Penitentiary, where inmates can volunteer for the hospice program. The inmates
care for one another in the last stages of life. This act of humanity is often the only chance someone may have
had in his entire life to be able to care for someone else—it transforms people. It turns out that helping people
is healing.

We traveled to New Orleans to meet nurses that worked during Hurricane Katrina. Tears were shed here.
None of us can really imagine what happened. The nurses we met talked, relived, and cried about what they
experienced during the hurricane. I came to New Orleans hoping to talk to the nurses that had to perform
euthanasia on their patients, but in the end it wasn't the right story to tell. The people haven't forgotten, but
they are ready to move on and rebuild.

In Florida we spent time at the Tidewell Hospice homes with nurses doing palliative and hospice care. Elisa Frazer told a story of helping an Italian gentleman at the end of his life, surrounded by family singing "That's Amore." I was crying and laughing at the same time.

We visited a Catholic nursing home run by the Sister Servants of Christ the King in Mt. Calvary, Wisconsin. The sisters that keep the home running smoothly are Sister Michael and Sister Stephen. They have animals here, not just a few animals but the whole shebang. Cows, horses, peacocks, llamas, sheep, goats, geese, alpacas, and a whole room full of birds in the entrance hallway next to the chapel. There are a couple of dogs roaming the halls. It's incredible—this is the first health facility that I have been to that lets animals roam free. The residents love it; most of them had farms and animals, and when spring hits and the babies are born, the nurses often bring them in to show to everyone. It's marvelous, life affirming, funny, brilliant. It also encourages family members to visit the residents, particularly grandkids who get to play with the animals. How smart is that? I love Sister Stephen.

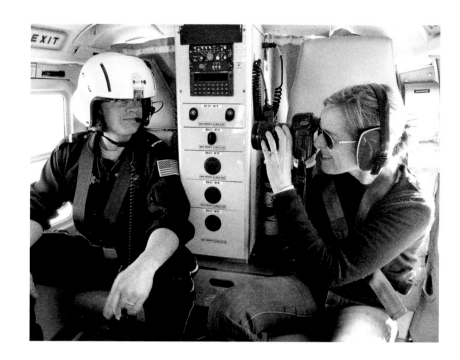

Matt Tederman poses mid-flight aboard the LifeNet helicopter outside of Omaha, Nebraska.

I have questions. How can we break the cycle of poverty in Eastern Kentucky? How can we prevent our returning troops from needing so much psychological repair? How can we find a way to minimize end-of-life care so that one third of our Medicare dollars are not spent on the last year of life? How can we mobilize a team of nurses to help us find answers? They have ideas.

I am not who I was before. There are people in this country with so little that they cannot live. There are people who have to make the choice to either work in the coal mines or not feed their families. People have to choose to live with pain or die with dignity, children have to unplug their parents from machines, doctors have to decide when there is nothing left to do, and nurses have to navigate all these waters.

I expected warriors out there and in a way that's what I found—just not the way I expected. Nurses do fight to care for us, in spite of ourselves, in spite of the obstacles in their way. And they fix us. When they can no longer fix us, they make sure that we are comfortable and that our time leaving this earth is as rich as it is entering.

Nurses have seen things that none of us can imagine. I'm in awe. I do believe that they are a special breed—some combination of innate compassion and learned behavior. I wish I could say exactly what it is, because I'd bottle it up and drink that potion. But it's not consistent, and, of course, there are many roads that lead to being a nurse. I hope we have captured that.

—Carolyn Jones

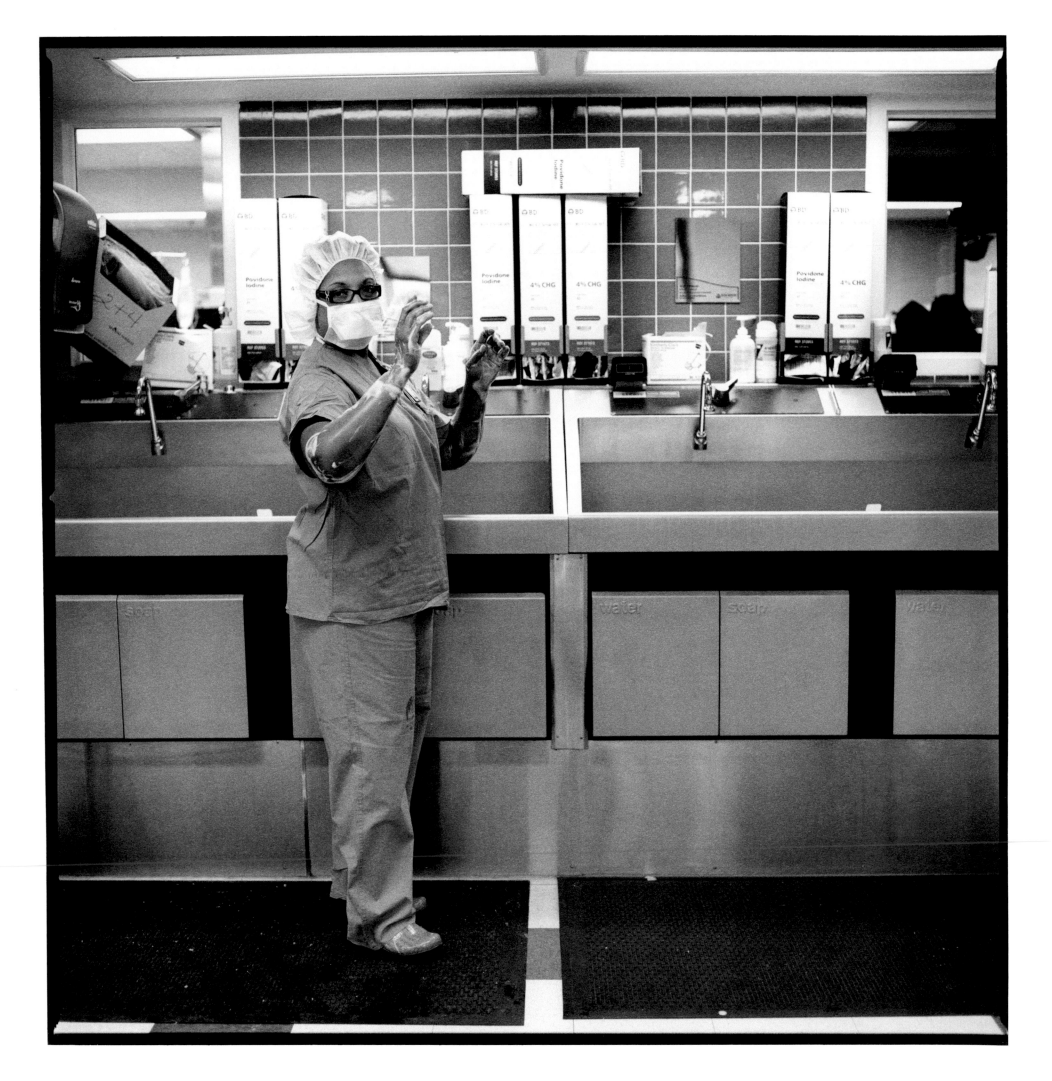

THE AMERICAN NURSE

PATRICIA ABBOTT

THE JOHNS HOPKINS UNIVERSITY SCHOOL OF NURSING, BALTIMORE, MARYLAND

Patricia Abbott, PhD, RN, FAAN, has been a nurse for twenty-five years and is now an associate professor at the Johns Hopkins University School of Nursing. She was among the first to see that computers were going to become crucial to the nursing profession and got into the field of nursing informatics to make sure that nurses had a voice in the merging technologies.

I am an associate professor at the Johns Hopkins University Schools of Nursing. I have been a nurse for thirty-five years.

I spent much of my childhood with my beloved grandmother. I grew up listening to stories about my great-great-grandmother, a midwife, and how she carried a derringer in her bag to ward off drunken soon-to-be fathers. Growing up during the Great Depression, she and my grandfather had only sixth-grade educations. "Nanny" encouraged me to be a nurse. Influenced by her stories, I paid my way through nursing school and became a nurse at the age of nineteen.

In the late 1980s it became obvious to me that big changes were coming to health care. More and more computers were showing up on the wards. Nurses, however, had no voice in the way the computer systems were being built. The question became: how are we going to get nursing represented in that black box?

In 1989 I jumped into a new field called nursing informatics. Although still a rare breed, our numbers are increasing. I received a grant supported by the Stimulus Bill to scale up the health-care workforce for the new era of "e-Health." My generation of baby-boomer clinicians is not comfortable integrating computers into their professional practice, and that is one of the things I am working to change. Some have embraced the "new ways of doing" while others have just chosen to "age-out." Our incoming students are thinking of nursing in very different ways; it requires that we all adapt.

I always wanted to give nurses a voice in the technology that was being built to "make our jobs easier" because if you don't design things with the user in mind, stuff doesn't work. For example, I completed a usability study of portable clinical computers—a great idea because mobile clinicians need mobile solutions—but the on-off button was right next to another frequently used button. Well, busy nurses kept hitting the wrong button and turning the machine off. The frustration was so high that the nurses rejected the device.

People have an outdated conception of nursing. Even my dad used to ask me, "Do you still wear a nursing cap?" When I started teaching in 1990, I used traditional techniques—standing in front of classroom with an overhead projector. Now, twenty years later, I teach 100 percent online. Geography has become irrelevant, and the outreach into remote areas has really given me new perspectives. In many ways, as I teach students all across the world, I become the student and learn something new every day.

I am also working on a telehealth study in cardiovascular health with African Americans living in Baltimore City. Susan Rice and I venture into blighted city neighborhoods in her "Flintstone Mobile." There may be fifteen row-houses that are burned out and boarded up, but there is one house where our CHF patient lives. Our goal is to work with patients in that community to install telehealth devices in their homes in order to monitor their conditions, teach them about their disease, and help them keep in contact with us. The device has a blood-pressure cuff, thermometer, scale, and glucometer. It asks them questions, provides educational video, and supports video telephony. When we started, the things I worried about most turned out to be trivial. I worried about being viewed as just "another white girl from Hopkins." The real problem turned out to be having no local provider who would come into these dangerous neighborhoods and hook up the Internet, or the fact that those old houses were not wired for grounded electrical plugs. It was also hard removing the devices after the study was over. The patient's sense of connectedness and someone caring about them—even via a computer system—turned out to be transformative. Taking that away was difficult.

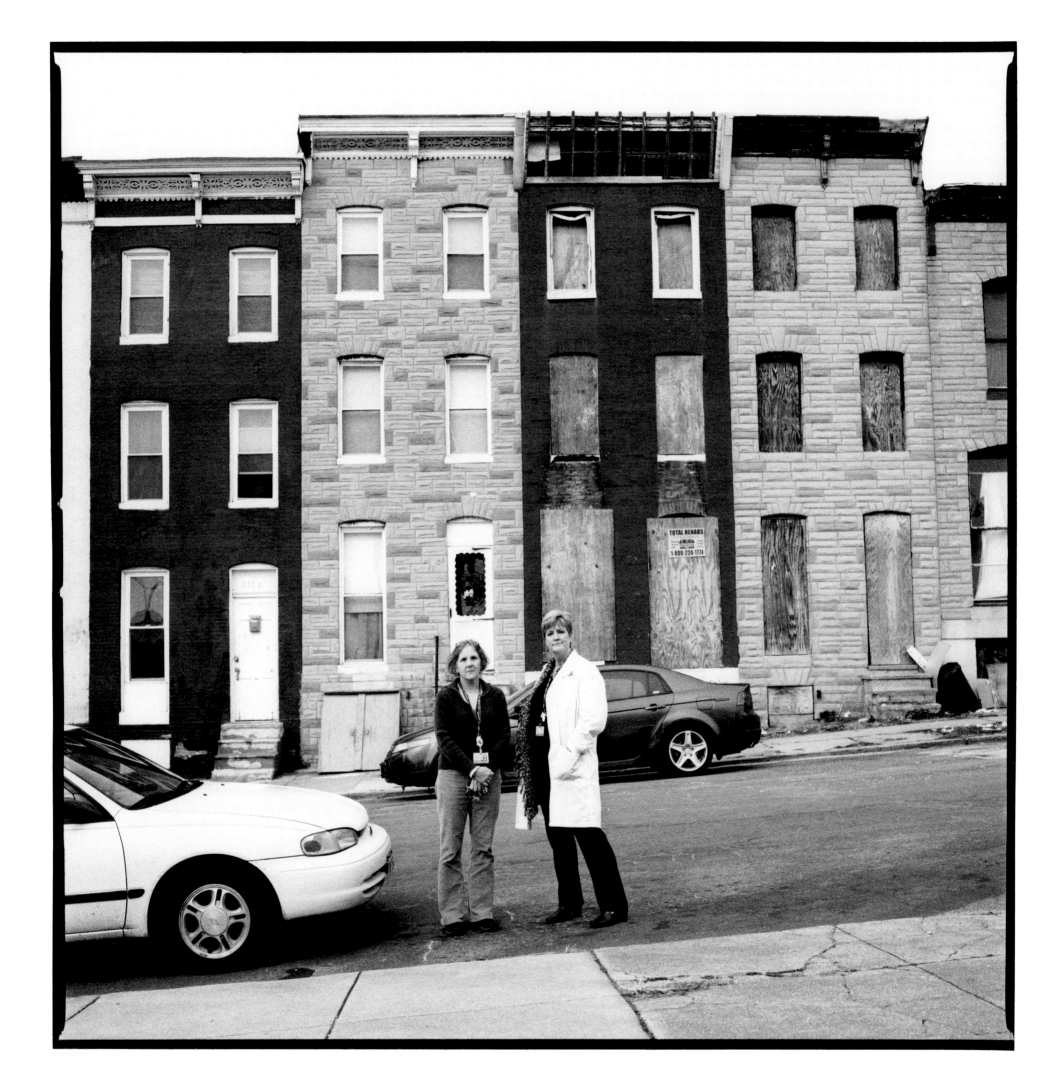

BRIDGET L. KUMBELLA

MONTEFIORE MEDICAL CENTER, BRONX, NEW YORK

Bridget L. Kumbella, RN, MA, BSN, grew up in Cameroon, where she had access to the best possible education in her country, and migrated to the United States in 1987. She wanted to study to become a doctor until she realized that nurses were the ones with the most direct access to the patients. She now holds an advanced degree in nursing administration from Teachers College, Columbia University, and teaches the value of cultural awareness in nursing.

I work in the ICU at Montefiore's Wakefield Campus. I've been a nurse my whole life. I started out as an LPN at the age of twenty-one and then went for my associate's degree, my bachelor's, and then my master's.

I'm the oldest of four kids, and when I was growing up, my father decided I should be a nurse because I was compassionate and caring. My father had been working in a nursing school when he fell from the fourth floor and hurt his back. He always said he knew what it was like to be lying on your back and not get the type of care you deserve. So, growing up, that was an inspiration for me.

Actually, I thought I'd pursue a medical career, but when I got to the hospital, I saw that nurses really make a difference in helping the patients alleviate their fear. Most of the time, it's a fear of not knowing. When you take the time to hold the patient's hand, and be honest and genuine, they can feel that energy. That means more to me than being a doctor, who comes in for two minutes and walks away.

I always try to practice being fully present on the job. When someone comes in from a traffic accident, for example, I take two minutes to calm myself so that I can make it be all about the patient. I always want to be positive and dignified. We learn in nursing school not to be judgmental and to focus on the whole person, not just the part that is hurt. We try to understand if the patient is acting out or behaving badly. What is making them so scared? It could be that they are undocumented and worried about what will happen if they are discovered. It behooves the nurse to take the time to gain the trust of the patient.

I was fortunate to do my undergraduate work at the College of New Rochelle, where they teach about cultural differences. We have patients from other countries who don't trust doctors and are scared of strangers. We have people of all religions. If a patient is sick, the holy rosary can provide spiritual comfort. Or it might be a feather for an American Indian that helps with the healing. So you have to look at what matters to that patient in terms of the whole picture.

To be honest, some of my frustrations about the job are because I don't think our policy makers from business and financial backgrounds truly understand what it takes to be on the front line. It's not just about walking into the room and giving medication. It takes time, and each case is different. Most people come in understanding, and they're willing to get better. Unfortunately, we also have angry people who are drunk and got shot or stabbed. There is stuff going on in their lives, so you have to be willing to really look at the total picture and plan an intervention based on what you're dealing with.

The pledge of nursing is to help and support people through the healing process, but when the time comes, we are also there to give them a dignified and peaceful death. Where I come from, when we lose one person, the entire village cries. So I cry with the families and with the patients; that is just who I am. We lose some patients, but we also change lives in a lot of positive ways.

I had one patient, an older man who came in with no identification. He was listed as a John Doe. His heart rate was 29, so there was no time to waste. I contacted the cardiac surgeon, we put in a pacemaker and saved his life, but there was no one there for him. So I went to his chart and got the address where the ambulance picked him up. I asked the nursing supervisor to contact the precinct. We begged them to go see if there was a landlord or super at the building who could get an emergency contact or next of kin. They did, and the patient's son came right in. It was the best reunion ever. How could that not uplift your spirit?

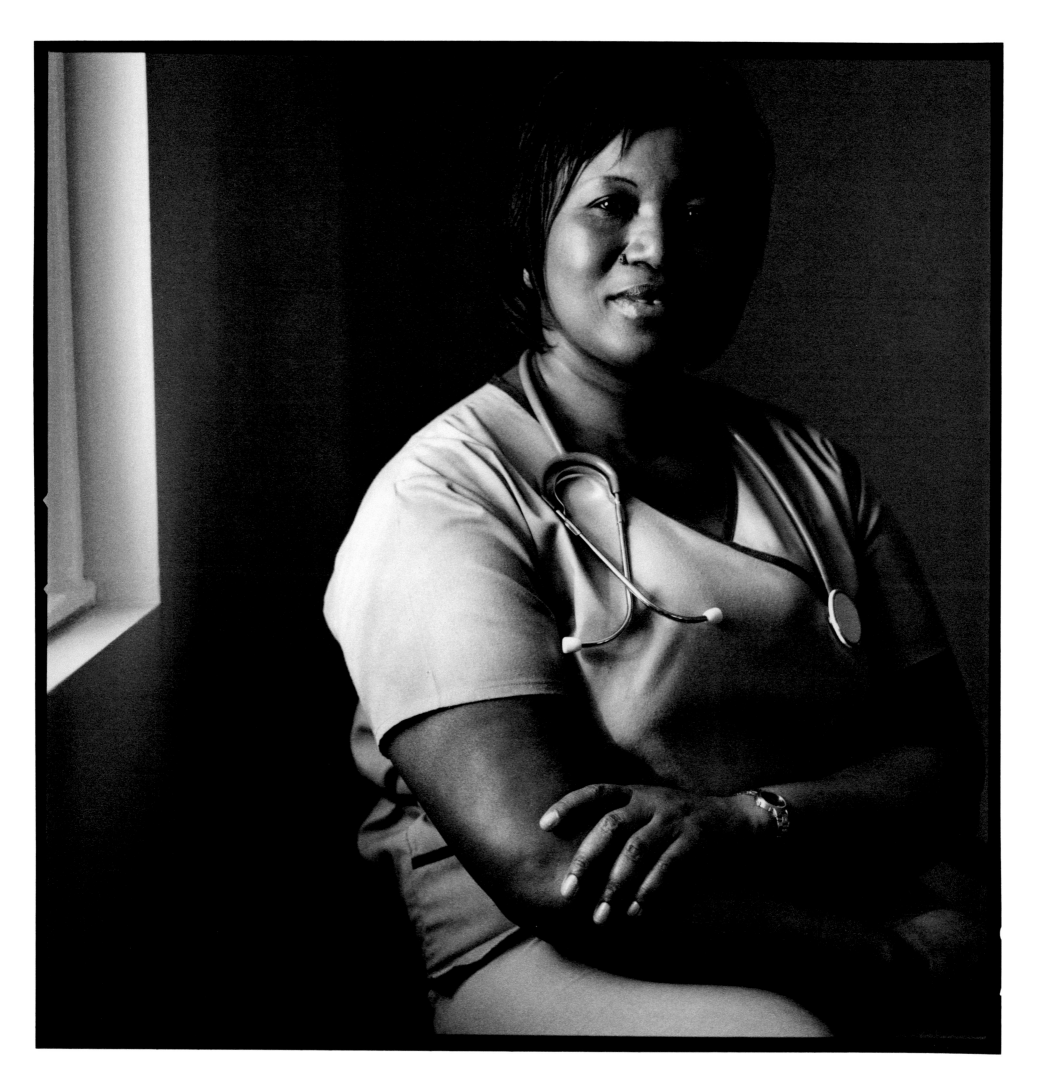

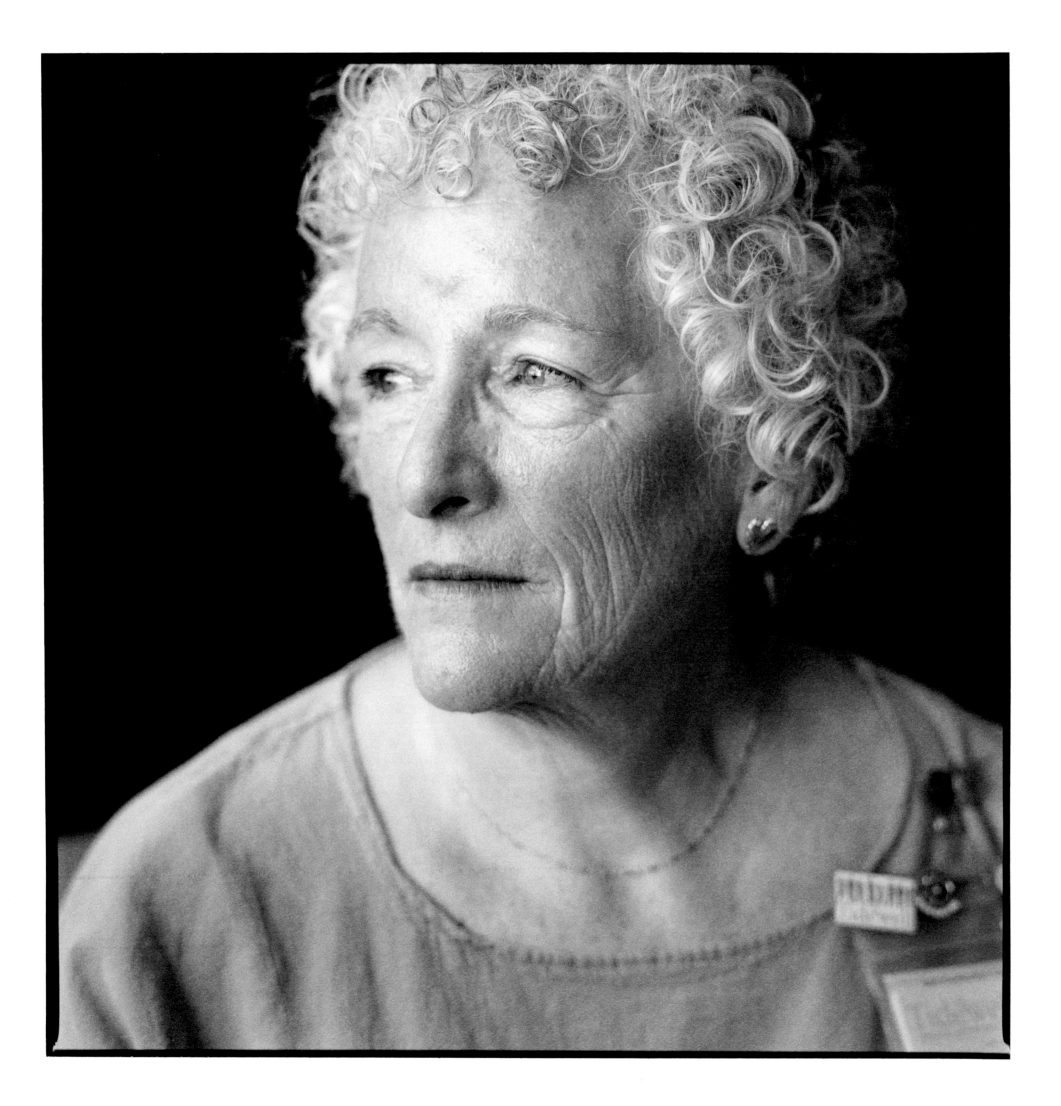

HEATHER COWAN

TIDEWELL HOSPICE, VENICE, FLORIDA

I always wanted to be a nurse, but life kind of got in the way. I had a family and then got divorced. So, at fifty years old, I went back to school to get my RN. Before then I'd been a massage therapist and body worker.

I think the intimacy is what drew me to hospice. I often say that I get nourishment from working with people who are dying, and from their families, because it is so honest and intimate—what I call "real real." It fills me up and calls forth the best parts of myself, which are vulnerability and trust.

This work is a continuation of Buddhism, my spiritual path, whose foundation is that everything is temporary. All we have is this moment. The past and the future are only thoughts. I practice this in my life. If I can stay in this moment, I can give the best part of myself.

In the past three years, both my adult children died of complications from long illnesses. I don't know what happens when we die, but I still feel my children. What's important is being right here with the grief, the love, and the deep understanding of the moment. My job teaches me this every day, and it brings me peace.

Sometimes I am overwhelmed when dealing with a parent who is losing a child. I can be present, but I'm selective about telling them what happened to me. I make sure it is appropriate for the person's needs.

I had a patient in Colorado, an older woman who'd been in hospice for many years—that was when Medicare paid for hospice for as long as needed. Toward the end she got more and more frightened. Up until then, she'd been a model of sweetness and love. Then, when she got scared, she made us lock the bathroom door and put chairs against it. Apparently, her mom had died when she was nine years old and her three older brothers had sexually abused her. She was petrified that her brothers were hiding in the bathroom, and there was little we could do to help, except sit with her and hold her hand. It was a very difficult death because she never got over her terror. It was a lesson to me about taking care of business before we die, if we can.

It is a privilege to be there for someone at the end of life. This is not a job where you come in saying, "This is going to happen and this is how you have to do it." My job is to see where the person is and follow where they're going. I think the patient knows what he or she is doing. I follow their lead, and I do it really well. Sometimes I have a little wisdom to help, and sometimes I don't.

We had a delightful lady named Ruth, who had Alzheimer's. One day she said, "You know, I'm very old." I asked her how old. She said, "I'm ninety-five and I'm getting older, faster, every day. In fact, I'm getting so old, so fast, that I can't keep up anymore." I just wrapped my arms around her. She was right. It was a huge lesson for me about people with Alzheimer's. Sometimes they have great insight and express it so clearly.

I work in two different hospice houses. One of them is mostly about managing symptoms. We can control pain and provide the best quality of life. The patient gets to say how much medication because it's also about being as lucid as possible. The other house where I work is for longer-term patients who can't stay at home. Some of them have little kids, or they don't have any caretakers.

I want people to know there is an alternative to suffering and living in a hospital where there's noise and you can't sleep or have any privacy. We have music, and pets are allowed, too. I want to start a grassroots movement to let people know that this is a gentle place to be and a gentle place to die. Family members can rest in this kind of peace, and that makes a difference to the patient as well. I have often said that hospice is the way all medical care should be given.

Heather Cowan, RN, grew up in Shaker Heights, a suburb of Cleveland, with a younger sister. She graduated from Cleveland State University and Boulder College of Massage Therapy. At fifty, she attended City College of San Francisco to get her RN, a lifelong ambition. Her first love is working with hospice patients, where she combines her passion for Buddhism, and living in the moment, with her appreciation for being what she calls "real real." Being a hospice nurse has taught Heather how to live her life, be her best self, and keep saying yes to whatever happens.

SHANNON CARROLL

CALLEN-LORDE COMMUNITY HEALTH CENTER, NEW YORK, NEW YORK

Shannon Carroll, BA, ASN, RN, NPS, grew up in Cambridge, Massachusetts, in a very religious family, with his mother and three siblings in a two-bedroom apartment. Shannon came out on the Maury Povich show when he was sixteen and subsequently filed for emancipation from his family in order to seek a better life. The first person in his family to attend college, Shannon graduated from U Mass, Amherst, and is currently attending NYU full-time for a master's degree and his nurse-practitioner license.

I am a registered nurse care manager, and I work with about two hundred HIV positive or AIDS diagnosed patients. I help them set goals in health care. It's not just about treatment or medication management; it encompasses all the psychosocial aspects of this disease. We talk a lot about the isolation that can come with this disease.

Nursing was not my first career choice. After college, I moved to Seattle, got into music, and started a company called Angry Boy Productions. For ten years, I was a producer and a DJ. I was a queer punk back then and got some tattoos. I got a little lost in that world and started to lose myself. It was a great life for a while, with big paychecks, but then months of no work at all. It was like rich, then poor, then rich, then poor again. I wanted to figure out a way to end poverty in my life forever. I saw nursing school as a way to get focused and to give back to the community. Also, nursing opens up a lot of possibilities. You can travel anywhere, make your own schedule, and you can do other things as well. A lot of nurses have other careers they are developing. So five years ago, I sold the production company and went into nursing school.

Nursing is a very rewarding job, but it is also very stressful. We're often understaffed and very overwhelmed with need. But I think that is a symptom of a larger issue, which is that people do not have access to health care. We are simply overwhelmed by the numbers of people walking in the front door.

I do urgent care as well, and that is really hard. We never know what we are going to get. There are the routine cases: people who have a sore throat or are throwing up. Then we get people who have self-inflicted wounds, which we know is a cry for help, but they've scarred themselves for life. Or people who are HIV positive, but have not had any help for ten years.

What really scares me is when a patient's health gets to the point where it is going to be difficult for them to rebound or they don't have the motivation to get better. It feels like the ship is sinking, and there is nothing I can do about it. My other big fear is that I will make a mistake. I see a lot of people who are emotionally fragile, and I worry whether I gave them the right amount of attention.

Stuff like that really shakes up anyone who does this job. And because it's so fast-paced, it's hard to regroup. I just have to move on to the next patient. Luckily for me, my partner also works here, and he understands the work. We met on a dance floor back when I was a DJ, and were married in Seattle before we moved to the East Coast. We walk to the train together every night, so that is basically twenty minutes of debriefing.

When I leave here at night, I know I've done some good work and I've helped somebody. I get a lot of reward from my patients who thank me for the work I've done. At the same time, I leave here wondering if I've made the right choice giving up something I loved for something I also love, but often sometimes hate. I definitely have ambivalent feelings, but overall I feel very positive about my job. I keep my head above water, and I feel like I'm adding some good in the world.

I've seen a lot, and I've come out on the other side. This is an unbelievable strength for me. I really like people and I love to dance—so I just keep dancing. I try to stay fully engaged in life, and it keeps me positive.

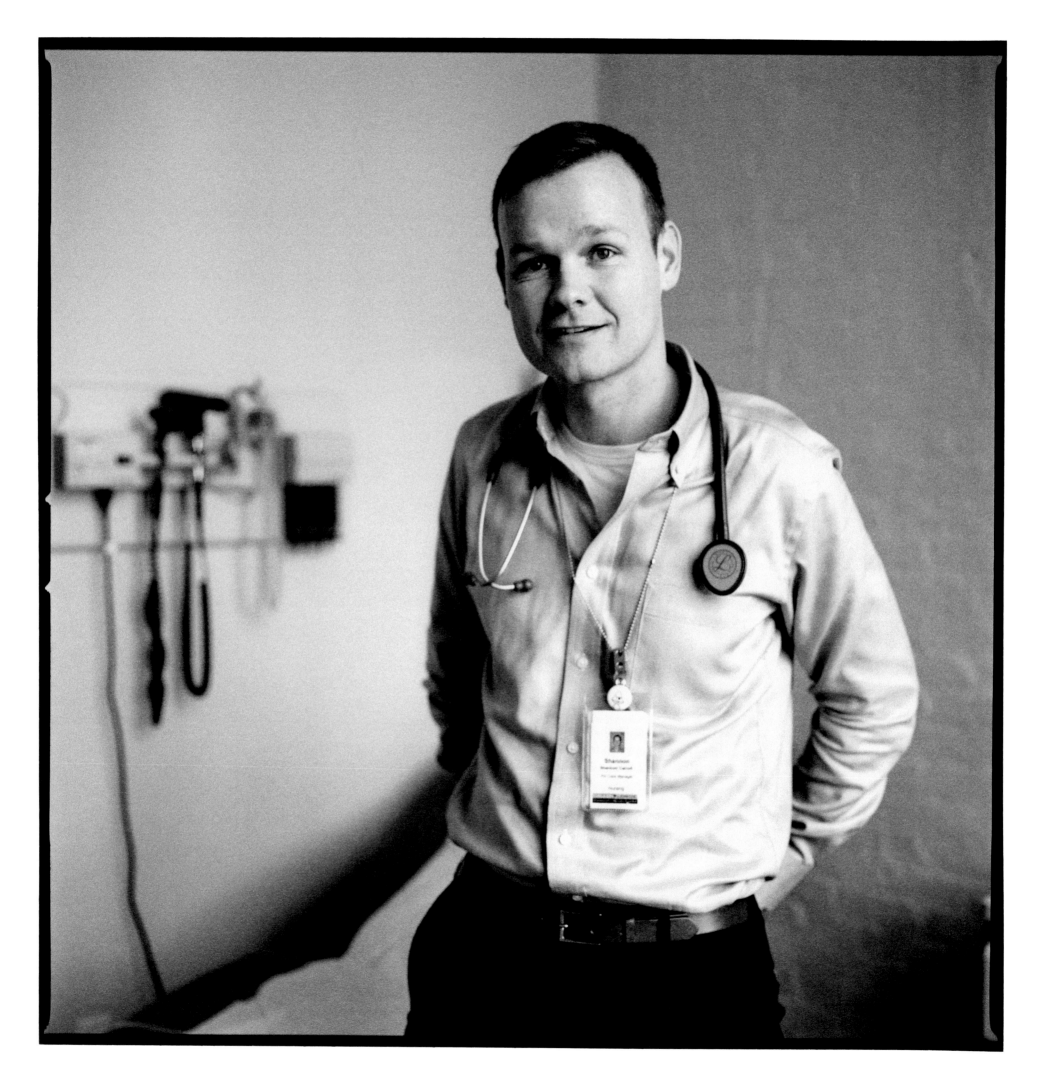

RANIMARIA TOLEDO

THE JOHNS HOPKINS HOSPITAL, BALTIMORE, MARYLAND

Ranimaria Toledo, BSN, RN, CEN, TNCC, was born in Westmont, Illinois, and grew up in Columbia, Maryland, with her parents, two older sisters, a niece, and various other family members from time to time. Her mother is from the Philippines, and her father is African American. Today, she is living her mother's dream by becoming a nurse. She has a bachelor's degree in nursing and is working on her master's to become a nurse educator. She is also certified in emergency nursing and as a trauma nurse. For the past seven years, she has worked in the emergency department at the Johns Hopkins Hospital.

I am one of the nursing supervisors in the adult emergency department at Johns Hopkins Hospital. I am also an orientation facilitator and education nurse.

It was my mom's dream to go to nursing school. She unfortunately did not have the means to finish school. She wanted her three daughters to become nurses. I admired nursing and enjoyed taking care of a woman with multiple sclerosis when I was in nursing school, so I ended up carrying out my mother's dream. My older sister is also a nurse.

The days in emergency are always different, and you never run out of surprises. We average at least two adult- and pediatric-trauma arrivals by helicopter per week in addition to the many trauma patients who are brought in by ambulance or just walk in. When a trauma patient is coming by helicopter to Johns Hopkins, the emergency department is alerted through our Emergency Response Box. After we get that call, we alert our trauma team. We advise them as to what the mechanism of injury is so that they can anticipate treatment. We also alert them to the age of the patient, the treatments administered by the response team, and any other information that is known at that time. We send a nurse and a physician up to the helipad to wait for the helicopter. When we get them, we bring them down into emergency for treatment. The most recent patient was a nine-year-old boy who was hit by a vehicle and, unfortunately, didn't make it.

We have to deal with death on a regular basis; it is always difficult, but with experience we learn how. Unlike other floors, we don't have twenty-four or forty-eight hours to build a relationship with the patient; it's a very fast-paced environment. We have to deal with things quickly so that we can get to our next patient.

At any one time, we might have forty patients in our waiting room. Our team works really hard to treat each and every patient, and it often gets overwhelming. Somehow our team pulls together and creates a plan that may take hours to achieve, but we get through it. Our sickest patients are treated first, and it feels like we don't stop pushing through until our patient load is comfortably manageable. I often get into the car after a hard day and feel like it is the first time I am able to exhale.

I do think it takes a special kind of nurse to work in the emergency department. You just never know what the day has in store for you. You have a small amount of time to make a good impression on your patients and have to think critically under the most stressful conditions. You have to be up on your physical assessment skills and your knowledge. You have to read. You have to be ahead of the providers.

What makes my day is when our team works well together to save a life, or even just make a patient feel better. That gives me the adrenaline rush to keep on moving forward.

I picture myself staying here and doing this job for as long as I can. I started here as a graduate nurse and have been in the same department ever since, for the past seven years. I never get bored in my work.

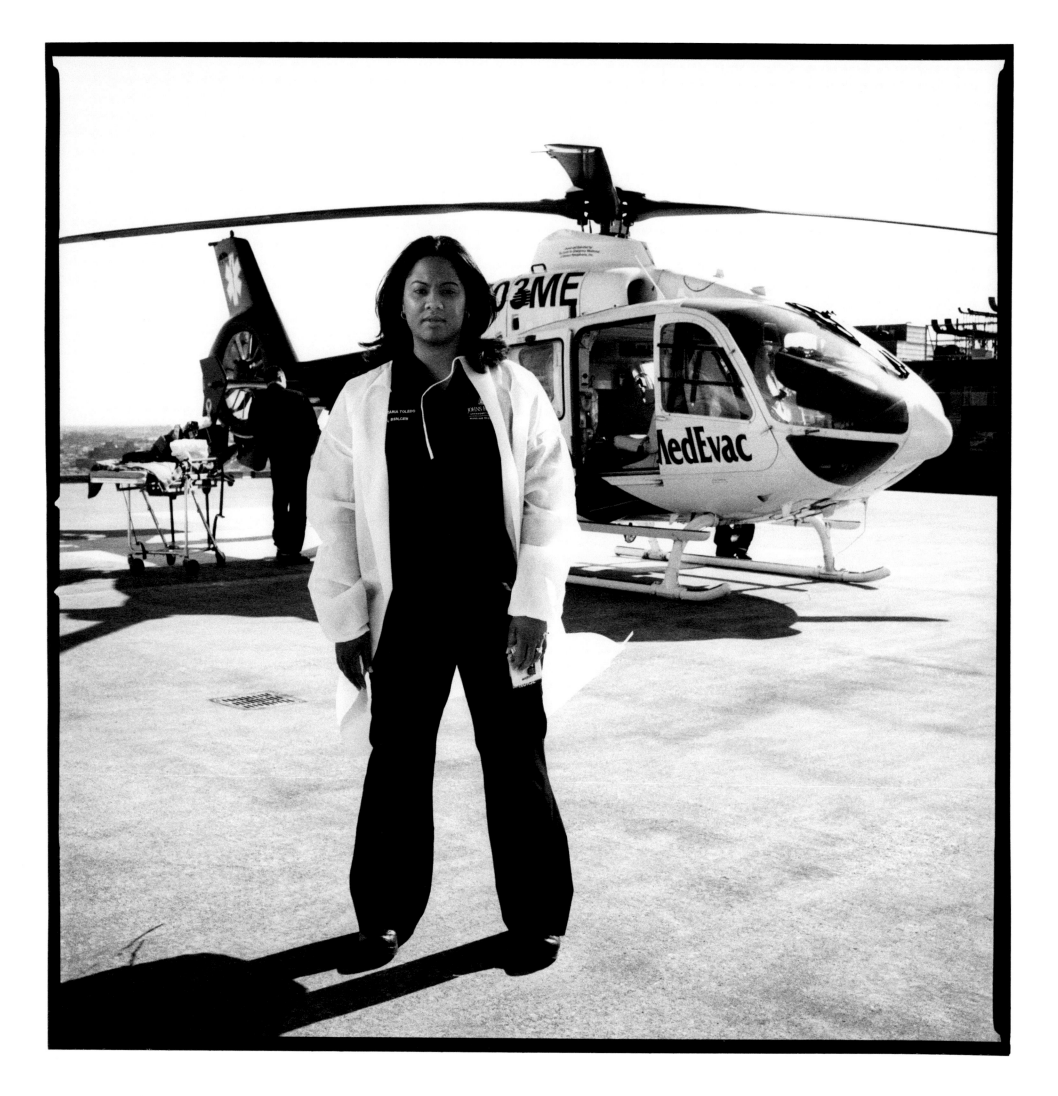

RENEE LAWSON AND JANICE ROMAN

CENTRAL WYOMING COLLEGE, RIVERTON, WYOMING

Janice Roman, RN, has been a nurse for more than twenty years and recently retired from the Indian Health Service. Now she works as an outpatient nurse for Help for Health Hospice. Her daughter, Renee Lawson, is a nursing student, currently enrolled in Central Wyoming College, and employed as a nursing assistant at Help for Health Hospice.

My name is Janice Roman, and I am a registered nurse who retired from the Indian Health Service after twenty-one years. I now work as a case manager and outpatient nurse for Help for Health Hospice. I'm a member of the Oglala Lakota tribe from the Pine Ridge Reservation in South Dakota.

My name is Renee Lawson, and I am a first-year student in the Central Wyoming College nursing program. I'm a wife and mother of three daughters. Both my mother and I are married to Northern Arapaho men, who are here on the Wind River Reservation.

Unlike others in my profession, I didn't dream about becoming a nurse. I had no calling. I was taking some science classes and had four kids to support. Most of my classes turned out to be prerequisites for nursing, so I applied for an Indian Health Service scholarship and got it. It wasn't until I actually started nursing that I realized it was the best career choice for me.

I've worked all these years on the reservation and have seen people in the ER when I worked in the hospital, but the best part of nursing for me is being a public-health nurse. I work with people in their homes and get involved with the community.

My first advisor was wonderful. Her name was Mary. I had gone into a patient's room, and she could see that I was shaking—I was so scared. And she said, "Don't be scared. It takes an awful lot to kill somebody. I'm going to tell you a secret. Before you even step into the room, take a deep breath and let the patient think you have all the time in the world for them. No matter how much of a hurry you're in." And I've done that throughout my career.

Just yesterday I sent Renee a text that said, "I just love nursing."

My mother is my inspiration; she really is. When she was studying for the program, I'd sit in her room with the flash cards and help her. I got to see her work at Hu Hu Kam Memorial Hospital in Sacaton, Arizona.

I remember when I was seventeen, we were in the car and there was a really bad accident on the other side of the highway. We pulled over, and my mom ran across the road and gave that guy CPR until the ambulance came. She was at it for about two hours because we were in the middle of nowhere, and this was before cell phones. She didn't say much on the drive home. When we got to the house, she broke down and started crying. She still had blood splattered on her. Her strength is just incredible. I thought there was no way I could ever be like her.

I started school to teach elementary education, and then I realized I'd burn out really quickly doing that kind of work. I started having babies and needed to finish school. I was only one semester away from getting into the nursing program and thought that was something I could do. So I jumped in, and it feels really good.

I was overwhelmed at first, between school and being a mom, but this semester feels a lot better. I really like Peds and OB. I think that being a nurse makes me a better mom. I have daughters, and I want them to be independent. I am working toward being a role model for my kids, like my mom is for me. She is really who I want to be.

I was just talking today to one of the nurses whose daughter is also going into nursing. We were saying how we are both wimps compared to our daughters. It takes a strong personality and a lot of stamina to be a nurse these days. You need strength to stand up and be an advocate for your patient. Renee is strong inside, and I am proud of her.

MARILYN DeLUCA

CONSULTANT, HEALTH CARE AND PHILANTHROPY, NEW YORK, NEW YORK

I've been a nurse since 1971. My current work is building the global health workforce. There is an estimated global shortage of five million health workers that is most severe in low- and middle-income countries. Health workers include health professionals—nurses, midwives and physicians, mid-level providers, and other cadres such as community health workers and managers. Approximately 85 percent of health care is provided by nurses and those they supervise. While health is the largest sector of philanthropy, few funders support workforce development. Donors typically target diseases such as HIV/AIDS, malaria, or TB. Health workers are needed to improve health, reduce maternal and child mortality, prevent and manage non-communicable diseases, and care for aging populations. These settings need resources and committed partnerships to build educational programs and systems that retain competent workers.

My clinical practice was in critical care. I became nurse manager of the medical ICU a year and a half after I began practice. I was fortunate to have two amazing supervisors—a director of nursing and a medical center director who encouraged innovation. As I have always been interested in systems improvement, I introduced primary-care nursing in the ICU. Each patient was assigned a primary nurse to manage his care during his ICU stay. When a nurse has responsibility for overall management of a patient's care, she addresses both their short- and long-term needs. The primary-care-nursing model improved patient care, communication with physicians and families, and nurse satisfaction. The model allowed more professional autonomy. In one study, we learned that nurses ranked professional autonomy over salary level or work schedule. Critical care is very intimate. While all of nursing is intimate, in my view, critical care is more so because the patients are so vulnerable.

I pursued a PhD in health policy and reform to acquire a better understanding of health systems. Despite my clinical practice and experience as a member of medical center leadership teams, I had limited appreciation of macroeconomics and policy issues that drive health reform. The role of nurse-practitioners grew in the 1980s, and will continue to grow. In some states, typically rural states, nurse-practitioners are authorized to practice to the full extent of their preparation. For example, they can write prescriptions and admit, manage, and discharge hospitalized patients. I am working with colleagues to encourage similar authorization in New York State.

If we could start from scratch, we would build a very different health-care system than the one we currently have. Many of our current problems—high costs and fragmented care—are the result of the unexpected consequences of policy decisions. In the coming years, nurses will likely play more dominant roles in health-care delivery. They have the capacity and clinical skills to improve the continuity and quality of care. To demonstrate how nursing models could impact the cost and quality, I would like to see a large-scale project to improve the continuity of care. This nurse-led, community-based, primary-care project could be implemented in a dozen states and run for several years. Primary-care nurses practicing in these communities would work with the clinical staff in area hospitals to manage their primary-care patients during hospitalizations and then following their transition back into the community. We could then compare data on quality and cost for patients in the twelve demonstration sites with patients in twelve "traditional" settings.

Marilyn DeLuca, PhD, RN, MA, MPA, was born in New York City and grew up in Queens with three older sisters. She holds a master's in public administration, a master's in nursing from NYU, and a bachelor of science in nursing from Hunter College, CUNY. She earned a doctorate in public administration with a concentration in comparative health systems and reform politics from NYU. Marilyn is a consultant as well as Adjunct Clinical Associate Professor, College of Nursing and Research Assistant Professor, School of Medicine at NYU. She frequently lectures on health-care workforce, health systems, and public-private partnerships for social change.

BRIAN McMILLION

VA SAN DIEGO HEALTHCARE SYSTEM, SAN DIEGO, CALIFORNIA

Brian McMillion, RN, MSN, MBA-HCM, was born and raised in San Diego, California, with one sister and many, many cousins in his large extended family. In 1986, he joined the US Army as a medic, where he obtained a college fund and then went into the Reserves. He was called to active duty for the first Gulf War. Today, he has a double master's degree and works as a coordinator in the Caregiver Support Program at the VA San Diego Healthcare System.

For the past year I've been working at the Joint Base Lewis-McChord Medical Command, working with the Warriors in Transition. My job is taking care of injured soldiers. Any concern you have in your daily life just pales in comparison to the challenges these soldiers are facing. When you meet an amputee who wants to run a marathon, it makes your own problems seem small.

My family has a long history of military service. Both my grandfathers were in the Navy, and have fifty-two years of service between them. My father was in the Air Force and brought the family to Japan for his tour.

I got interested in medical care when I was fourteen. I knew a nurse who took care of my grandfather, who had Lou Gehrig's disease. She treated me like an adult, taught me all kinds of things, and gave me confidence.

At eighteen, I was working at Taco Bell, and my dad gave me a little lecture about going into the military or going to college, but he didn't think I was ready for school so the decision was kind of made for me. I was a bit rebellious, and the military gave me structure and taught me discipline. When it came time to decide what I wanted to do in the military, I gravitated toward medical care.

When I was called up to the first Gulf War, my dad had some regrets about steering me in this direction. But by then I was well-trained and actually a little bit excited. It was scary when I got to the Middle East. Sometimes we had to wear protective gear because of the threat of chemical attack. Luckily we did not experience that, but we spent a lot of time preparing for it. Then we moved away from the border of Iraq and set up a staging area for our hospital. It was fascinating to work in an ER where six different languages were spoken and the beliefs about emergency-response activities were completely different. Men, for example, could not take care of women without a female escort.

In 2003, I was called away as a mobilized reservist to Landstuhl, a regional medical center in Germany that was a landing point for all of the medical evacuations coming out of Iraq and Afghanistan. You would go into the ICU and check to see if someone would be ready to go, and they had just woken up from being in a coma, or woken up from sedation that was needed because they were intubated, and you'd pull a tube out of their throat, and one of the first things they would say to you—laying there missing limbs—is, "When can I go back?" Something happens to you inside when you hear that. You love them tremendously at that moment, but you also want to smack them and say, "No! You ain't going anywhere. You've already given enough, brother."

After being on active duty, I got hired at the VA as a medical-supply technician where I got to see the lifestyle of a nurse. So I became an LPN, then an RN with an associate's degree, and then I got a master's degree in nursing.

At Walter Reed, I helped the returning veterans negotiate the health-care system. It is like a big, confusing puzzle when you come back from a war zone with a new injury or disability. As a case manager, you get to help people plug into all the different services that are available and return to some semblance of normal. After Walter Reed, I went to Fort Irwin, California, and then was sent to San Diego, which is my hometown—a stroke of luck. I was there for two years, and then moved on to Western Regional Medical Command in D.C., where I was writing policy, auditing units, and helping to improve services provided to wounded soldiers. I never thought I'd be in the military after twenty-five years, but it's been rewarding in many ways.

In the end, my experiences in active duty inspired more than traumatized me. They made me realize how blessed I was just to wake up each morning with all my limbs, without needing painkillers, and without having experienced nightmares all night. I also realized that if I can help one of these guys, I can continue to do this work.

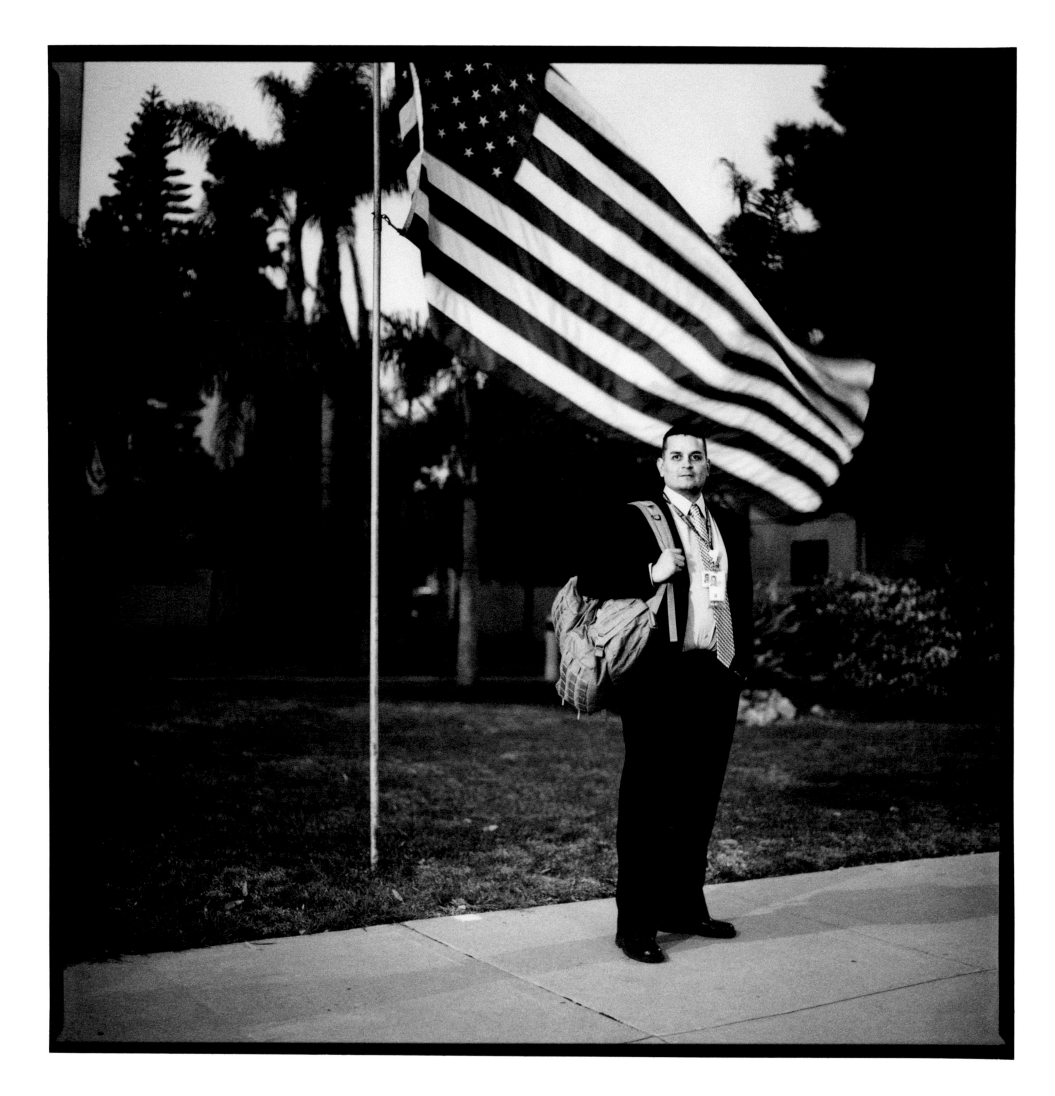

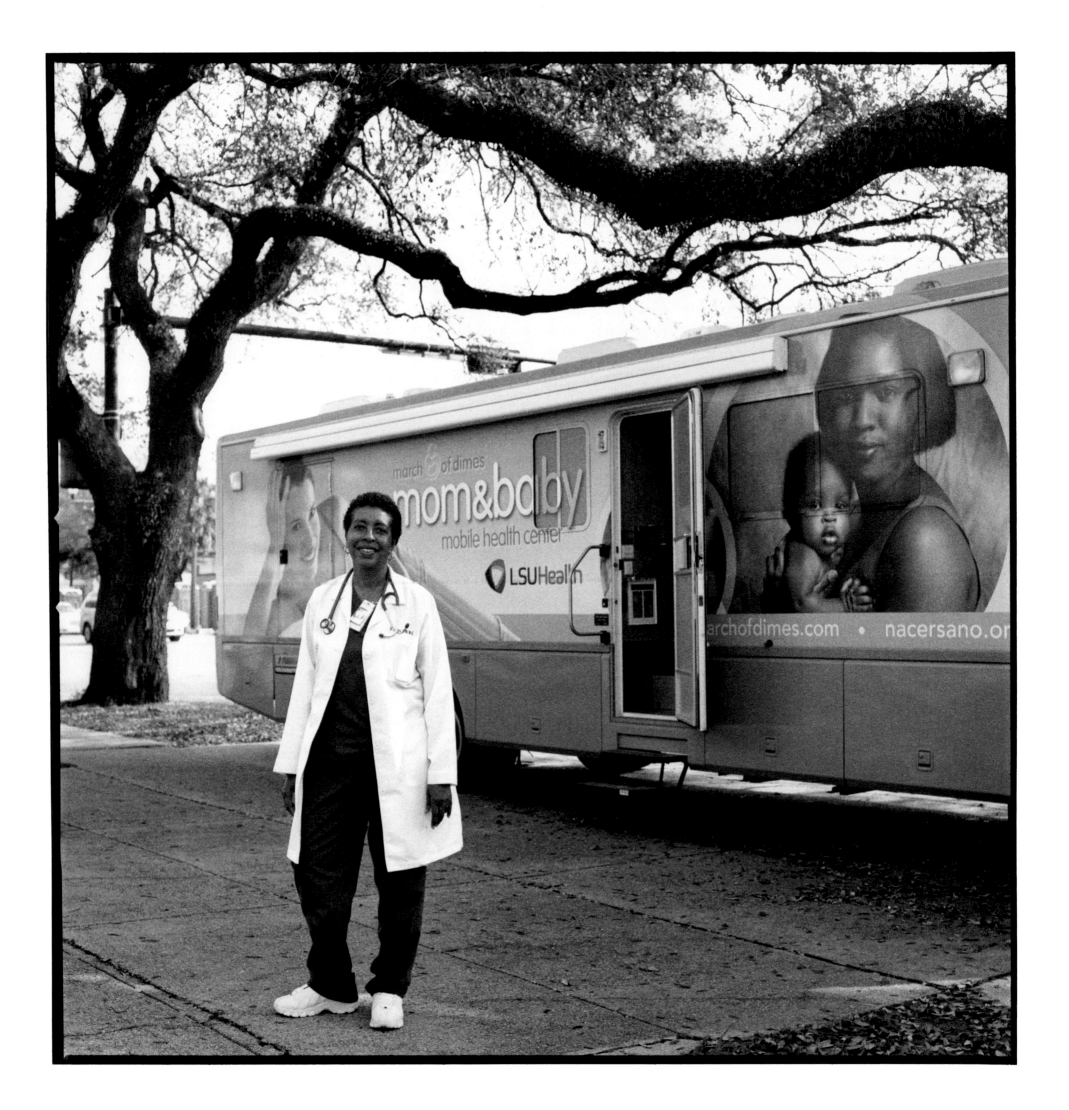

DEBORAH NETTLES

INTERIM LSU PUBLIC HOSPITAL, NEW ORLEANS, LOUISIANA

I am a family nurse-practitioner, and I work on the "mom&baby" mobile unit, which is sponsored by the March of Dimes and the Interim LSU Hospital. The purpose of the unit is to go into the community where women may have problems with access to health care.

I grew up in the Lower Ninth Ward in New Orleans, and my mother was a nurse. She was an LPN, and then went back to school to become an RN. I wanted to be a nurse since I was a little girl, but my mother tried to steer me toward another profession. I majored in sociology and then pharmacology, but my heart was always in nursing. After about eighteen months in school, I changed my major, and I've been a nurse ever since. Most of my career has focused on women's health.

The mobile unit goes out five days a week and serves three different communities including the Ninth Ward, where I used to live. I've seen patients who are the granddaughters of people I've known.

Our bus is very colorful and painted with pictures of mothers and babies. It is fully equipped with an exam room. We can do obstetrical ultrasounds on the bus.

Many of our women live in pretty secluded areas—some not even accessible by bus. Others need to change buses three or four times to get to a clinic where the wait time can be two hours for a ten-minute appointment. We can use time much more efficiently by gathering together a group of eight women for a two-hour meeting in a program for obstetrical patients called Centering Pregnancy.

We use community space, like church meeting rooms, to combine taking care of the patient with education. During our meetings, we do assessments in a private corner, where we check for signs and symptoms of complications. The rest of the time is spent on education and counseling. There are a total of ten sessions, and each one focuses on a different aspect of self-care and self-awareness. We talk about immunizations, feedings, what is normal, and what isn't. Our research shows that with Centering Pregnancy the outcome is better for both the baby and the mother. About 50 percent of all pregnancies are unplanned, so we also continue health care after delivery. We want to make sure women understand about contraception and that there are ways to plan their pregnancies.

I think it is very important to provide support, and I really enjoy the opportunity to communicate with these women. They need someone to talk to. I have always chosen jobs where there is time to talk to the patient.

I've been through two hurricanes in New Orleans. In the 1960s, we lost everything to Hurricane Betsy. We woke up in the middle of the night surrounded by water. So it was important to me, after Katrina, that I do volunteer work. I immediately went to the Common Ground Clinic, where we provided primary care. This was three weeks after Katrina, and many of the health-care facilities in the city were closed. I also worked with the LSU OBGYN Department and the Office of Public Health to provide prenatal care at a public-health clinic. Obstetricians and pediatricians weren't available, so we saw a large number of patients.

I can relate to not having health care. When I grew up, we didn't go to the doctor very often. I can remember going to immunization drives where masses of people showed up for polio shots. As far as women's health was concerned, we didn't discuss it. Something as simple as a menstrual cycle was a mystery. That's how old I am and how long I've been around. I believe the women's services we provide, and the things we talk about in our program, have been instrumental in saving many lives.

Deborah Nettles, CNS, FNP-C, earned a bachelor's degree in nursing from LSU in 1975, a master's in nursing in 1991, a post master's certificate in the family nurse-practitioner program in 2005, and is currently working in the doctorate of nursing practice program at Loyola University, with an expected graduation in May 2014. She has been a nurse for thirty-five years, focusing mostly on women's health and including eighteen years in inpatient women's health services at the US Public Health Service Hospital in New Orleans and Meadowcrest Hospital in Gretna, Louisiana.

MARY HELEN BARLETTI

MONTEFIORE MEDICAL CENTER, BRONX, NEW YORK

I am a critical-care nurse working in the ICU at Einstein Hospital (a division of Montefiore) in New York. I've been here thirty years. I am not one of those people who always wanted to be a nurse.

I had a difficult childhood. My mother told me she knew she was making a mistake at her wedding, but didn't have the courage to back out. I grew up in the Bronx and lived with five family members in a one-bedroom apartment.

I originally studied foreign languages and went to work for Merrill Lynch, where I translated correspondence. After three years, I realized I just couldn't keep pushing papers. In 1974, women had two choices: get married or live at home. So I got married, and that proved to be even worse than living at home. I got divorced, and wound up studying to become a nurse because a friend said it would be a good way to make money and have a flexible schedule. But then I developed a burning desire to pursue nursing.

I got my bachelor's and master's degrees and developed this love for critical care. I'm interested in my patient's medical, physical, emotional, and spiritual needs, as well as the needs of the family. I've studied Reiki for the hands-on treatment of anxiety, stress, and healing. I went for a two-year program for the purpose of meeting the spiritual needs of dying patients and their families.

How often does anybody get to come home from their job and know they saved someone's life? Or, if I couldn't save them, I stood at the bedside of a dying patient with my arm around the daughter who was losing her mother. I've been blessed to have those experiences dozens of times in my career.

My whole life I've marched to the beat of a different drummer. I used to have purple hair, which I'd blow dry straight up. I wore tight jeans, high heels, and—God forgive me—fur (now I am an animal rights activist). My patients loved it. They said I was like sunshine coming into their room.

When I met Joe, I was happy being single. I was sick of dating and was on the path to becoming the cat lady of Yonkers. I was taking care of Joe's father, who'd had a brainstem stroke. I sat up all night with him and coached him to keep breathing, in order to keep him off the ventilator. On my day off another nurse took care of Joe's father, and she said to me, "I hope you forgive me, but I took the liberty of discussing DNR (do not resuscitate) with the son and wife."

I realized I'd let them down by not doing that myself. I was trying so hard to keep him alive, but I should've seen that what he needed was a DNR and the family needed counseling. From that moment on, I explained everything to them about how the organs were failing and we needed to let him go. Joe sent me this letter. He mistook what I was saying as something more than just caring for his father, and I agonized because it was the first time a family member had made any kind of approach to me. I was afraid he was mixing emotion with grief, so I didn't answer the letter for a month. I just prayed and cried over it. When I did call him, we talked for a long time.

Joe turned out to be my soul mate. I really didn't want to get married, but one day I found myself in the dress, and I thought about my mother. Was I making the same mistake as her? Then I felt as though an invisible hand was pushing me up the steps, and I knew the Lord had other plans for me.

Joe was there for me when my mother died, and my dog got sick, and I got cancer. For twenty-four years, he's been driving me to and from work, always waiting for me on that hill at Einstein every day.

Mary Helen Barletti, MSN, MA, BA, BSN, RN, AAS, CCRN, was born in Mount Vernon, New York, and grew up an only child in the Bronx. She graduated from St. John's University in 1973 with a BA in modern foreign languages and earned her master's in developmental psychology from Teachers College, Columbia University, in 1979. She received her AAS in nursing from SUNY Rockland Community College in 1981, her BSN from Dominican College in 1986, and her MSN as a critical care clinical nurse specialist from Columbia University in 1993. Since 1981 she has been a staff nurse at Montefiore, never wanting to leave the bedside. Though she recently retired, she continues to work at Montefiore on a per-diem basis.

AMY BROWN

THE JOHNS HOPKINS HOSPITAL, BALTIMORE, MARYLAND

Amy Brown, BSN, RN, OCN, was born in Baltimore, Maryland, and has two younger brothers. Her family moved from Baltimore to Montana when Amy was fifteen years old. She has a bachelor's degree in nursing and is currently earning a master's degree in thanatology, the study of death, dying, and bereavement. Amy has been a nurse for twenty years and has held eleven nursing positions.

I am a nurse on Weinberg 4B, the GYN and GYN oncology (cancer of the female reproductive organs) unit at Johns Hopkins. Nursing and health care are all I've done. I started out at fourteen as a candy striper at a hospital in Maryland. This was in 1984 when volunteers were free labor. I remember making beds, feeding patients, helping them to the bathroom, and wheeling them to their cars. Today, if you're a volunteer, you have little patient interaction because of liability and insurance.

I was also a volunteer nurse with a group of surgeons, nurses, and operating-room workers from Minnesota. I went to Guatemala with them four times doing hernia repairs, cleft-palate repairs, and such. We'd pay our own way and take our equipment with us. My first trip to Guatemala was my first time out of the United States, and I was so affected by all the poverty I saw. Some people had never slept in a bed before. It was life changing.

I've also worked as a traveling nurse here in the US. I've been to Seattle, Montana, Delaware, Massachusetts, Maryland. I really bopped around. It's the reason that I've had eleven jobs in my twenty years as an RN.

I spent seven years in Livingston, Montana, in a twenty-five bed hospital. I'd have a newborn baby, a ten-year-old, a ninety-year-old, and everything in between. I came to Johns Hopkins in 2005 and have been here ever since.

I take care of the most dynamic, courageous, and outstanding women. These are very special ladies going through one of the most difficult and challenging times of their lives. I get to witness their courage and the love of their families. Research has shown that when you have a sick family member, it impacts the entire family. But when it's the mom who is sick or dying, then that family suffers more profoundly and on a deeper emotional level. I've always felt that women are the life force of the planet, so I feel I am caring for the caregivers of the world.

It's difficult to be in the moment when you work in a very task-oriented profession such as bedside nursing. I am always being pulled in many different directions at once, juggling and multitasking. So when a patient wants to talk about something very personal and meaningful, it's difficult to do that when I can hear beeping IV pumps, call bells, overhead pages; or when I can hear someone in the hall say, "Where's Amy Brown? Have you seen her? She's got a phone call;" or when the clock is ticking and I know I have 10 p.m. medications to give or blood just arrived from the blood bank or the recovery room is calling to give a report or . . . It's easier when I am off duty, so sometimes I stay late after work to talk with my patients.

I am proud to say that I am a bedside nurse who loves her job, which is kind of a dying breed. There aren't a lot of bedside nurses who relish being just that—a bedside nurse. So many bedside nurses are unhappy and are looking for something else: a teaching job, an IT job, a drug-rep job, some kind of administrative job. We have people graduating from nursing school and going straight to nurse-practitioner school without a lick of RN-bedside experience. I don't think the general public understands the tremendous worth of bedside nurses— until they are sick and need one. The engaged bedside nurse is priceless. I care for patients, not machines. I think there is something special and profound about being with someone who is anxious, terrified, or full of fear. A lot of my job is just talking and getting to know people. The bedside nurse, who is a friendly face and a good listener, can be a healing presence. I've had so many great experiences being a witness at the bedside of true human spirit. I had one patient, not too long ago, who told me, "There are good nurses and there are great nurses. The difference is that a great nurse will share part of her soul with the person she's caring for."

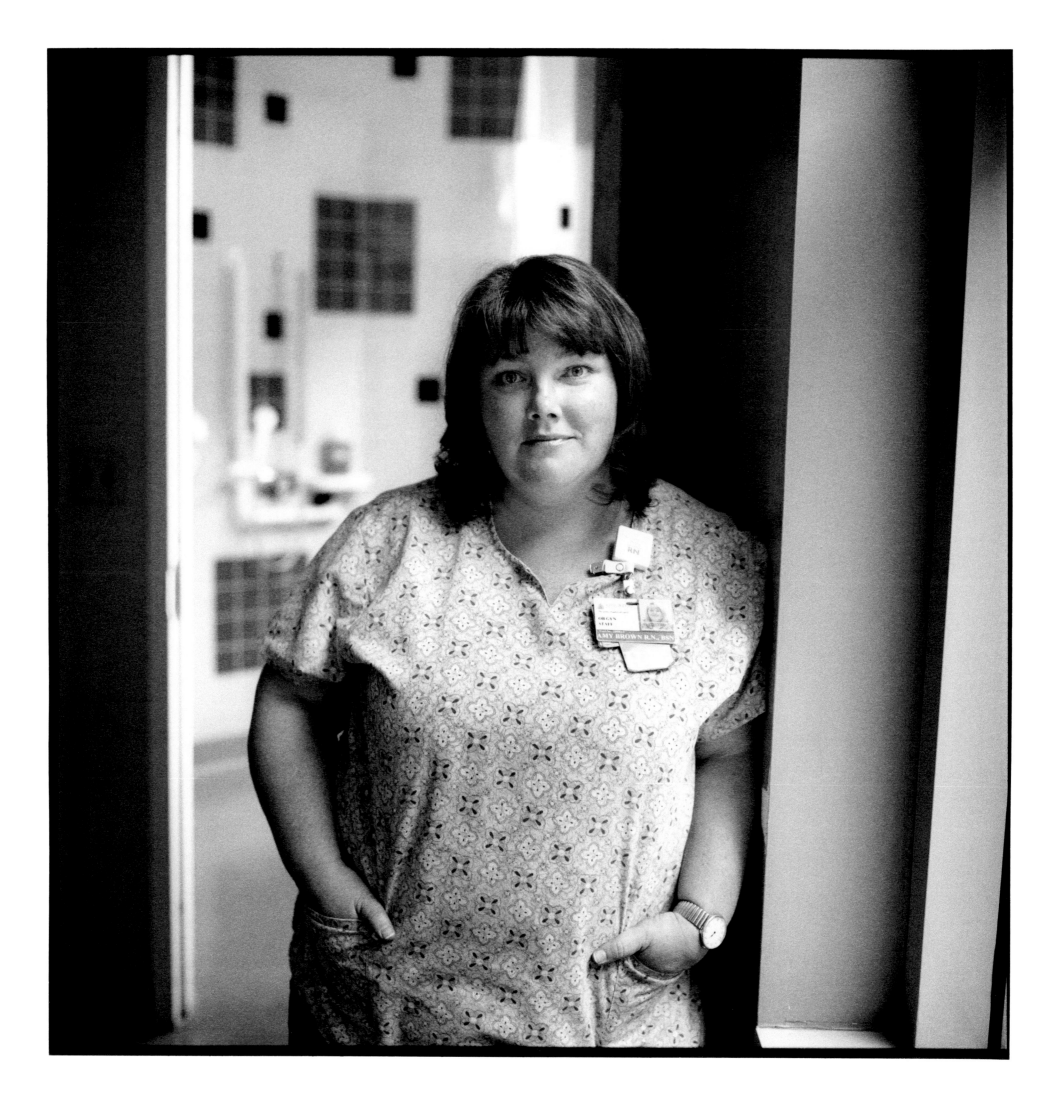

MARY JO MALONEY

MONTEFIORE MEDICAL CENTER, BRONX, NEW YORK

I have worked at Montefiore for more than twenty years. My job title is manager of chronic care, and I work for CMO, Montefiore Care Management, the unit that manages contracts with health plans for the more than two hundred thousand patients who come to this hospital. If you come to the hospital and you are HIP, Medicare, or Medicaid covered, we are the people who will actually manage your benefits. We help if you need home care, rehab, or a nursing home. We talk about the kind of care that is needed and how best to arrange it. I usually meet with the doctor in his office, and we talk about what the patient wants. How are we going to help? How can we keep the patient out of the hospital?

A lot of our patients are elderly and at high risk for falls. They frequently get readmitted to the hospital. I try to establish a relationship of trust with the patient. I am like this transitional person who finds these sick, complex patients and makes an intervention to keep them safe and healthy.

For example, I worked with this eighty-six-year-old man who had lived on the Grand Concourse in the Bronx, in the same apartment, for his entire life. He lived alone, without any support. He had significant functional decline and was at great risk of falling. He had to come back to the hospital many times. We got him home care, but he had no family; there was a son, but they didn't talk. I don't know why, and it was none of my business.

The man did grow to trust me. I got him to use Life Alert and got the super in his building involved. But he still kept getting readmitted. I saw him in the hospital, and he was very stoic, very resistant to any help. He was losing weight because he didn't have anyone to shop for him. Finally, I got him to admit he couldn't go on the way he was. I got him to think about hospice, even though that word really scared him. After a long, long conversation, he finally agreed to a home-hospice referral. He had the financial means to pay for home health care, and was on hospice services for the last eight months of his life. In the end, he was able to die at home, which is what he wanted. My job was to see that his wishes were met. If I could do that safely, then I'd done my job well.

I have personal experience with these issues because of my father, who was diagnosed with Alzheimer's disease when he was fifty-nine. It is worse than almost any other disease because it just strips you. No one knows the devastation that follows. He suffered for almost fourteen years. He was so young; it was unacceptable. He had to retire early, and we had to take the car away from him. He was like Jekyll and Hyde—very agitated and unable to understand simple directions. My mother couldn't handle it. It was very difficult.

People hate to be patients. They are so vulnerable, and no one knows what it is like until you are a patient. As a nurse, we always want to fix everything, and sometimes we can't. Having been involved with my father's condition made me realize I can't fix everything. I can only offer options.

I work with a team in the Bronx offices, and there are many different ways we can support our patients. There are telemonitoring programs for the elderly who live alone. It is set up near the phone, and every day they have to check in and answer questions. Based on how they answer, we know whether to send help. It's just one of many services we can provide. I love my job and am proud of what I do. Not many people can say that.

Mary Jo Maloney, BSN, RN, was born and raised in the Bronx, with one brother. She received her BSN in nursing from Lehman College in the Bronx, graduating with honors, and has been a nurse for twenty-five years. She started at Montefiore Medical Center, and has worked in a variety of specialties. She was inspired to be a nurse by her father, who always wanted her to pursue a career in nursing.

JEAN MARIE PATTON

TIDEWELL HOSPICE, BRADENTON, FLORIDA

Jean Marie Patton, BA, RN, CHPN, was born in South Bend, Indiana, and grew up with two sisters and a brother in Bremen, Indiana. She earned a BA in business in 1986. In 1999, she attended State College of Florida, Manatee-Sarasota in Bradenton, Florida, and graduated in 2002 with an AA in nursing. She was a floor nurse at Manatee Memorial Hospital for a year and, since 2003, has worked at Tidewell Hospice. Always an advocate for her patients, she has an indomitable spirit that enables her to deal with the dying while maintaining a boisterous sense of humor.

I am a registered nurse for Tidewell Hospice in Bradenton, Florida.

I was really good at math and science when I was a kid, so I thought about going into civil engineering. My dad kind of pushed me in that direction, but I got sidetracked.

When I was sixteen, I was diagnosed with a recessive gene disorder called Wilson's Disease, which my brother also had. The symptoms came on slowly. I was a good student, but then my speech and handwriting started getting slurred. I would drool. It was like having a stroke. It was so embarrassing, and my mother took me to a psychiatrist. Then my older brother started having the same symptoms. He was nine years older, and at our sister's wedding my mother noticed he had a tremor. She took him to the Mayo Clinic, and when he was diagnosed with Wilson's, they examined me for the same thing. It is a very rare disease.

I almost died. The symptoms got much worse before the medication started to work for me. I lost a couple of years and went to college when I was twenty. I studied business and worked in banking. Then I was an office manager in a doctor's office.

My brother died from our illness because he refused to keep up with his medications. I decided that, after what I'd been through, I wanted to help people. I knew what it was like when people made fun of you because of something you couldn't control. So I quit my job in business, got my CNA, and went to work at Tidewell. I loved working here, loved the patients, loved the interaction, loved getting the patients to laugh. So I went back to school on the side. It took three years to get my RN degree. I've now worked here for eleven years.

Of course I get close to my patients. How could I not? I'm not a robot. I am involved with them and their families. I really connect with certain patients, especially the younger ones. Those are the hard cases.

I travel a lot, visiting people in their homes. I have fifteen homes that I cover, and I am in all sorts of places trying to build a rapport. In some places, I have to act like I am in the 'hood. I've been to homes where I had to say, "Get the guns off the table or I'm not coming in. And give me those bullets." Or, I am in fancy, schmancy houses where it's all, "Yes, ma'am" or "No, ma'am." At the end of the day I am exhausted, but I know this is what God intended for me.

I've seen thousands of people die over the years, and what I do every day is a beautiful thing. I am good at it. They call me the "wacky" nurse because I like to make people laugh. After what I went through as a child, I want to make people smile. If the patient is ninety and she wants a beer, I will sneak it into her room. If she wants a cigarette, I will get one for her. I mean, she's ninety—she deserves it. I don't always follow the rules, but I always do the right thing. I do what I'd want someone to do for me. Life is short; enjoy every day.

I don't understand why the doctors always want to give chemo, even if the patient is 101. I've gotten into lots of fights about this. If I were 101, I'd want chocolate, beer, potato chips, and my dogs in bed with me. Let me enjoy what time I have left. Don't try and save my life. No one is going to live forever.

My mother says I should run for mayor because I have such a big mouth. Everyone knows I speak my mind. It's a privilege and an honor to do what I do; I walk on sacred ground every day.

BRAD HENDERSON

CENTRAL WYOMING COLLEGE, RIVERTON, WYOMING

I am a nursing student at Central Wyoming College and will graduate in one more year. On Mondays and Wednesdays we are in class, and then Tuesdays and Thursdays we come to the Lander Regional Hospital in Lander, Wyoming, to practice what we have learned.

My grandmother got me interested in nursing. I went to live with family in Austin, Texas, when my grandmother was in the last stages of Alzheimer's disease. The intention was for me to help out, but I had no idea what I was supposed to do. It was difficult to see her at that stage because she didn't know me or anyone else. She was like a prisoner in her own house and was always trying to escape. She thought my grandfather was stealing from her. It was a terrible way to go, but that kind of jumpstarted my interest in nursing. My older brother, a neonatal ICU nurse in Albuquerque, New Mexico, also inspired me.

At first, I was drawn to the pharmaceutical side of medicine. I'm fascinated with how we're able to invent drugs that affect the body in such incredible ways. Then I found out that going to pharmacy school is a nine-year ordeal. I decided to be a nurse because taking care of patients interested me. Once I started, nursing just grabbed me and made me grow up.

The first step in nursing school is to obtain your certified nursing assistant license, and I signed up for the course in 2009. After that, Pat, the nurse-practitioner teaching the course, hired me to help care for her mother, who was in the late stages of Alzheimer's and living at home. While I was caring for the mother, I met Pat's daughter, and we eventually got married.

In my class at Central Wyoming there are forty-two students, and six are men. It's funny because when I tell people I'm a nurse, they'll say, "It's nice to see some male nurses." But I would never say, "I am a *male* nurse."

There are certain procedures I don't ever want to do—like the urinary catheter. I know the day will come when I'll have to do that, but I'm going to feel awful. Currently, I am in the OB, the pediatrics portion of the nursing program. This is where it's a little tricky being a male because a lot of women don't want to hear about breastfeeding from me. The husbands also seem to prefer having a female nurse for their wives. Plus, I believe that women are better with newborns. I don't have kids yet, and I was so worried the other day when I was with the babies. The OB nurse said, "Just get in there, Brad—you're not going to break them."

In this hospital we treat a lot of Native Americans, and there are cultural differences. For example, Native Americans, for the most part, will not look you in the eye. They feel that it is a sign of disrespect. To the other person this may seem like the patient is not paying attention, but that's not the case. In school we have a class in cultural understanding because we see a lot of Native Americans in our practice.

At the hospital we have a room called the Native American healing room where, if they choose, patients can see a medicine man from their tribe. They come in here and burn incense and play drums. I believe they should be allowed to practice the traditions of their culture.

I am still undecided as to what I'll ultimately do with nursing. I'm thinking seriously about going into nursing anesthesiology.

I'm excited about the possibilities because there are so many subdivisions in nursing. As we go about our clinical rotation we see different perspectives of what it is like to work in the hospital. By the time we finish, we will have been in almost every section of the hospital, which will be helpful in making a final decision.

Brad Henderson was born in Crowley, Louisiana, and moved to Carlsbad, New Mexico, when he was five. He graduated from high school in 2003 and worked for a Hilton Hotel for three years. He was inspired to go into nursing while taking care of his grandmother and because his brother became a nurse. He is currently a student working toward an associate's degree in nursing at Central Wyoming College in Riverton. He is scheduled to graduate in 2013 and intends to pursue a bachelor of science and a master's in nursing in order to become a nurse-practitioner.

PEGGY ARVIN

CONSULTANT, PRIVATE FOSTER CARE FOR MEDICALLY FRAGILE CHILDREN, FRANKFORT, KENTUCKY

Peggy Arvin, BSN, RN, received her nursing degree when she was thirty-four and has been a nurse for thirty years. After retiring in 2009, she became a consultant for a state-contracted, private foster-care agency in Frankfort, Kentucky. In October of 2006, she received the Kentucky Medical Association's Outstanding Layperson Award for her accomplishments in caring for Kentucky's state-committed children.

I'm an RN and work as a nurse consultant for a child-care agency that receives foster-care children with medical issues who are removed from their home, usually as a result of abuse or neglect. Our foster parents are trained in medical issues so that they can meet the needs of these children.

It seems like every child who is removed from the care of their parents has a drug issue somewhere in the family. Some were born with fetal alcohol syndrome. Others have multiple health issues because their mothers abused Oxycontin or methamphetamine, which has been spiking in Kentucky for the past ten years or so.

In 2006, I was working with the Kentucky Cabinet for Health and Family Services. We would review the records of the children who had died as a result of abuse or neglect, and 75 percent of the time there was some type of drug abuse.

All at once, I was getting calls from social workers who had removed a child from a meth home. They wanted to know how to handle it, but I didn't know what to tell them. I decided I needed to obtain some education about the problem, so I attended a conference on meth abuse to learn more about this drug, which had just moved to Kentucky from out west.

We had to coordinate with our child-welfare agency, EMS, and law enforcement about how to respond when they were called into a meth home. We wrote a protocol about how to extract the child from the house, on how to work with law enforcement, and what was needed for a medical assessment.

The emotional part is rough for all of us. We have one child whose parents owed either meth or money to a relative who kidnapped the child and said, "Every day you don't pay me, I am going to burn the child with a cigarette." The two-year-old was brought into foster care, and we found twenty-two burn marks on the child.

We had a mother who was standing on the side of the road trying to sell her baby for Oxycontin. I've been doing this for eighteen years, and it is still hard to comprehend.

There is also a lot of sexual abuse going on, with both girls and boys. In a meth house, drug users are around all the time. Meth increases the libido, so children are very susceptible. And there are usually guns in the house.

The other problem is that when the parents aren't high, they're sleeping very soundly so, in essence, no one is taking care of the children. We see five-year-olds taking care of their siblings in these filthy houses where there is no food. It does seem like, on all fronts, drug abuse is escalating. Economic factors certainly contribute to the problem; so does mental illness. It makes it difficult to raise a child.

Part of this is the nurse's story. There are nurses out there on the front line who are working with children and adults in different areas of drug abuse. They are providing care, as best as they can, to people affected by drugs. Right now, we do not have long-term studies on the effects of drugs, such as meth, on children.

Where can we make a difference? I think people have a lot of respect for nurses, and if we speak out on an issue, people will listen. Nurses can write articles about what they've seen, how they've dealt with certain situations, and what positive steps can be taken to combat this problem. I think this is a growing area of nursing that really needs attention. Nurses are not just part of a hospital; they are part of the community. Anytime you make a statement, you have a voice and someone will hear you.

CARLY TURNER

THE JOHNS HOPKINS HOSPITAL, BALTIMORE, MARYLAND

Carly Turner, BSN, RN, was born in San Diego, California, and grew up with her parents and brother in the northeast part of the country. She has a bachelor's degree in nursing and is currently in grad school for a Family Nurse-Practitioner degree. She has been a nurse for seven years, starting at Johns Hopkins. She was also a traveling nurse, working in New York and California. She returned to Hopkins where she works today as a critical-care transport nurse for Lifeline Transport. Every month she attends meetings educating her about different medical topics so that she is up to date on all the systems in her critical-care truck.

I work at Johns Hopkins, through Lifeline Transport. We transport patients between facilities and also within the hospital from, say, ICU to different procedure areas. We also have a flight team.

Lifeline Transport allows us to bring Hopkins to the patients. We can do things that can't be done in smaller community hospitals. Patients want to come here because of the physicians or because this is a top-notch facility. We're a critical-care truck. You can have a paramedic and EMT team for a less invasive call, or a nurse and paramedic team for a critical-care call. We take vented patients and patients on drips. There's nothing outside the scope of nursing that we can't handle.

I started out in the ICU. You need at least two years' experience in critical care before you can come to transport. We have paramedics and EMTs who have a lot of field experience, which is partnered with the nurse's hospital experience. In the ICU you are usually focused on one area of medicine, but with transport you take on all kinds of patients of different ages, sicknesses, and acuities. We are also dealing with the families of these patients.

It is so busy in the ICU that you can't always spend a lot of time talking to the patient. In this job, you actually get to step outside the medicine part of nursing. When you're sitting in an ambulance with a patient, you can really learn a lot in fifteen minutes.

I think the essence of being a nurse is being able to adapt to each person. Not every patient or family member is going to need the same thing, so you need to be intuitive and understanding. There are many times in this job that I've been humbled by the patients and their families. For example, I was taking care of this woman in neuro ICU; she'd been diagnosed with a brain tumor and was basically at the point of herniation, meaning she would soon be brain dead. I took care of her and her husband. She did go brain dead, and he decided to donate her organs.

He was sitting by her bed, and I was in the room just trying to be supportive. He told me that exactly a year ago on that very day, he and his wife got a knock on the door at two o'clock in the morning. It was the police saying that their daughter was in the hospital. He said that was impossible; she was in her room. It turned out the daughter had snuck out of the house, gotten in a car accident, and been killed. He broke down, saying he didn't think he could get through it without his wife, after already losing his daughter.

It gave me the chills. There was nothing I could say to take away his pain. I just cried with him. Later he told me that it meant a lot to him to see my emotions. Sometimes just being human and letting go can be helpful to the families.

The hardest part of our job is when you feel defeated. Maybe you have a difficult patient or a difficult team of physicians. We work really long days and don't always get a break. We have a very heavy workload, and it can be very draining both physically and emotionally.

Sometimes you get so wrapped up in how busy it is that you forget to just be a person. A huge part of it is coming into a hospital room and introducing yourself. You have to stop and think, if it was me, how would I want to be treated? I think that sometimes we have to remember this is a person—not just a diagnosis or a room number. It's about human interaction, showing compassion, and relating to someone.

Nursing makes you realize that you never know what people are going through. Everyone is special. Everyone has a story.

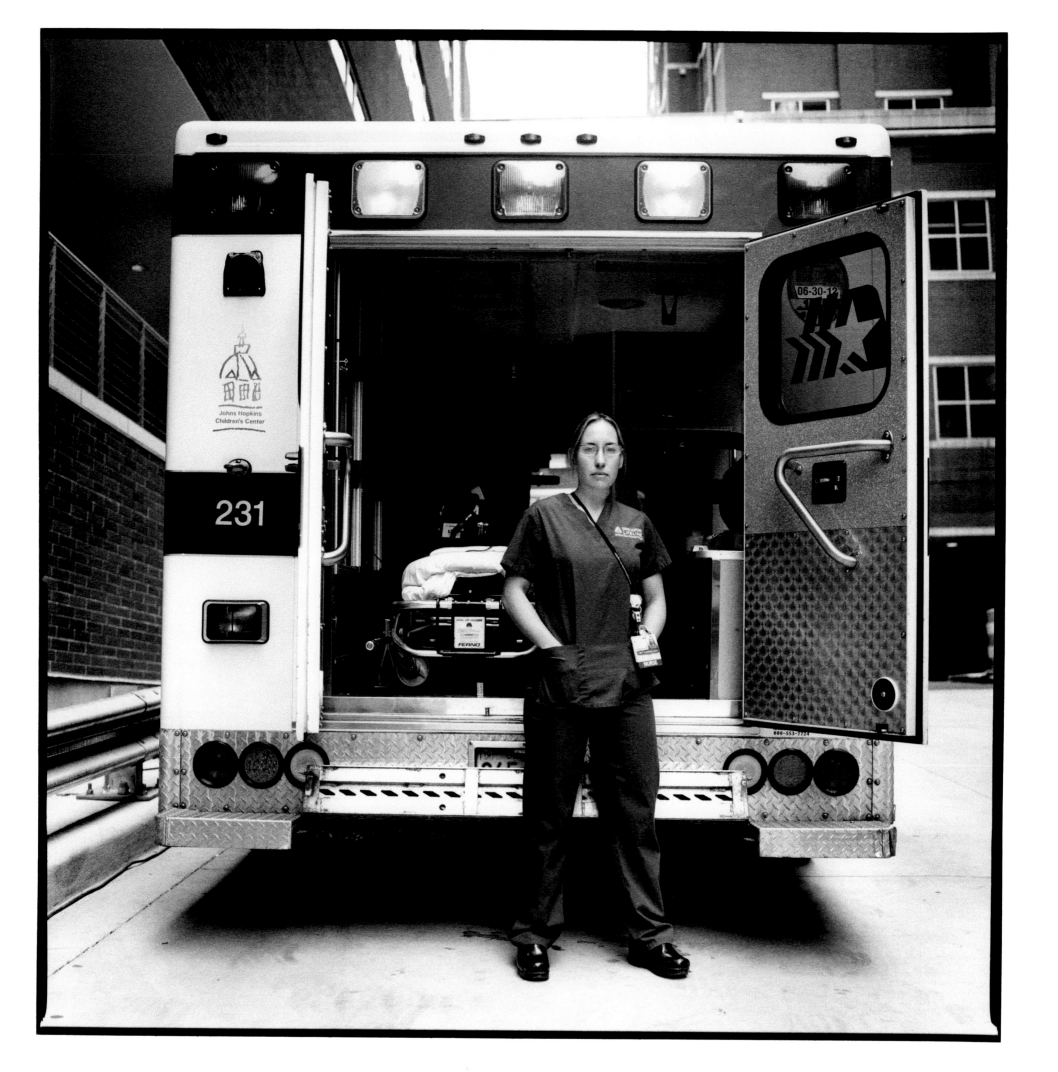

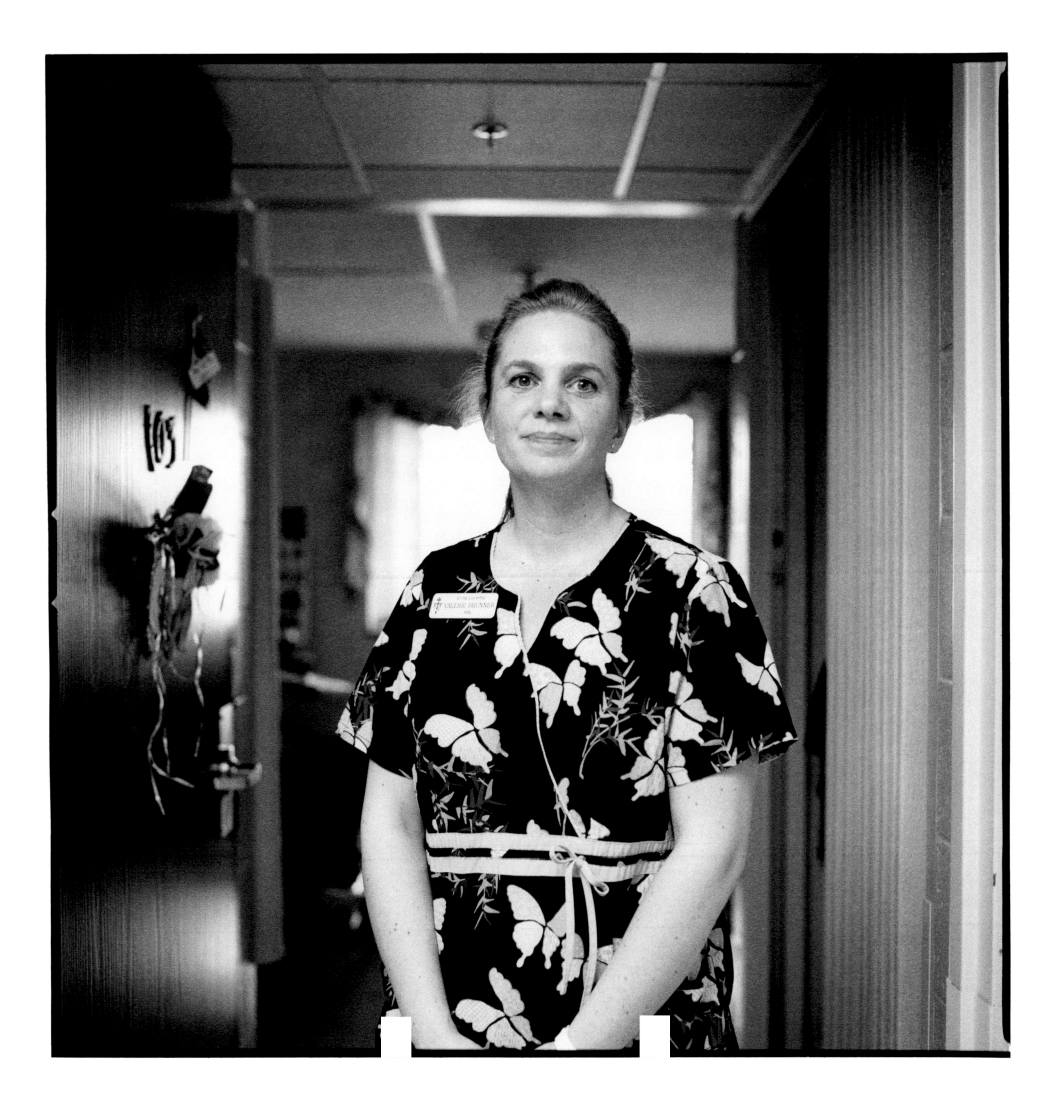

VALERIE BRUNNER

VILLA LORETTO NURSING HOME, MT. CALVARY, WISCONSIN

I'm a registered nurse, and I work at Villa Loretto in Mt. Calvary.

What I really love about nursing is the problem-solving aspect of trying to analyze what's going on with the patient and figure out the best treatment plan. In long-term care, I got to know the patients and work closely with them. I discovered that I liked working with older people. This surprised me because I was kind of nervous and scared at first. Then I grew accustomed to the work and found that it was very fulfilling.

You really need to see older people as individuals. I had always thought people in a nursing home would be bitter and not want to communicate or be around other people, but I was wrong. You can always joke around with them.

I had one resident who was very prim and proper and always wanted her hair to be just so. One day she wasn't able to go to the beauty parlor. When I came in the next morning, she had set her hair with toothpicks and Cheetos. She actually did a nice job.

We take a holistic approach to caring for our residents. We look after their spiritual and medical needs, pain control, and the needs of their families. We branch out into many different areas to provide what they need, with dignity at the end. My own faith has been restored working here.

I love being a caregiver. I am the advocate for the residents with the doctors, helping to put together the puzzle pieces as far as what might be going on. We are the eyes and ears of the doctors. As far as nursing skills, they are probably fewer than what you need in a hospital, but we are definitely gathering data, and we need to know about every diagnosis. I find this work much more rewarding than hospital work.

The vibe in Villa Loretto is not as negative as some people might think of a nursing home. There's a lot of compassion and interaction with the patients. Families come to visit. We have all these animals, and they are very therapeutic for the patients. A lot of our residents lived on farms, so they're used to being around animals, and it sparks their interest.

At home, I have two little girls, a seven- and a five-year-old, and they think I take care of the animals here. When my five-year-old was asked what she wanted to be when she grew up, she said she wanted to be an animal nurse, like her mama.

Valerie Brunner, RN, BS, went to school to be a speech therapist. She earned her bachelor's degree and was about to start working toward a master's when she decided that speech therapy wasn't for her, though she enjoyed the medical parts. She switched to nursing and, in two years, had her degree. At first, she thought she wanted to work in the ER and started working the nightshift on a medical-surgery floor in Sheboygan. Then she took a position at Villa Loretto, where she discovered she most enjoyed long-term nursing care.

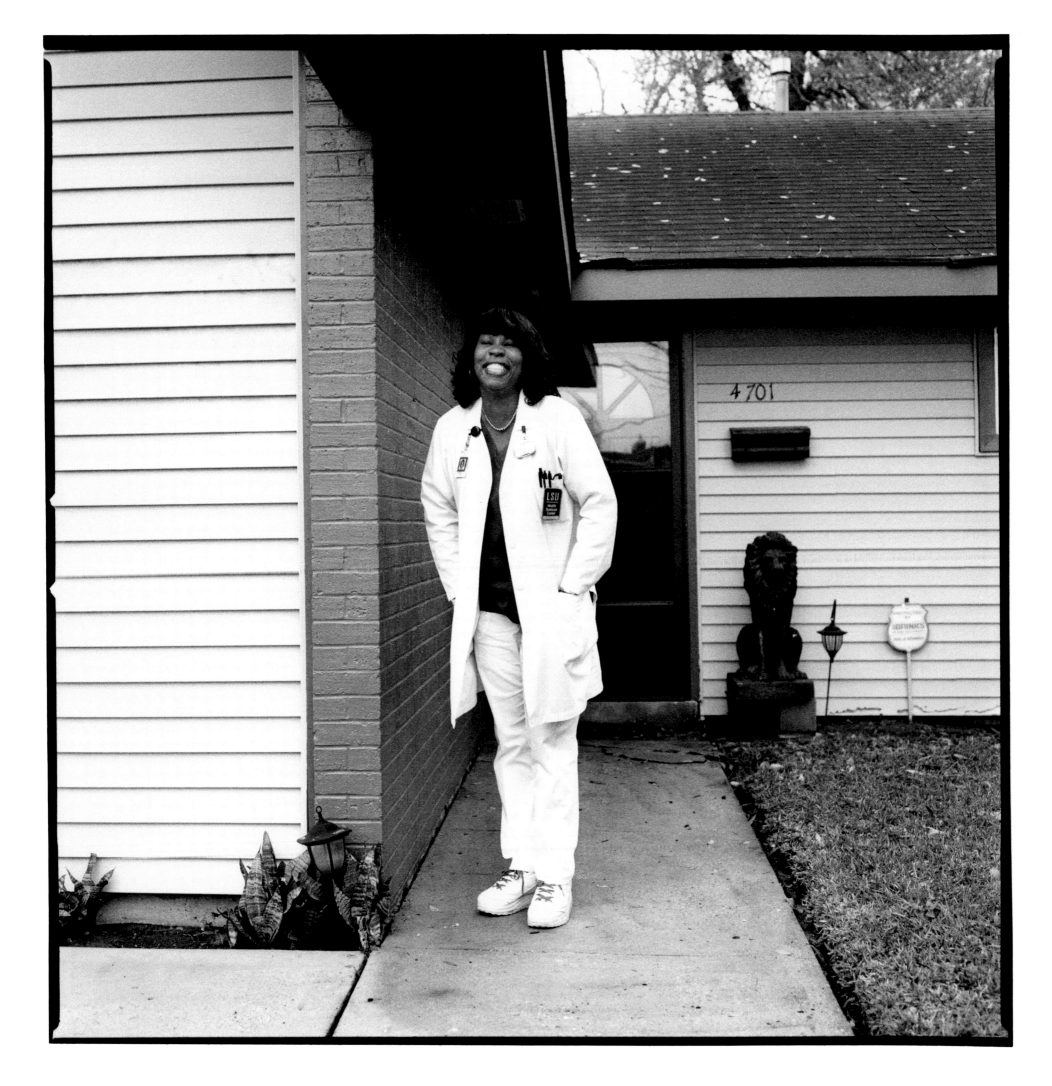

JULIE NEWMAN

INTERIM LSU PUBLIC HOSPITAL, NEW ORLEANS, LOUISIANA

I am an RN manager and the house supervisor at the Interim LSU Public Hospital in New Orleans.

Unlike many, I never wanted to be a nurse. I used to get physically sick when I walked into a hospital room. In 1976, I was a high-school dropout and I had the opportunity to work for a program through the hospital that assisted welfare recipients in earning income. The job was to babysit children in one of the hospital wings. I was able to watch the nursing assistants and read all the journals. I decided to take the test to be a nursing assistant. I got a 72, and they told me my score was too low. I took it again and got an 85. And then a third time I scored a 92. They finally hired me.

I took the job and decided to go back to get my GED, mainly because it meant I'd make more money. For the same reason—namely greed—I studied to become an RN. School was hard because I was working full-time and raising five children. I always say my kids grew up in spite of me, not because of me.

I started out in pediatrics at the old Charity Hospital and was in that building until Hurricane Katrina hit. At the time, I was manager for the clinic and the pediatric emergency room. My family evacuated, but I couldn't go because I was on the emergency management team. Before I left my house, I put some valuables, like my jewelry and camera, in the trunk of my car, which was good because nothing else survived. My whole house, and everything in it, had to be gutted.

We were close to the Superdome, so after the flooding there were a lot of helicopters buzzing around the hospital and constant gunshots. We were directed not to go near the windows. At one point, the National Guard came running through the hospital looking for a sniper in the building. We were scared, but we had to keep the children calm. We had enough juice and water for them, but we had to stand guard to make sure that no one came into the building. People were outside—one guy was bleeding—but they wouldn't let us let anyone in. The phones were out, and cell phones didn't work. We kept getting reports that we were going to be rescued, but no one came when they said they would. The heat and the stench were awful. I was on the last bus that pulled out of the hospital, and they put a padlock on the building.

With Katrina, I lost not only my home but also my whole social network. I lost my church environment; it closed and a lot of the people in the parish are no longer here. I had two best friends, and they are both gone. One moved to Dallas and then she died. I wasn't even able to attend the services. No one in my immediate family died, but my world is nowhere near the same as it was before Katrina. I had to live in a trailer for a long time.

People say that it's been six years and I should just get over it. It's like living in a Stephen King novel—you went to sleep one night, and when you woke up, everything was gone.

If it happened again, I'd do the same thing, not for myself, but to prevent someone else from having to do it. I've already lost all my property and anything that had meaning to me. Nothing could be worse than Katrina.

After Katrina I worked in Injury Prevention, which is part of the hospital. We taught car-seat installation and went to schools to teach safety to the children. Currently I am the House Supervisor, which is the on-site administrator overseeing hospital operations such as nurse staffing, patient-bed assignment, and employee behavior during evenings, nights, weekends, and holidays. I am close to retirement. I no longer worry about a lot of things that used to bother me. I realize they're not mine to control.

Julie Newman, RN, was born at Charity Hospital in New Orleans, one of six kids. A junior-high-school dropout, she obtained a GED and a technical certificate as an LPN, and then graduated from the LSU Health Science Center's Allied Health Program with an associate's degree in nursing. She has been a nurse for thirty-two years. In 2005, she was honored along with other Hurricane Katrina rescue workers as Glamour *magazine's Women of the Year. She is photographed in front of her home, rebuilt after Katrina with the help of the St. John's Lutheran Church group of Illinois.*

NANCY SCHREIBER

THE NIGHT MINISTRY, CHICAGO, ILLINOIS

Nancy Schreiber, PhD, MSN, APN, was born in Terre Haute, Indiana, and moved around as a child, living with her grandparents after her father was drafted. Her family, including a younger brother, moved to Columbus, Ohio, when she was nine. She completed her nursing diploma in Terre Haute and worked as a staff nurse while completing her BSN from Indiana State University. She became a teacher and finished her master's in 1978. She earned her PhD in educational psychology at Loyola University in 1995. She began working for the Night Ministry in 2001 and is now a full-time employee.

I am an advanced-practice nurse with the Night Ministry, a job that developed from my position as a community-outreach nurse.

When I graduated from high school in 1958, women had three career choices: nurse, teacher, or secretary. I'd planned on going to college, but my parents said they could only afford nursing school. Back then, it was a diploma program, and you got room and board for very little tuition. While I was in the program, I also took college courses and stayed another year to get my bachelor's so that I could teach.

Then I got in my Volkswagen and went to Chicago, where I always wanted to live. I got a job teaching in nursing school. After I started my family, I did some continuing education and ran a program out in the suburbs. But I really wanted to get into the heart of things, so I got a job at Rush University as a practitioner-teacher, which meant I had both bedside and teaching responsibilities. Toward the end of nineteen years, there was a lot of empty space in the classroom, so I lost my job. This was in 1999, and I'd just gotten a divorce. I ended up putting together four part-time jobs, and the Night Ministry was one of them. The more I worked there, the more I realized this was where I was meant to be.

I am very active in my church, which has a night-ministry program to prepare meals and serve them to people from the bus. We make three stops a night around Chicago. About half of our patients are homeless, and I became mesmerized by the community that was built around this program. I started out doing one night a week and became full-time in 2003. This job gave me the freedom to get into areas like spirituality. As a nurse, we're not encouraged to talk about someone's faith. Here I find the freedom to just be myself and to acknowledge people for who they are, without the need for explanations.

My first breakthrough came with a gentleman I treated who had a sore throat. After a stay in the hospital, he got better and came back to thank me by serenading us with his mariachi band. Now they come regularly to serenade us, and that helped spread the word of what we are doing here.

Our latest site is where the people are really in need and the least capable of helping themselves. We don't have appointments: people show up and, if they need something, we take care of them. You may only see them for fifteen minutes, but you get to know what's going on in their lives. The beauty is that this work is not confined within four walls; it is purely service. Every day I struggle to climb the stairs on the bus, but once I am on it, I'm in heaven. It is always fast and furious on the bus, and I barely have time to breathe.

Some of our clients are barely getting by, but others try to take advantage of our programs. At Christmas we give out gifts for the children. One time I saw this family drive up in their brand new Lexus; they got out of the car dressed to the teeth to stand in line to get a gift.

We only give one gift per person, so somebody came up with a baby, got the gift, and handed the baby to someone else. They changed the baby's clothes and brought her back again. It was comical to watch what people go through. I used to be judgmental, but then I realized it's a function of survival. Manipulation is probably the highest skill the homeless need to survive on the streets.

The other day someone asked me when I was going to retire, and I said, "Never!" Though when I can't get on the bus anymore, I guess I'll have to quit.

MEAGAN SHIPLEY

BALTIMORE CITY HEALTH DEPARTMENT, MARYLAND

I have been a nurse-practitioner for the Baltimore City Health Department's Adolescent and Reproductive Health Program since 2008. We provide family-planning services for young people between the ages of ten and twenty-four.

As an undergrad, my major was zoology. I was in a grad program at the University of Miami, catching rats in the Everglades, when I decided I really didn't like research and academia wasn't my thing. I started volunteering at an HIV organization and began looking into careers in health care and medical social work. My aunt was a nurse, so I looked into it and decided to be a nurse-practitioner. I chose the career because I preferred the nursing model of education, which puts more emphasis on holistic care and patient education, rather than a medical model, which focuses on problem solving and illness. I always wanted to work with teenagers. I can be very patient with kids, even if I'm not so patient in the rest of my life.

I worked on a general medical/surgical floor in a New York hospital for four years while I was in school. I moved back to Baltimore to be closer to my twin sister and her kids, and got this awesome job. I worked in a temporary position at Johns Hopkins for four months while going through the hiring process. Working in a hospital can be stressful, and you have to deal with a lot of complaints. I had a hard time watching cancer patients die in the hospital because there was nothing I could do. This job is a different kind of stress, and I feel I have a bit more control. At the Teen and Young Adult Center where I work, I can take more time with my patients and bond with them.

Once a month, I provide services out of a van on a block in downtown Baltimore, which is home to many adult-entertainment venues. We go out in two vans. One is for needle exchange; we take old needles in exchange for new ones. Not a lot of cities allow needle exchange, but Baltimore is on the cutting edge as far as this program is concerned. We also give out condoms. We talk to the girls and see if they need tampons or food or whatever. We are trying to give them access to a medical home.

The other van is for STD testing, pregnancy tests, and birth control. The African American girls mostly choose Depo-Provera, which is an injection that lasts for three months and is very effective. The white girls request the pill, and the Hispanic population generally wants the patches. It's interesting how it breaks down.

I'd love if they'd wait till they were twenty-five before having kids and go to college first. I wish we could offer better support to the younger girls who have babies—maybe allow them to go to school with their kids.

Our goal is to eventually have a table for exams and PAP tests; that's in the works. We're also working on developing a wound-care program. We usually work with someone from Baltimore HealthCare Access, trying to get them insurance if they qualify.

We are mostly dealing with people whose lives are out of control. It's a seedier crowd, and some of them are doing prostitution on the side. We would love to get these kids off drugs, but in the meantime, if we can give them another week to live, and maybe the option of going into rehab, then that is the goal.

Although I started out wanting to work with HIV patients, right now I am working on the prevention side of HIV-related care. I feel like maybe I can make a difference with these kids. Maybe I can't solve all of their problems, but I can listen and talk to them about their fears or regrets, and I can help make them feel better. I give them a place to talk and understand.

I think you can either give up or you can keep on trying. I can't give up.

Meagan Shipley, MS, FNP-BC, grew up in Cumberland, Maryland. She received a BS in zoology at the University of Maryland and then dropped out of a PhD program at the University of Miami after realizing she didn't want to be a researcher. She earned a BS in nursing in 2004 and an MS in nursing (Family Nurse-Practitioner) in 2007 from Columbia University School of Nursing. She currently works with teens and young adults for the city of Baltimore.

JUN TING LIU

SAN FRANCISCO GENERAL HOSPITAL AND TRAUMA CENTER, SAN FRANCISCO, CALIFORNIA

Jun Ting Liu, FNP, BC, MSN, L.Ac., TCM, PhD, was born and raised in Shanghai, China, one of four children. She practiced as an anesthesiologist and as a Western and Eastern integrative medical doctor for fifteen years in China before moving to the US in 1989. Once she learned English, she worked her way up the educational ladder from RN to Nurse-practitioner and eventually earned her PhD. She combines Eastern and Western healing techniques in her practice and is currently at work on a dissertation paper called Using Different Approaches to Treat Breast Cancer.

I am a nurse-practitioner working at San Francisco General Hospital.

I was a doctor in China from 1974 to 1989, when I moved to America. There are many differences in patient care between China and America. In China, the doctor and the nurse spend an equal amount of time with the patient. Documentation is much less than in America, so there is more time to work with the patient, not the paperwork. Here, people threaten to sue, so we need to do all the paperwork; this is not the case in China.

The other big difference is that when a patient is admitted to a hospital in China, he or she always has a family member at their bedside. Here, I often find that patients are alone, and I am the only one at their bed. One patient in the ICU had cirrhosis, and we needed to know his family history and emergency contact, but he had no family and no friends. This is really sad to me.

I think that Eastern and Western medicine each have something to offer the patient. Monday through Friday, I am a full-time employee of General Hospital, where I provide Western-medicine diagnosis and treatment. But there are some patients for whom this does not work. For example, at the hospital we had a Jehovah's Witness who would not take a blood transfusion. The patient wanted to know if there was something else he could do. So I discussed this with my attending doctor and the pharmacist; then I made a soup with ingredients that would increase this patient's hemoglobin count. The outcome was that the patient's hemoglobin count went up and his wounds healed very well. The surgeon was very happy. He said, "Continue on nutrition support—food as therapy!"

The hospital does not allow acupuncture, so I can't use my needles here. Also, I am not allowed to use my Chinese herbs. I can only use food as therapy.

On the weekends, though, I have an outside practice where I do everything myself. I combine acupuncture with herbal treatments. I treat people for asthma, eczema, muscle sprains. I once treated a woman with breast cancer. Her doctors wanted her to have a mastectomy, but she refused the surgery. I told her I would treat her for three to four months, but if she did not get better, she had to see the surgeon again. She agreed, was very cooperative, and did everything I said: diet modification, lifestyle modification, and Chinese herbs. In four months her cancer disappeared. She went back to Kaiser Hospital, and they did not find any cancer cells. They have her return every year for a mammogram, and three years later, there is no recurrence of cancer cells.

It makes me very happy to help people like this on the weekends, and if Medicare or Medicaid does not cover the treatments, I will provide free service for some patients if they will benefit from those treatments.

I take a holistic approach with each patient. I try to determine if their situation is urgent and if they need Western medicine, or if I can help with an Eastern-medicine approach that is less invasive. For example, one patient came to my clinic with back pain and wanted acupuncture. I had treated his spouse. So I did an assessment and found he had unstable blood pressure, high cholesterol, and coronary-artery disease. I told him I'd give him a treatment for his back, but that he needed to see his primary-care doctor the next day. He went to his doctor and discovered that he needed cardiac-bypass surgery right away.

I use what I learned in China combined with what I am learning in America. I try to figure out the best way to diagnose a patient using both disciplines. I want to provide quality care that is less invasive and for less cost.

GERMAINE WILLIAMS

THE JOHNS HOPKINS HOSPITAL, BALTIMORE, MARYLAND

Germaine Williams, BSN, RN, CNOR, an only child, was born in Miami, Florida. She spent her first nine years living with maternal grandparents in Dayton, Ohio, and then moved to Miami to be with her parents. Williams has a BS in animal science and a BSN in nursing. She considered being a veterinarian and once had a tough but interesting job slaughtering cows and pigs for human consumption. Currently enrolled in a master's in nursing program, Germaine has been a nurse for twenty-six years, the last sixteen of them in the operating room. She has always worked at Johns Hopkins.

I am the nurse clinician for thoracic and oncology services in the Weinberg operating room at Johns Hopkins.

When I was nineteen, my grandmother became ill, and because my parents were working all day, it was my job to take care of her. I enjoyed—for lack of a better word—being around sick people and thought it was something I was good at, so I followed that path.

I like working in the operating room because most of the time we are giving patients a better quality of life. I also like incorporating the families into the patient's care by giving them information. I got here by default. I always thought OR nurses didn't have much autonomy—that they only took direction from the surgeons, but didn't have much input on patient care. I didn't want to be in that realm. But I was working on a unit where the schedule didn't work for me, so I interviewed for an opening in the operating room and did a share day. I liked it. One of the best parts is that you're with the patients as they go to sleep and you can impart comforting words. I try to smile under the mask and hope they see a twinkle in my eye. Also, I discovered that the operating room is a collaborative effort among the team, including the surgeons. It's one place in nursing you either love or hate. I love it.

It is very busy. We have some slow times around Christmas, but for the most part, all sixteen of our rooms are filled, sometimes with more than one case, from Monday to Friday.

It is scary when we have trauma cases. You never know if someone with a gunshot or stab wound is going to survive. Hopkins is a Level One trauma center, and we're always prepared, but it can affect you emotionally. I remember once we had this boy who'd been shot in the chest by the police. It was an unfortunate situation, as the police thought he was reaching for a gun when really he was going for his cell phone. We did everything we could, but he didn't make it. He was the same age as my son, so that was a really sad day.

The only way to deal with something like that is by knowing that you gave 100 percent, even though the outcome was not what you wanted. You can't save everyone; you can only do your very best. The hardest part of the job is sustainability—to give 100 percent of all you have to every patient, every day. By your fifth patient, when it is six or seven o'clock at night and you are thinking of going home, it is challenging to keep up that energy.

We do a lot of surgery for cancer. Sometimes we discover that the cancer has spread to such a degree that taking out the tumor won't really help the patient. We call those "open-and-shut" cases because there's nothing to do but close the patient.

I am usually the first person the patient sees upon waking, but we don't talk about what happened during the operation. First, because the patient is still under the effects of the anesthesia and won't remember; and second, because the patient needs the support of family and friends when they're fully awake and able to comprehend what we are saying.

I would never lie to a patient. I'll just say, "You did very well during the surgery." But in my mind I am thinking, this is going to be very sad. I hope things work out after the diagnosis, but it is a very tough part of the job. I am a believer in positive thoughts. Even if the prognosis may not be what the patient expected, there is still some life to be lived, and, hopefully, that patient can live in comfort and quality until the end.

EMILY FITZGERALD

DOMINICAN UNIVERSITY, SAN FRANCISCO, CALIFORNIA

I am an unemployed nurse currently working as a waitress at the Umami restaurant in San Francisco. I wanted to be a nurse when I was little, but my parents pushed me to be in the business world. I went to UCSB and got a degree in communication. I worked selling ad space at the *Wall Street Journal* here in San Francisco. I did that for two and a half years and was promoted, but every day on the bus going home, I just didn't feel fulfilled. After a bit of soul searching, I quit my job and decided to pursue my dream of becoming a nurse.

Getting through nursing school in the Bay Area was tough. I went to three colleges at a time, including summer school, to get all my prerequisites done in one year. Then it was three years of school while I waitressed three or four nights a week. Somehow I got through that, and two weeks ago I took my RN exam and passed. Now I'm looking for a job, but it's a hopeless scene for recent grads in Northern California.

New graduates cost the hospital about $90,000 per person to train because we need more guidance, and it's cheaper for the hospital to bring people in from other countries. So they've done away with the training programs. I think it's starting to turn around, but not quite yet. This area has a lot of great hospitals and the best pay in the country, so nurses come from all over to work here, which makes things pretty bleak for new grads.

While I was still in school, my mother was diagnosed with stage-three breast cancer that had metastasized into her lymph nodes. It was the first time someone in my family was sick. I was with her every weekend, and now she is in remission, but my stepfather was just diagnosed with prostate cancer, so we're helping him through that illness. What I learned from caring for them is that you can make an impact on a patient just by being there and taking the time to listen to what they need. I was also able to help my grandpa who recently passed away. I think it prepared me to deal with losing patients. It will always be hard, but I want to be there to help support the families.

During my clinical work in school, I got to try out different aspects of nursing. I loved the ER because it kept you really busy. I've never been as excited as I was working in labor and delivery. When I first saw a baby being born, I wanted to burst into tears, which I know is the worst thing to do, but I was so excited for the parents. Eventually, I'd like to end up in the NICU (neonatal intensive care unit).

As a beginning nurse you have to give enemas, help patients with bedpans, give shots and medicine, and hang IVs. I had to complete 160 hours in my last preceptorship, and by my 120th hour, the nurses realized I was up for doing anything they asked—like giving a bed bath to a man who was four hundred pounds. Luckily, at Kaiser, they finally got some lifting equipment. Nurses mess up their backs all the time because they have to reposition the patients, and a lot of them are overweight so the equipment really helps.

I had a wonderful preceptor who taught me that great nursing was about being really polite and knowing what to say to make the patient feel better. Prioritizing is really important, and she taught me a lot about time management. She really looked out for me and gave me as many opportunities as she could.

I can't wait to start my nursing career. I want to take care of patients, and I am really excited about learning a lot more, so that I can become a fantastic nurse. I know it will be tough, but I think, overall, taking care of people is going to recharge me.

Emily Fitzgerald, BSN, RN, was born in Redding, California, and grew up in Belgium, with two siblings. She has a BA in communications from UCSB and, in 2011, earned a BSN from Dominican University in San Rafael. She trained at Kaiser Hospital, in Vallejo and Oakland, and is currently looking for a nursing job in the San Francisco area. (Postscript: in July 2012 Emily was hired as an RN in the medical/surgical unit at UCSF Medical Center.)

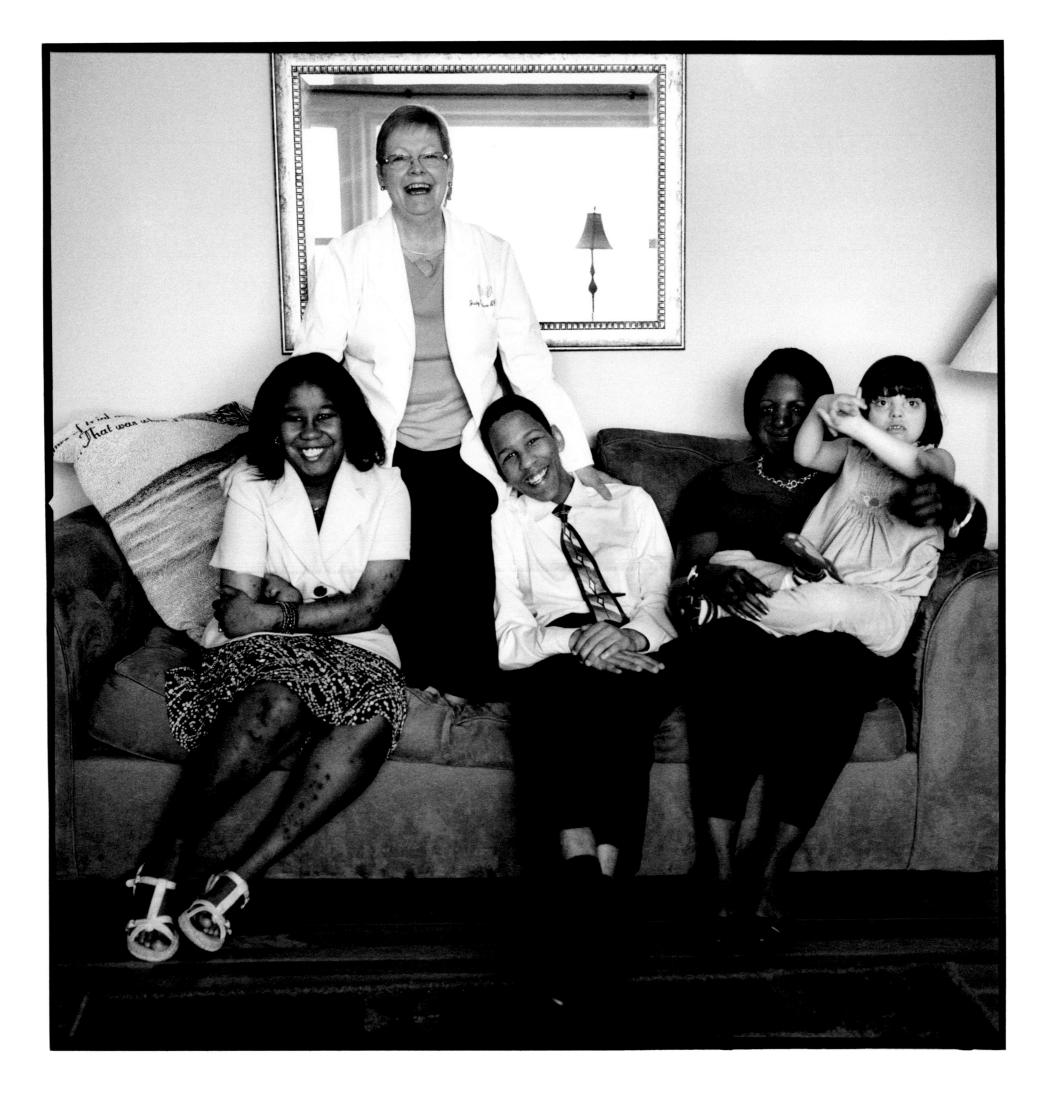

JUDY HARRISON

HOMETOWN PEDIATRICS, LEXINGTON, KENTUCKY

I am a pediatric nurse-practitioner, and I also teach pediatric nursing. I work for the juvenile detention center and take care of eleven- to eighteen-year-old incarcerated kids who need health care.

I always wanted to be a mother, but only wanted to be a nurse after doing foster care for ten years. I come from a huge family and was always taught that it doesn't matter if you are different. I had two birth children, and then discovered I couldn't have any more, so we chose the foster-care route. It's really much easier than pregnancy. They bring them to you! We chose foster care because we wanted to give back, and from there it just kind of blossomed, and we went right on to offer foster care to the medically fragile.

In the 1970s, foster children would be sent to a nursing home if they were not perfect—if they had seizures, for example. I didn't like that idea, so I asked the state if I could keep those kids. My husband and I believed that children couldn't thrive in a nursing home; they needed parents and a place to live. We learned very quickly that if the kids are in a home and form some kind of relationship with their birth family, then 90 percent of the time, they'll go home.

Many of the birth families were dirt-poor; some lived without running water or electricity. You don't need running water to take care of a seizure condition, but it does require extra time and care. We were willing to provide the care to get them home.

The children who came to me were from all over Kentucky, but they came to us based on the fact that they needed medical care that I was willing to provide. In the 1980s and 1990s, many of our children came because we were saving premature babies earlier and earlier. When I started foster care, the age of viability was thirty-four weeks, and in the nineties it was twenty-four weeks. Now I think it is twenty-two weeks. A lot of these children come from families with limited resources. Others were not premature, but were born with congenital anomalies that the families couldn't handle.

One of my adopted daughters was born with myelomeningocele; she had an open portion in her spine that had to be repaired. Her birth family thought it was a sign from God that she didn't need to live. She stayed with us until she died at fourteen. At one point I had four children with spina bifida living with me—all needing to be catheterized, diapered, and braced. Kristina was born with Treacher-Collins syndrome—no ears or facial bones, square eyes, and she needed a tracheostomy for breathing. Her parents were told she wouldn't survive, so they abandoned her. Her doctor asked me to see her. I had seven boys at the time, but I went to see her in the hospital and knew immediately that she was my daughter. And she didn't die. She is now twenty-eight years old and is a pediatric hospice nurse.

Does it take extra care? It does—they're worth every minute of that extra care.

We saved a lot of kids, but a lot of times what the children needed was a mama to care for them until they died. Sometimes it was just that their birth mama needed another mama because she couldn't do it alone. So many times these children had two mamas, and we'd share that child until they died. We took turns rocking, talking, and singing to them. There's no way to measure what a wonderful thing it is to watch a family accept that their child is dying and to know they died peacefully and happily. My own belief is that children who die go straight to heaven. They leave my arms and go back to where they came from.

It is an emotional roller coaster, and I'm careful with myself emotionally. I have a good support system, and

Judy Harrison, RN, MSN, CPNP, APRN, was born in Hamilton, Ohio, and lived in Waco, Kentucky, with two sisters and a brother. In 1974, she began foster parenting and was privileged to be a mom to more than one hundred children. She earned a nursing degree in 1988 and a master's degree and Pediatric Nurse-Practitioner certification in 2011. She was program manager with the Christian Appalachian Project and developed a training program for foster parents caring for medically fragile children for the Cabinet for Health and Family Services. A committed caregiver by any measure, Judy is the personification of all that is remarkable about nursing and the human spirit.

I understand that you need to love people with an open hand. People are not ours to hold on to; that's not the way that works, especially with children. If you keep an open hand and let them go when the time comes, they're either going to become productive adults or they're going to go straight back to heaven. Neither is a bad outcome.

In my mind, there is nothing more precious than a dying child. You've only got a limited amount of time to give them what they need and to put as much life as possible in them before they go.

We don't do medical first; we do life first. That might mean doing dialysis in Hilton Head at six o'clock in the morning, so that we can all go to the beach. So be it. Living comes before medical.

Of course, we had to modify the house; there was so much equipment. We had all these monitors and seventy-five feet of connector tubing running all over the house. We all learned to walk over and around all the equipment. We did all the IVs and meds at home. We learned to reorganize and redo. Because of the wheelchairs, the walls were always banged up, but I had to give that up. The children learned to operate the blood-pressure cuffs. They would say, "Mom, my pressure is 138 over 80. Is that okay or do I need a pill?" They were good at standing on each other's oxygen lines; the other child would turn blue and scream, "Mom, he's standing on my line. He's going to kill me!" You get used to it. You yell back, "Get off his line."

Right now I only have one child left at home—Amanda Kate—and after cooking for ten kids, I am so happy that she likes cereal. I hate to cook. After feeding all those boys a pound of bacon and a whole loaf of bread for breakfast, it thrills me to not have to cook anymore. From eleven to eighteen years old, the only thing those boys needed was to eat. At about sixteen, the eating was replaced by the need to have a sexual encounter, because they are male. The sex education thing was always interesting. The one thing I want to know is: if most of the body parts don't work, why do the sex parts always work? I have no clue. But, yes, with seven boys the testosterone was always a problem.

Two of my boys—Marcus, who died at twenty-one, and Justin, who died at sixteen—had one goal in life before they died and that was to have sex. Justin had cystic fibrosis and fetal alcohol syndrome, and when these nice volunteers from Make-A-Wish asked him what he wanted, he said he wanted to see Hugh Hefner and the Playboy Bunnies. They said they were willing to go, and the cardiologist even offered to go along in case of arrhythmias, but I explained he wasn't going. There are some things that mothers just can't allow. So we went instead to see some wrestlers—not my idea of a fun time—but Justin was thrilled. He stood up with his oxygen tank and yelled, "Bring on the boobs!" I squeezed his scrawny leg and said, "Do that again and we go back to the hotel." With seven boys, it is either toughen up and come to the party, or they run all over you. So we toughened up and did what had to be done.

Justin lived life to its fullest. One time, he and his friend had lain down in the middle of the road and put yellow crime-scene tape around themselves, just to see if the police would come. They did. Once he rented twenty-three X-rated movies in two hours. I don't really remember the medical things; I just remember the look on those volunteers' faces when Justin said he wanted to visit the Playboy Bunnies.

Justin, like my other older children, planned his own funeral. He invited every female in his high school to

come, and they did; there were probably two hundred girls at the funeral. I had asked him how he invited them, and he told me, "Well, Mom, you just walk up to them and say, 'Hey, you wanna come to my funeral?'"

Marcus chose a rap song for his funeral, and my mother—my little, white, Baptist mother—was appalled. I thought it was much healthier that he got to choose his own music. I don't think we've ever had a sad funeral for any of my children. We know we did everything humanly possible to make their life wonderful.

Mine was the first medically fragile foster home, but now there are probably about thirty of them. Not all of them take kids who are dying or kids in wheelchairs. Every house has its own thing. I didn't take kids with behavior problems because my children were so fragile that they could've gotten hurt. I took the very, very sick kids.

We have families who will take kids who are going to die. My son and his wife fostered three kids who died. They're getting ready to adopt again. I'll have another granddaughter; she will probably live into her teens. We'll have her until then. Death and dying comes easy to us as a family.

We are a very spoiled nation, and we really think we can cheat death. It makes for an unhealthy, emotional group. If you can't accept dying, how can you accept it when it's your turn? Part of the problem is that medical professionals are trained to fix people. But some things can't be fixed; that is just not an option. If you're in the health-care field, you have to understand death as being just as important as birth. In America, people think death is an option. In other countries, death is a much bigger celebration than birth.

After I finished fostering, I taught foster families of the medically fragile for twelve years. We had a blast, spending the weekend together, telling each other our horror stories. It gave us all a chance to get to know one another. I still hear from a lot of them. Today, I have eight very wild grandchildren. I love them dearly, but don't plan on living with any of them. I've always had a house full of children, but now I get to send them back to their parents.

We had two commandments we lived by in our house: you go to church every time the door is open, and you graduate from something. My grandmother made sure that all nine of her children stayed in church and that her children made sure that we all stayed in church. God was always explained to me as a friend who I can talk to and depend on. I've always lived with the ease of knowing I am only here for a while. My children are only on loan to me from God, and that is fine. Would I trade my life some days to be a greeter at Walmart? Sure I would. God and I have discussed that.

I came from a strong, faith-based family, and my family is still steady as a rock. I was very lucky to have the family I have, so I needed to pay that forward.

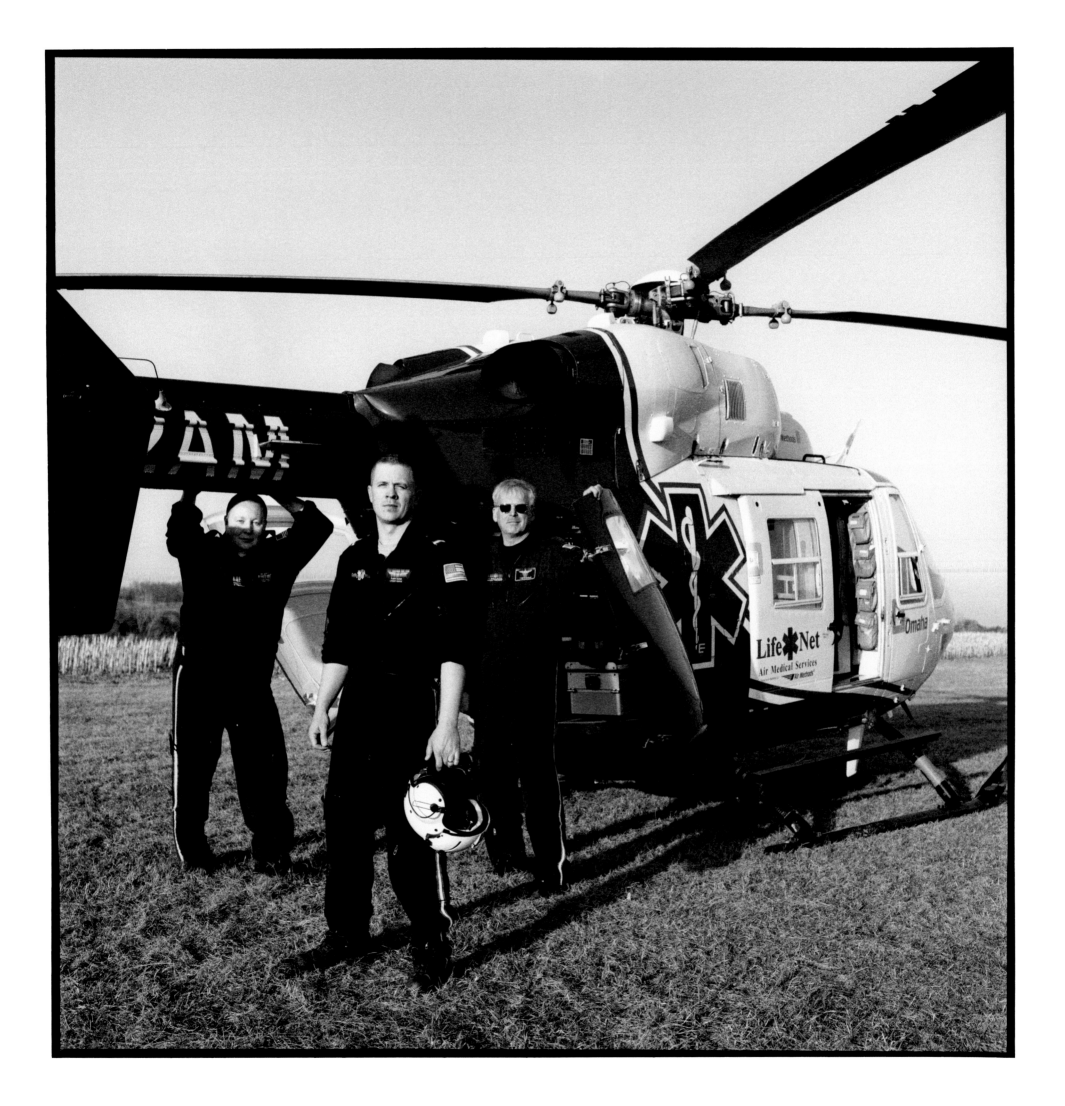

MATT TEDERMAN

NEBRASKA MEDICAL CENTER / LIFENET IN THE HEARTLAND, OMAHA, NEBRASKA

I've been a flight nurse with LifeNet in the Heartland, working out of the Nebraska Medical Center, for the past six and a half years.

I didn't know that I wanted to be a nurse when I was young. I just knew I wanted to be involved in flight. As a kid, I worked long hours on my family's farm, and that taught me a lot about having a good work ethic, which has served me well in this job. I also learned about compassion from working with livestock. This job has a lot of long hours, but it is very rewarding.

Our typical day starts at 7:00 a.m. We get to the office and get a rundown from the off-going shift about what their day was like. They'll brief us on the condition of the aircraft and give us an inventory of the supplies, in case we need to restock anything. We're responsible for the narcotic logbook, so we go through and count them every day. It has to be done on every shift.

We take a look through the aircraft and check that we have everything we'll need for the day. We try to grab some breakfast, but we always have the radio with us. Then we wait for a flight. During the day we work on our continuing education.

Our dispatch center is located in town. When we get a call, we respond very quickly. We get a brief report on the nature of the call, and then the pilot will clear us for takeoff. He keeps an eye on the weather. Ultimately, it is the pilot's decision whether we take the flight.

Kids are always the toughest flights. A few years back we had this kid who was on a snowmobile in a rural field. He didn't see a barbed wire fence and ran right into it. He had a very severe laceration on his neck and was in pretty rough shape. We were able to secure his airway, and the outcome was positive. It's flights like that that make you feel you can provide a life-changing service for the patient and their family, but it can be tough. Most times, you can't help but think of your own kids. It reminds you to be grateful every day and give your own kids a big kiss when you get home from work.

I enjoy the job so much that it never seems like work to me. I get to fly, which can be very exciting, and I get to help people when they really need it. This is what I was trained to do, and it is very rewarding.

Matt Tederman, BSN, CFRN, was born in Gothenburg, Nebraska. He grew up with three older sisters and a younger brother on a farm in central Nebraska, where his family grew corn and soybeans and raised some cattle. Most of his family members are still farmers. Matt earned a BS in nursing from the University of Nebraska Medical Center and worked in adult ICU at Creighton University Medical Center from 2002 to 2004. He then worked in the ER there until late 2005, when he became a flight nurse with LifeNet. He has been a nurse for ten years.

PATRICIA SOKOL

THE AMERICAN MEDICAL ASSOCIATION, CHICAGO, ILLINOIS

I am a nurse attorney and work for the American Medical Association as a senior policy analyst.

My first nursing job was on the surgical floor. Before I had even gotten my board scores, I was approached by my senior nursing staff and asked if I'd take over the orthopedic floor. This was in Colorado Springs, and on the other end of the orthopedic floor was the burn unit. As a brand new nurse, that was one of the most frightening things I'd ever done in my life.

Law crept into my career rather late. When my husband retired from the Air Force, he went to law school in Indiana. I was looking at all the things involved in nursing and wondering if I wanted to go back to school for an advanced degree. For me, it kept coming back to policy. I was beginning to see the burdens of my patients in a different perspective, and it was all about policy. One patient, for example, was a single mother who had cancer with her pregnancy, and one of her other daughters was just starting school. I asked if her daughter was excited about school, and she said she wasn't because she had nothing to wear. I called around and got these donations for her. I felt like this was really important, and it was something out there that I just didn't see.

It seemed like the only way to make changes was through policy. I started taking nursing-policy classes and realized that's what I wanted to do. My husband got a job in Chicago, where there are three law schools that focus on health law. The best was Loyola, and that's where I went.

The bigger reason I went to law school was to understand the juncture between health and policy. I wanted answers to why people couldn't enjoy their health experiences. Why did so many aspects of a person's health journey become a huge cloud over their head when they became ill or when utilizing the system for even the best of reasons? For example, I was in a farming community, and not all farmers have insurance. This one family was perfectly capable of paying for the birth of their child, but costs had exceeded the projected hospital bills that they would have to pay. There were some items they wanted to bring themselves to save money—sanitary napkins and Tylenol, for example—and it took forever for the hospital to agree that they could bring their own supplies.

Another issue was with teenage pregnancy. We were dealing with whether the parent's insurance would cover these girls or if they needed to go on Medicaid, but we were overlooking the possibility of home care, where they could continue their education. Why isn't policy making it easier for someone to go to school, have this healthy baby, and come back to continue their life, if that's what they choose? I had the sense that policy was interfering with these kinds of solutions.

Sometimes I miss working with patients, but I know that a lot of the things I am doing with my colleagues is making a difference. Besides, if I went back, they wouldn't use me for bedside nursing anymore. In fact, we have a really derogatory term in nursing that we use when you get older, have a few more letters after your name, and have been away from nursing for a while. They call us "old clipboards," because you walk around with a clipboard and it's like you're always taking notes. I really don't want to be an "old clipboard."

You know, health and law belong to everybody. But where are we teaching this? New health laws are coming into place, but all we talk about is insurance. For example, there are Thrive Schools where a part of the math curriculum is teaching kids how to read labels and understand the meaning of a fat calorie. This is the kind of information that needs to be woven into the curriculum; it's just as important as math.

Patricia Sokol, RN, JD, was born in New Kensington, Pennsylvania, and because her father was in the military, grew up in many different places, including Massachusetts and Colorado. A nurse for thirty-five years, she went to law school at Loyola University Chicago, was admitted to the bar in 2000, and has been a nurse attorney for the past twelve years. Her expertise is in safety science (patient safety), improvement methodology, risk management, and clinical ethics.

ROSEMARY LIVINGSTON

CHILDREN'S NATIONAL MEDICAL CENTER, WASHINGTON, D.C.

Rosemary Livingston, RN, BSN, was born and raised in Virginia with her three siblings. She attended the University of Pittsburgh for undergraduate nursing and is currently attending George Washington University for her master's in leadership and management. She was inspired to pursue nursing in response to medical issues experienced by members of her family. After graduation, she came to Children's National Medical Center and began working in August 2010 on the heart and kidney unit. She has only been out of nursing school for two years and loves her job working with kids.

I am a staff nurse on the heart and kidney unit at Children's National Medical Center in Washington, D.C.

I grew up right outside of D.C. in Northern Virginia, not far from the hospital, and always wanted to work here. I have a little brother with special needs who has been treated at this hospital, and I've actually been a patient here myself. So I knew this was a good hospital, and this is the first place I applied to after graduation. Two years later, I am still here.

I work with kids who have congenital heart defects; some come to us at birth and some a little later. Any kid with a heart issue comes to us. We take care of them before and after surgery. I also have renal patients—kids with kidney disease or failure. A lot of those kids wind up with transplants. I've taken care of kids who've passed away, and that never gets any easier.

Some people say they could never work with sick kids, but for me it is the opposite. Children have this will to survive that is so strong; they're always fighting to get better. They never give up. You can't ask for anything more than that.

We have kids who are really sick, and yet, you have clowns walking down the hallway, and you have a kid with an amputated limb on a bike. It sounds corny, but these kids give you the inspiration to keep on trucking through your own life. If they can deal with their stuff, I can deal with mine.

One of the big draws for working here is that we see all kinds of families—black, white, Hispanic, Asian, whatever. This makes the job a little more rewarding. I recently had a case where a doctor was explaining to a mom about her daughter's condition, and it was really upsetting news. She held my hand, and when the doctor left the room, she said, "Rosemary, can you explain that to me?" She was basically asking me for help to understand what was happening to her child. So I got a box of tissues and sat with her for twenty minutes, and we talked about all the scary stuff. That was one of those experiences where you go home feeling good about what you did for someone else, even though it was upsetting.

We had this other little girl, one of our renal patients, who was in our unit for months, and I probably took care of her thirty times. We all started to have a special relationship with her. She was really sick, and we didn't think she was going to make it, but then she ended up walking out the door. We had a big party for her.

I'm happy I'm here right now. A lot of the pediatric nurses on the unit are young, in their twenties and thirties, and many of them move on. But, for me, this experience has enriched my life, and I've learned a lot. My interests lie in making the process easier for the patients, making the system more patient/family centered, and improving the bumps along the road. I think I'm getting led in that direction, although I don't want to lose having my foot in the door of patient care.

I was raised Catholic and am a spiritual person. I realize that we're never going to understand why a baby is born with a congenital heart defect and has to be split open three times. I don't think anyone has a true answer for suffering or for why it happens. Whether or not a nurse is religious, I do think it is a calling for a certain kind of personality. I think love is a big part of it.

If you ask any nurse about what they feel for their patients, it's love for people. You don't want your fellow sister or brother to suffer. We are all in this together, and if you can help someone out, it boils down to making a connection and, of course, to love.

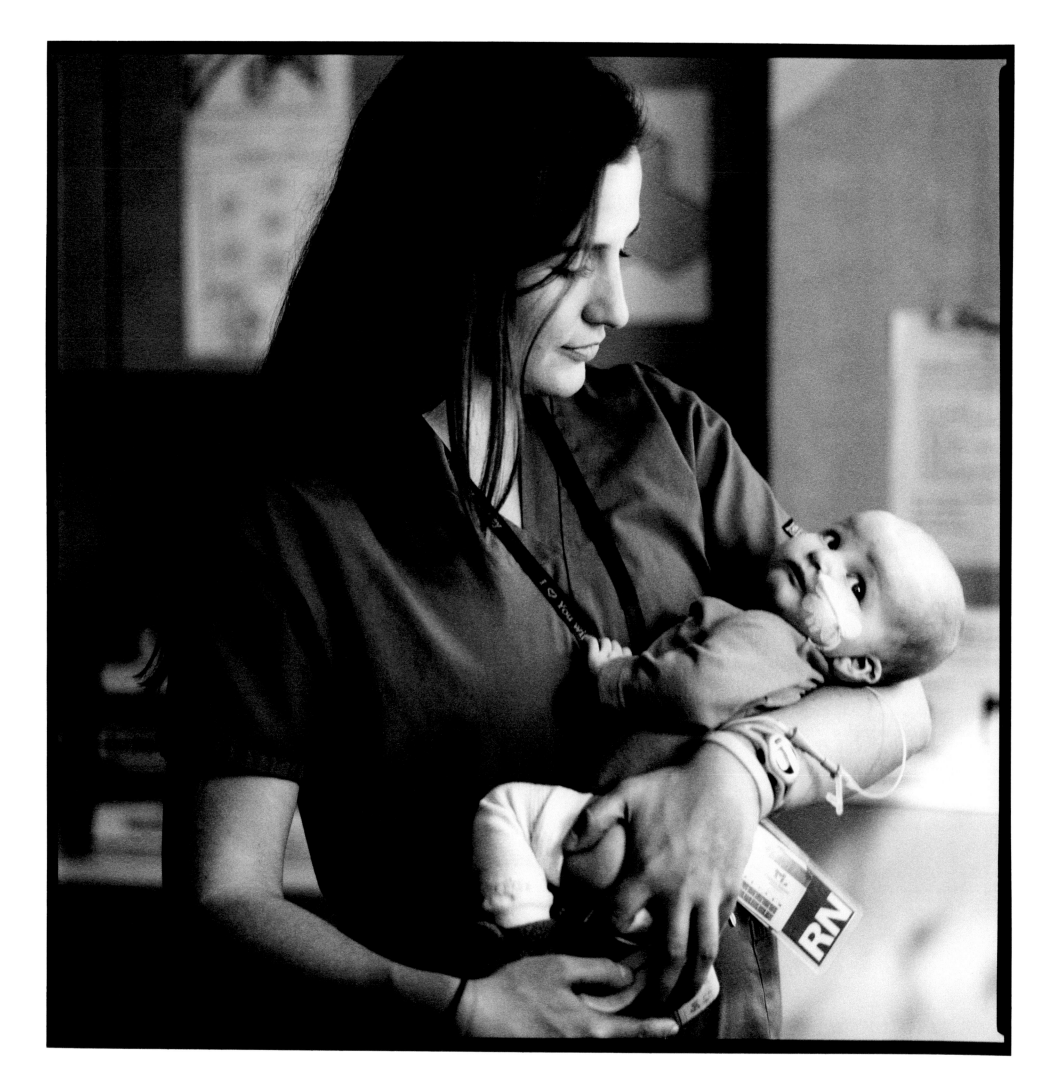

MARIANA NOGALES

CLINICAS DE SALUD DEL PUEBLO, CALEXICO, CALIFORNIA

Mariana Nogales, RN, FNP-C, graduated from medical school in Mexicali, Mexico, with a degree as a Medical General Practitioner. After coming to America, she learned English and in 1994, at the age of thirty-six, earned her license as an RN. In 2003, she received her bachelor's in nursing and then went back to school in 2007 for her master's nurse-practitioner. She earned her NP license in 2008 and has been practicing ever since.

I am a nurse-practitioner at Clinicas de Salud del Pueblo in Calexico, California. I was born in Mexicali, Baja California, Mexico—a city on the border between California and Mexico. I wanted to be a doctor when I was a kid. My youngest brother was born with a medical condition, hydrocephalus, and I wanted to learn more about it. He had several surgeries in San Diego, but he died when he was twenty-six years old.

In Mexico, I'm a general practitioner and worked for three years before I got pregnant. My dad is a US citizen, and I wanted to come here. I didn't like the way the hospitals were being run in Mexico, and the country was going through a really bad time back then. I needed to do something else with my life, so I came here and went to school to learn English. As a single mom, it was easier to get work as a nurse than to go back to school for a medical degree. Sometimes it is awkward when the doctors here realize I am also a doctor, but over the years I've learned that you have to know your place and know what you can and cannot do.

I enjoy working at the Clinicas de Salud because I get to see a lot of patients. Almost all of them—I'd say 99.9 percent—are Spanish speaking. I do mostly geriatric medicine, even though I'm not a geriatric nurse. I like working with older people; I like educating them. I see mostly chronic-care problems: diabetes, hypertension, obesity, and a lot of depression.

I also do women's health, and I enjoy working with teens. I talk to them about things they're afraid to discuss with their parents. It's amazing how little they know.

My job at Clinicas de Salud is part-time. I also have a full-time position as an RN at the Calipatria State Prison, where I've worked for seven years. It's a Level Four maximum-security prison.

We're on the border, and sometimes the patients will go to their local pharmacies in Mexico and self-medicate. They like to use a lot of homeopathic products, but they don't realize that these products can contain chemicals. Most of the time they don't even know what they are taking. They bring the pills to us, and even we don't know what they are. I have one patient who had back pain and got some pills in Mexicali. He started to gain weight and experienced swelling. Eventually, we discovered he'd been taking cortisone pills. We try to educate the patients, but sometimes it's impossible.

It's frustrating for me because my geriatric patients can't afford certain treatments, but the inmates can get almost anything—MRIs, medications, specialists at UC San Diego. Well, we are not here to judge anybody; we have to take care of the inmates, but like I said, it's frustrating. That's life.

I like the people that live in Calexico. There are a lot of Mexican people—not a lot of Chicanos and not a lot of white people. You have to go much farther north to find a population that doesn't speak Spanish. It's like another Mexican city. I've been living my whole life between these two cities—Calexico and Mexicali. To me, it's like it is just one city. It's just a fence that divides us. It's just a fence.

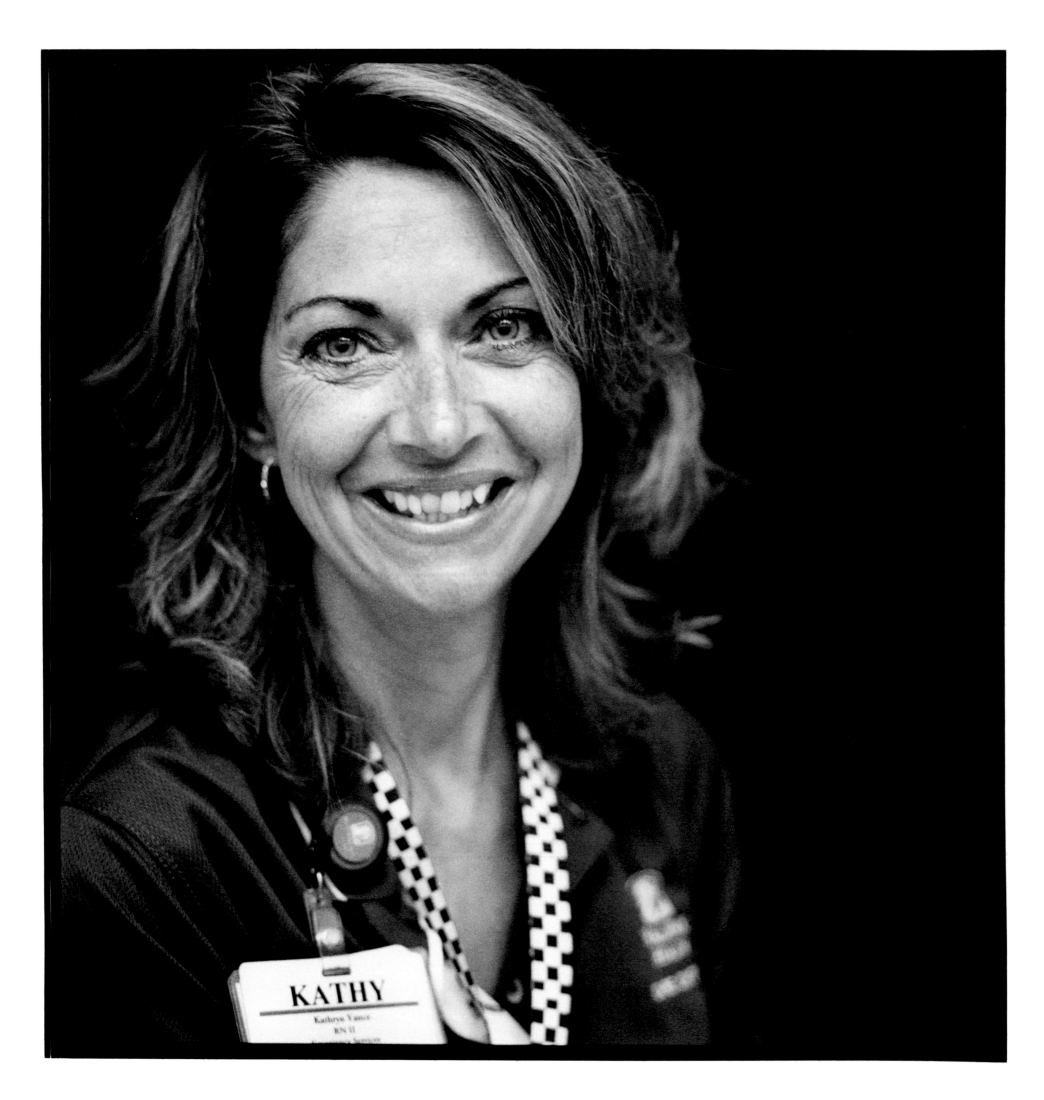

KATHY

Kathryn Yance
RN II
Emergency Services

KATHY VANCE

HALIFAX HEALTH MEDICAL CENTER, DAYTONA BEACH, FLORIDA

I am a registered nurse at the Halifax Health Medical Center, and I currently work at the Infield Care Center, Daytona International Speedway, where I am the nurse manager.

We provide free service and care for the crowds that come to the races. They are very faithful and true to NASCAR. One woman, for example, came in and she was actively having a myocardial infarction. I told her she was having a heart attack and had to check into the hospital. She refused, saying, "I'm sorry, I'm not going to miss the 500 for this. I'll go see my doctor when we are done." She left. There was nothing I could do because she refused care. I don't know what happened to her.

When the cars wreck, if the injury is severe, they go to the Halifax Health Medical Center. Otherwise, they come to us, and we do a head-to-toe assessment. We make sure they're okay to go back to the track. Last night, there was an unbelievable wreck when one car hit the fence. The driver came in without a scratch on him. The cars they race have a lot of safety features not available on regular cars.

We had one crewmember who came in with a bad injury to his leg, and I told him he needed to go to the hospital for IV antibiotics. He refused. When he returned the next day, I told him he was going to lose his leg and he might even die if he didn't get treatment. I think a light bulb went off in his brain because he finally agreed to be admitted to the hospital. I mean, I am a fan of racing, but I also have some medical education.

If there is a multiple-car wreck, we can take between four and six drivers. If it's ever like forty people injured, which I hope never happens, they'd go to the hospital.

I love NASCAR and have been a fan since I was a little girl. My love for NASCAR blends with my skills for nursing and for accounting. I believe they all combine to help me where I am today. I have an awesome job that is kind of laid-back because you can enjoy yourself while you work. We watch the race on TV and cheer on our favorite driver.

I don't go out to the racetrack; my job is to man the care center when they are racing. When the race event is happening, it's anybody's guess as to what can happen. We never know who is going to walk in the door; it could be a patron who fell off their chair or has the flu. We get the usual complaints: nausea, vomiting, sore throat, fever, headaches.

We also treat over-beveraged guests.

Every day I come to work and when I hear those engines roar, it's very exhilarating. I feel like a little girl who is getting ready to go on vacation. I get that feeling in the pit of my stomach that we are going to do something fun today.

Kathy Vance, RN, was born in Winchester, Virginia, and grew up with two sisters and a brother. She served in the military from 1988 to 1994 and went to nursing school for her associate's degree after being discharged from the US Navy. She worked at the West Virginia University Hospitals-East from 1998 to 2008. When her family moved to Daytona Beach, she found a job at the Halifax Health Medical Center in 2008; two years later, it merged with the Daytona International Speedway. She has been a nurse for fourteen years.

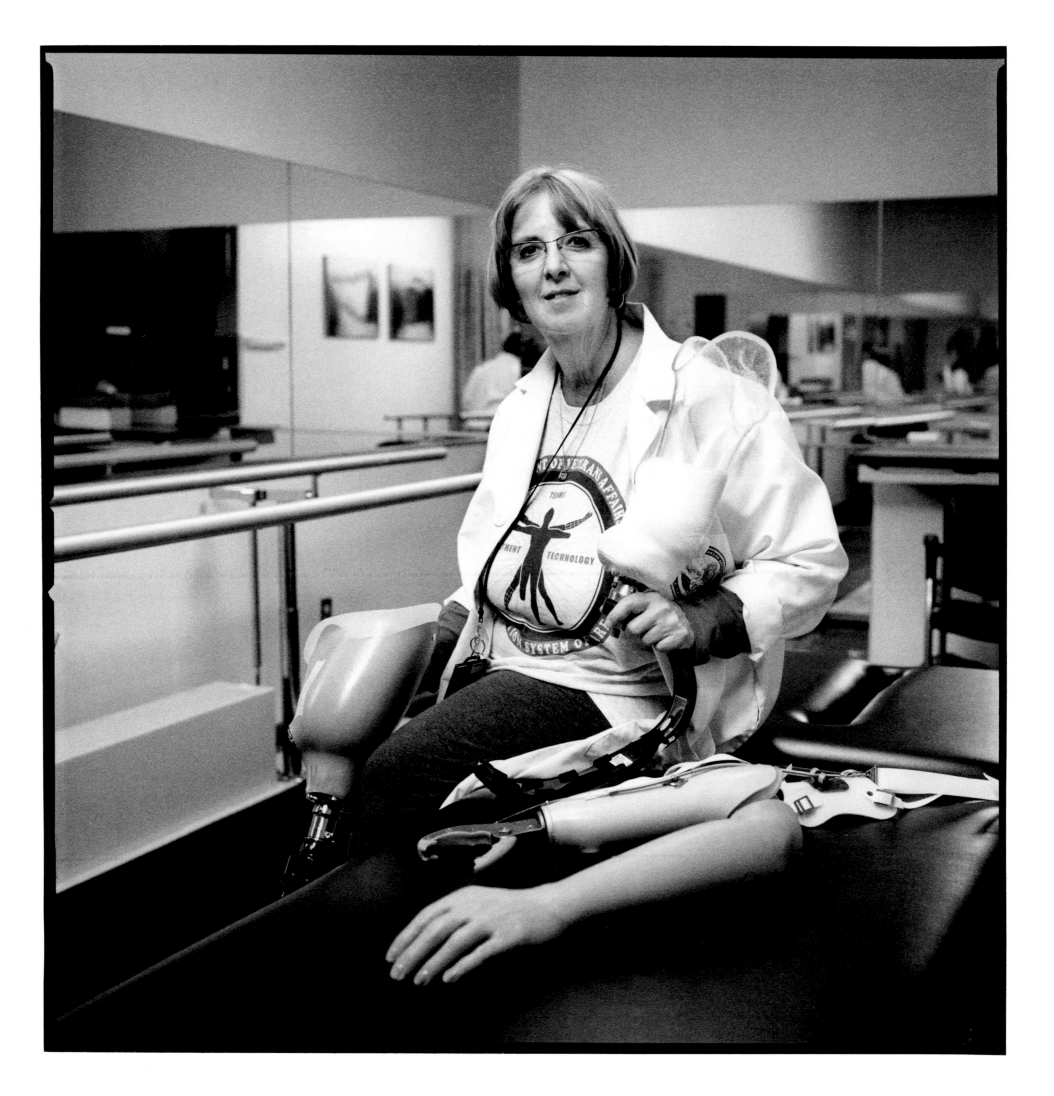

DEBORAH VELEZ

VA SAN DIEGO HEALTHCARE SYSTEM, SAN DIEGO, CALIFORNIA

I have been a nurse for almost forty years and worked in three hospitals before I came to California, where I now work at the Veterans Hospital.

I was a really active kid, always into all kinds of sports and activities. In high school I took all these typing and shorthand classes, but I kept thinking I didn't want to spend my life taking notes for other people. A friend suggested I try nursing, so I applied and got in. I loved it right from the very first because I was interested in developing as a workingwoman who was able to self-support and grow. I did a two-year degree and was a working nurse for many years. I got my bachelor's, my master's, and then my nurse-practitioner degrees. I matured into my current job, and I never stopped wanting to learn and grow. Every time you see a patient, you learn something, and then you want to know more about what you saw and understand it better. I think that's why I keep wanting to develop in my profession.

I am currently the PAVE coordinator at the VA San Diego Healthcare System. PAVE stands for Prevention of Amputation in Veterans Everywhere.

I participate in the weekly amputee clinic and perform bedside evaluations for patients who are about to undergo an amputation. I perform ongoing patient and staff education about the PAVE program and participate in the Major Medical committee, which evaluates veterans for motorized mobility. I also manage a local rehabilitation database of functional outcomes for traumatic brain injury, stroke, and amputation.

Through case management, I refer veterans to the established limb-salvage services if they are at high risk for limb loss. The services include numerous clinics: amputee, brace, orthopedic, podiatry, vascular surgery, and wound care. Working along with Social Services, I facilitate the amputee and stroke support groups.

After 2001, we started to see veterans coming back from Afghanistan and then Iraq. Now we interface with the Department of Defense as these soldiers become veterans and need our services. We identify patients who are at risk of losing limbs and follow through with them. It's really case management of that certain population of patients with special needs.

My dad and my husband are both veterans, so I feel comfortable working with these men and women. We provide prosthetic limbs for different activities, depending on the needs of the patient. We have prosthetics for swimming, running, almost any level of activity. We have to keep refitting them as bodies change and the equipment wears out. Of course, all the work is custom. We have a clinic that meets once a week. If someone can't wear a prosthetic limb for one reason or another, we provide him or her with motorized mobility. We want everyone to move forward. This is a very special population, and I like being its champion. I am grateful that nursing has provided me with a venue to be caring and creative.

We develop relationships with the veterans that can continue for years and years. I've learned that the human spirit, and its will to live, is incredibly strong. I am amazed every day by these veterans and the life force they personify. They are an inspiration to me and everyone else in the country.

Deborah Velez, RN, MN, GNP, grew up in St. Louis with two sisters. She works at the VA San Diego Healthcare System, helping veterans and specializing in the concerns of amputees. She participated in the development of the amputee-education handbook, The Next Step, *which is distributed to all amputees nationally. She also co-authored "Providing a Helping Hand: Upper Extremity Prostheses," published in the journal* Nursing 2011. *She has been active in the Phantom Limb Pain (PLP) study, the largest clinical trial in the US on the subject. Still, her greatest accomplishment is her twenty-year-old son, who is currently studying nursing.*

SANDRA BARNES

MONTEFIORE MEDICAL CENTER, BRONX, NEW YORK

Sandra Barnes, MSN, RN-BC, Patient Care Coordinator (PCC), was born in Kingston, Jamaica, and grew up in Mandeville with her two older siblings and grandparents. A nurse since 2001, Sandra is currently an RN staff nurse at Montefiore, working on the transplant unit where she cares for patients following their kidney or liver transplant. She has always wanted to be a nurse and used to take care of her grandfather before he passed away at the age of eighty-seven.

I am an RN at Montefiore in the Bronx. I work on the Red Zone and have been here for six years. We have different zones here. For example, the Silver Zone is surgery. The Red Zone is for medical or surgery patients.

We have thirty-five bedrooms, and each nurse has about seven patients. There is a lot going on, so you have to prioritize. I used to work in a nursing home, which was not as hectic as it is here.

Our patients are in different conditions when they come to our floor. We have some who are alert, others who are on a ventilator or a drip. We never know what state they will be in when they come from the emergency room, although we are told when to expect a ventilator so that we can set up the room.

When I care for my patients, it is like I am taking care of a family member. That's how I look at it. There's no difference to me. I have the same caring feeling toward them. I recently had a stroke patient; he was paralyzed, but he was so helpful. He wouldn't use the bedpan and had to walk to the bathroom. He never gave up; it really touched me. His wife took care of him, but then she died, and it was very sad. He went to a nursing home, but I wish I could've adopted him; that's how special he was.

Sometimes the most difficult part of what I do is not about dealing with the patient but with the family. I could be trying my best, but the family sees it from a different angle. If you take a minute to get a medication, they seem to think it took an hour. Some of them are really difficult; they are scared or emotional, so that makes them hard to deal with.

At the end of the day, you have to remind yourself that you're doing the very best you can. You have to hope that they see you are really trying.

My dream is that one day I could run a school for home-nursing attendants. I have a lot of ideas and thoughts about training nurses. I think that although compassion is something you are born with, it is also something you can learn.

I've always wanted to be a nurse. I really love what I do. I think I am compassionate and caring, and I have a passion for being able to help someone who is sick, by lending a hand or offering a smile. I always say that sometimes a smile can diffuse something terrible that's going on.

PAM DODGE

THE JOHNS HOPKINS HOSPITAL, BALTIMORE, MARYLAND

Pam Dodge, RN, grew up in Mendenhall, Pennsylvania, where she lived on a farm. She was thirty when she attended Chesapeake College in Wye Mills, Maryland, and graduated from the MacQueen Gibbs Willis Nursing Program in 1993. While attending nursing school, she worked as a groom for racehorses, a production manager for a boat manufacturer, and a bank teller. In addition to being a staff nurse in the PICU at Johns Hopkins, for the past year she's been the new clinical building coordinator, preparing the staff for a move to a new building.

I am a clinical nurse in the PICU (pediatric intensive care unit) at Johns Hopkins. Our patient population ranges from age zero to twenty-one years and 364 days. We have a vast patient population and care for a variety of complex illnesses and injuries.

Nursing was a second career choice for me, since I started late in life. I was a bank teller, but then I had a daughter who passed away at this hospital. She was born with a complex heart disease and had many surgeries and procedures over the course of five years. After she died, I went to nursing school so that I could work in this PICU. I wanted to do for others what they'd done for me.

I don't usually share my story with the patients, but even so, my experiences give me a better perspective on what these parents are going through. I know what it's like to be on the other side.

I've worked here for nineteen years. I travel ninety minutes a day to get to work because it just feels like I need to be here. Every day these kids in the PICU are mine for twelve hours. They are my family. Until recently, I worked exclusively on the night shift so that I could have more quiet time to work with the children and their families.

We have between one to four patients in a room, and that can be hard when one of them is dying. Patients and the families need their privacy. In our new facility, every room is going to be private.

It can be really hard after one child dies. There is not only the grieving, but you have to move on immediately to the next child because there's always another patient coming in right behind the one who leaves us. You just have to keep going.

It really ebbs and flows. Sometimes we have several really sick kids, and other weeks there won't be any. There might only be kids who are having their tonsils out, so you get to play with them in the cribs. Those are the good times, and you try to savor and save them in reserve, to draw upon later.

It's difficult for people outside of these walls to comprehend what goes on in here. You don't talk about it with laypeople because no one wants to hear about the sad or tragic things that happen. But we have our miracles, too. A child will come in from some terrible accident, and you think they'll never survive. Six weeks later the kid will be walking and talking. Sometimes I think these things are totally out of our hands. You always have to be open to the possibility of all things.

There are a group of us older nurses who are lifers here. We would like to cultivate new nurses just out of school to be lifers, too, but this is getting harder. Today, they come out of school and want to get higher degrees and move on to different things. I'm among this group of lifers, and I think each of us has a personal reason why we stay. If you ask any of the lifers why they are still here, they'd probably say, "Because it's what we do."

NAOMI CROSS

THE JOHNS HOPKINS HOSPITAL, BALTIMORE, MARYLAND

I work in labor and delivery at Johns Hopkins in Baltimore, Maryland, which is exactly where I've always wanted to work. When I was in high school, my sweetheart died of leukemia at this hospital. I just loved the nurses and the doctors who took care of him—mostly the nurses, who made a big impression on me.

Michael and I met when we were kids; we played soccer together and became best friends. He was diagnosed with leukemia, here at Hopkins, when he was fourteen. Michael was a jokester. One time, the doctors came in and said they needed to do blood work immediately because his blood sugar was like 400. Michael finally confessed that he'd put apple juice in his urine cup.

He graduated high school in 1995 and passed away the next year, just before he was supposed to get a bone-marrow transplant. I really think if he hadn't been sick, we would be married and still together. His death really affected me; it taught me how to be a more loving and accepting person. It also made me aware of the need for blood and bone-marrow donations. I am a bone-marrow donor.

I went to Hood College with the hopes of becoming a doctor, but I didn't do so well in premed. My freshman year was the same year Michael passed away, so it was a very difficult time for me. I went home and reevaluated my situation. I wound up at a community college for nursing, where I was lucky enough to meet and fall in love with my current husband, Jason. After we got married, we moved to Wyoming for five years, but it was with the understanding that we'd eventually come back to Baltimore, so I could work at Hopkins.

I worked as a nurse's assistant throughout my nursing school career and loved all the work, but I was really inspired when I witnessed my first delivery. To me, every birth is a miracle. I think it takes a certain kind of person to do labor and delivery. Some nurses say they can't handle the screaming, the spitting, and the sweating. To do this job, you need to be able to be a calming influence.

For example, we had a delivery this week; this woman was here with her sister, and at one point she said, "I just can't do this." So I grabbed her face and said, "You can do this. We're going to do this together. Your sister is here and this thing is happening." She grabbed my arm, and the baby was out in two pushes. She looked at me, and then we hugged and cried together.

It is an awesome experience to connect with another person and to build rapport and trust. It reminds you of your humanity. I can empathize with my patients because I had a great birthing experience with my son. I just remember crying with joy; I was so in love. I wish that type of experience for everyone, and I know it can be accomplished. It's also my job to make sure the mother gets the best bonding experience with her baby, right from the start, because I think that is what is going to make her care for the future of her child.

One of the biggest things I've learned in this job is not to be judgmental. I am proud that we offer genetic terminations and options to people that some places don't. We have patients from all over the world, with all kinds of different diseases: cancer, brain tumors, lupus, high blood pressure. If a baby has a genetic anomaly that's incompatible with life, we give them the option to induce labor early. It's very difficult for some families.

As a perinatal bereavement coordinator, I assist families through the struggle and challenge of delivering a stillborn or miscarriage. I assist the family with making many decisions needed for end-of-life care for their neonate, such as comfort-care needs and funeral arrangements.

Naomi Cross, RN, was born in Fort Hood, Texas, and, as an army brat (her father was in the military), she grew up in many different places, including Fort Carson, Colorado; Los Angeles, California; West Berlin, Germany; and Maryland. She has three siblings. Naomi attended Hood College, finished her degree at Harford Community College, and completed her nursing degree at Central Wyoming College. She plans to complete her BSN and MSN degrees at Notre Dame of Maryland University, where she has recently been accepted. In her role as a bereavement counselor, Naomi sometimes brings families to the statue of Jesus (shown opposite), which stands in the original main entrance of the hospital.

PHYLLIS PICKENS

CALLEN-LORDE COMMUNITY HEALTH CENTER, NEW YORK, NEW YORK

Phyllis Pickens, RN, BSN, was born in Brooklyn and always wanted to help people. She started out as a candy striper doing volunteer work in hospitals and liked it so much that she decided to become a nurse. She later discovered she had a grandmother who was a midwife in the South, so perhaps nursing was a calling with ancestral ties. She currently works with homeless youths in Harlem and on the Lower East Side of New York. As a lesbian, she reaches out to the gay, lesbian, bisexual, and transgender community and uses her own experiences to connect with troubled teens.

I am a registered nurse, and I work in the mobile medical unit in the HOTT—Health Outreach To Teens—Program. In addition to the clinic, we go out to Harlem and the Lower East Side to provide care and links to agencies for homeless youth.

The mobile unit is a way of bringing the clinic to the streets. Our goal is to help these youths get connected enough to come into the office for extended services. We provide health screenings and physicals—pregnancy tests, STI (sexually transmitted infection) screens, immunizations, and whatever they need. We deal with a lot of hepatitis C and young people who are newly diagnosed with HIV infections. It's not only about the medical aspect, but also about dealing with the shame and disappointment. It's my job to help them figure out that they can have a long, healthy life.

I spend twenty minutes with them maybe once every three months or so, and I only have that one moment in time to work with them. We try to make a safe haven for them, to have confidentiality and talk about their concerns without being worried that someone is going to get their chart or their information.

I work with a lot of different people, and I hear their stories and realize there are threads we all share. I try to help young people figure out what is happening with their bodies when they are going through trying times.

As a lesbian who is okay with who I am, I want to help young people who are gay, lesbian, transgender, or bisexual. Hopefully, I can be a safe person, without a lot of prejudices, for them to talk to and to help them trust the systems that may have hurt them because they are "different."

If I can help them figure out how to get through it, they'll develop tools to talk to other people. That is what I feel the magic of nursing is all about—giving space for patients to be able to talk about what's ailing them at the moment, and being a tool to help them feel a little bit better.

Just last week I was working with a patient who identifies as a transgender female and has been on hormonal therapy for more than a year. She has been on self-injections and is pretty well-established, but she has had tremendous struggles. She just met a guy who really likes her, but is ashamed to be with her because she's transgendered. Now, she looks totally female and no one would know, but he knows the details of her life and could not rise above them. I identified with what she was going through. I really didn't have any answers for her. I just let her know that you need to take care of yourself and keep striving for what you need. I think she found some peace in knowing she's not alone.

This work is hard; it's hard being present with people and being myself and not taking it home. You have to deal with the situations as they come, keep facing tomorrow, and know that it's going to get better. It's intense work, but having experience makes you a little bit smarter about how to work with people and treat them like human beings. It's a privilege for me to be able to go into the community and offer these services.

ELISA FRAZER

TIDEWELL HOSPICE, PORT CHARLOTTE, FLORIDA

Elisa Frazer, RN, was raised in Brooklyn, New York, one of five siblings. She worked in health-care administration for more than thirty years. Her titles ranged from staff nurse to clinical coordinator, to nurse manager, to assistant director, to nurse administrator. She spent most of her time in the surgical arena. She relocated to Florida in 2004 and became a dialysis nurse before joining the family of hospice nurses.

I've been a nurse for more than thirty years. I am currently a nurse case manager at an inpatient hospice house at Tidewell. My job is to care for the dying and their families, with special attention to the management of symptoms during the end of life. Our goal is comfort.

I was inspired to be a nurse at fourteen when my brother was hospitalized for six months and I witnessed angels care for him. I spent the majority of my career at the same hospital in Brooklyn Heights, New York. I started out as a floor nurse and worked my way through the ranks. I pretty much fulfilled my career goal, but then my parents took ill. My dad had a stroke and became a hospice patient.

Though I'd been a nurse for thirty years, I didn't know much about hospice. I thought it kind of hastens death, but then I saw how hospice embraced my dad and our family in the most supportive, spiritual way. At first, I found it difficult to keep my nose out of their business because I thought I knew better than they did about caring for my dad. He was no longer able to eat because he couldn't swallow, so I thought he'd starve to death. I'd feed him, but then he'd vomit. His case manager asked if I was sneak-feeding him, and I discovered that, since he could no longer tolerate food, I was doing more harm than good. This is just to say how hard it was for me to step back. Today, I see families doing the same thing, and I totally understand. I use my own experiences to help educate them.

Seven months after my dad died, my mom passed away and I applied for a hospice job. Here we work in teams with our physician, nurses, social worker, and chaplain to create a support system. We have a grief counselor to support the family for up to eighteen months after their loved one passes. Everybody has an important role, and we learn from each other. This is something I never experienced in my career as a nurse in a hospital.

People have strange ideas about hospice care. We had this little old lady come in, and she sat up all night. In the morning she asked when she was going to get "the big shot." She thought we were going to hasten her death. When I explained what we actually do, she asked for a big steak and some broccoli.

As a nurse I always fixed things; now I had to learn how to fix things in a different way. I can't make my patients better, but I can improve their situation. I can make sure we get financial aid for a funeral if the family can't afford it. I can arrange a wedding, which I've done several times. Once we had sixty people here for a catered affair, and it was actually beautiful. The bride wore her wedding gown to sleep that night. In another wedding, the groom was only in his twenties, but he had a brain tumor. His girlfriend had just given birth, and we had their wedding in the gazebo, with the six-month-old in her arms. It was so touching because the groom was able to stand up for the entire ceremony.

These are like little miracles we can make happen.

One time a family was coming in with the father and, in preparing the room for his arrival, I saw he had an Italian name, so I found a Dean Martin CD to play in his room. He arrived with about a dozen relatives. I made him comfortable, and his family walked in. A few minutes later, when I walked past the room, I heard them all singing "That's Amore." It was his favorite song. I'll never forget the tears and the partying in that room. To me, this is what it's all about—making something special happen.

MONICA OBERLANDER

MONTEFIORE MEDICAL CENTER, BRONX, NEW YORK

I am a registered nurse and started working at Montefiore Medical Center more than thirty years ago. For all those years, I worked in the Department of Obstetrics, in many different capacities. Right now, I work as a nurse manager in a reproductive-medicine office specializing in infertility.

I am one of five children, so growing up, we had a lot of kids and family around. I always wanted to be a nurse, even when I was really young. At first, I thought I wanted to work in pediatrics, but I soon discovered that sickness and children were not for me. It was too sad. My real passion for obstetrics began on my first rotation in college. I was twenty-one years old when I first saw a baby being born, and it's a moment I'll never forget. I can still remember the excitement in the room and the joy of the parents. It was such an exciting, happy event, and I felt a real sense of accomplishment being a part of it and helping.

I never thought birth was scary. It's always overwhelming because you don't know what to expect, but I quickly realized that it was stimulating to be around. I took a great interest in teaching the patients about breastfeeding and taking care of the babies. I liked helping the mom through labor. I'd tell her, "It's only one day in your life. You can get through this one day." Helping them with their contractions really gave me a great sense of satisfaction.

At the hospital, we saw every type of patient, from teens to older women, all sorts of couples and single women. The biggest insight I have from all those years is that, no matter what the circumstances surrounding the pregnancy, every mom wanted the best for her baby. It was always a magical moment when the baby was born. It gives the mom strength and courage to keep going. They all seemed very concerned and interested in knowing how to take care of the baby, even in the rare cases where the baby was being given up for adoption.

I met my husband at the hospital. He was an obstetrician, and we worked together day in and day out. We have four children of our own. My first three deliveries were very easy, but my fourth was complicated, and I had a C-section.

Now I work in an infertility office, and we see many couples trying very, very hard to get pregnant. There are times we have to tell people that there are no more options left for them, but they have to be ready to hear that. Most women feel that they can have a baby, that it is part of being a woman. It's a daily challenge for me because it was so easy for me to get pregnant. However, everyone has something in their life that's been emotional or a challenge.

For me, my husband was diagnosed with cancer when my youngest child was just seven weeks old. He lived cancer-free for five years, and then one day the cancer reoccurred. I took care of him for seven months, and I was so grateful for my training so that he could die in my arms at home. I also thought it was wonderful for my children because they were with him when he died. I think it gave them a whole different perspective on life. Now my seventeen-year-old daughter works at a bereavement center as a teen counselor. She felt that after what she went through with her dad, she was able to help other children. The experience made all my children more compassionate.

I obtained special training as a bereavement counselor when I worked in the hospital, and this helps with the infertility patients because there can be sadness. I tend to focus on the patients who have poor pregnancy outcomes. I have a strong sense of compassion because I know what it's like to lose someone.

Monica Oberlander, MA, BSN, RN, was born in New York and grew up in Eastchester, the second oldest of five children. She earned a bachelor of science in nursing at the University at Albany and a master's in nursing from Columbia University. She has spent most of her nursing career in labor and delivery. While raising four children, she worked in the maternal-fetal assessment unit and taught nursing at the College of Mount Saint Vincent. In 2005, she started to work as a nurse manager in the Institute for Reproductive Medicine and Health in Hartsdale, where she cares for patients with infertility issues.

VICKI HATFIELD

HOME CARE HEALTH SERVICES, PIKEVILLE, KENTUCKY

Vicki Hatfield, RN, was born in Williamson, West Virginia, and moved to Michigan as an infant. She has one living brother and a sister. Her other brother passed away as a toddler. When she was twenty, her family moved to Kentucky to be closer to their large extended family. She graduated from Pikeville College in Kentucky with a nursing degree and worked at ARH Hospital in the pediatric unit. Then she was hired to work at Home Care Health Services and has been there for about nineteen years. Vicki is photographed here with Mr. Smith, a home-health patient who suffers from black lung disease.

I am an RN and the patient care coordinator/quality assurance specialist at Home Care Health Services in Pikeville, Kentucky.

In this part of the world, you either go into coal mining or the medical field, which is one reason why the medical field is growing by leaps and bounds. Coal mining is a very dangerous living. Someone has to do it, of course, but with the older miners you see a lot of back injuries and black lung disease.

My current husband worked in the coal mines for nearly thirty years as a repairman. He took great pride in his work, but ended up with ruptured and herniated discs, so he suffers a lot of back pain. If my son wanted to work in the coal mines, I'd try and deter him because of the health risks.

Now I work in home health care. This is not just one type of nursing; you can run into almost anything. I have one-hundred-year-old patients and newborn babies. If someone has had major cardiac surgery and comes home, we help keep them stabilized so that they can heal completely and go on with their normal lives. Our goal is to help them stay out of the hospital. People want to be in their own homes, so when we succeed, it feels like an accomplishment.

We take a holistic approach and try to do a lot of education. You walk into the house and check to make sure that, for example, there are no rugs that can cause the patient to fall. Many times you have to improvise. I can't tell you how many times I've used a hanger on a curtain rod to hang an IV. We check for safety issues and, of course, offer a lot of information about medications and treatments. Some of these people live an hour away from a hospital or doctor, and they depend on us. I just want to be able to help.

It can be scary. I have had to park outside a patient's fence, so that their geese didn't attack me. There was a time when a patient's son was overly friendly with the nurses and actually ended up being arrested for that reason. But that seldom happens; it is almost always a positive experience.

I think I speak for the majority of nurses when I say that when you first start this kind of work, you want to fix everything. You may want to clean the house, but if you do, when you go back in a week, it looks just the same. I've been in homes where I had to keep moving my feet to stop the roaches from crawling up my leg. It's not for me to judge; I'm there to make sure the patient is safe and to do as much as I can. Eventually, you learn that you can't fix everything.

I've had several patients who have touched my life. I love the elderly patients. I've learned a lot from them, and they have amazing stories to tell. You can take care of patients in terms of medication and treatments, but you can also sit and talk to them, hear their stories. Sometimes that is as good for their mental health as any physical care you provide.

OLIVIA WASHINGTON

CENTRAL WYOMING COLLEGE, RIVERTON, WYOMING

I am a nursing student from Central Wyoming College, near the Wind River Indian Reservation. I graduated from college with an AA in psychology, and I am currently enrolled in the nursing program.

I grew up in a single-parent home on the reservation. We were very poor; there wasn't enough food for all of us. I thought it was normal to crawl into a dumpster to find food for dinner. Sometimes the electricity would be turned off and we had no heat. For the most part, everyone on the reservation had to struggle.

My mother is Native American; she's Northern Arapaho. My father is Mexican, but he moved to Reno when I was young. I have two brothers and one sister. My oldest brother was killed in a car accident when he was twenty. My grandmother, my mother's mother, lived with us and was like a second mom to me.

I went to a high school that was strictly BIA (Bureau of Indian Affairs), so it was all Native American. I only remember one or two non-natives. In school I tried to be invisible, but I was eager to learn and was always a straight-A student. My mother had dropped out of high school, so there was no one to help me with my homework. I sometimes spent hours on one math problem, figuring out how to solve it on my own.

I am the first person in my family to have graduated high school and college. I graduated with honors and was inducted into the Phi Theta Kappa honor society.

Growing up, we went to church every Sunday, and we attended powwows, which were like social gatherings where you dress in native regalia, sing songs, and dance. My grandmother would sew all the costumes. My siblings weren't so interested in the powwows, so it was kind of my own thing with my grandmother.

I remember my grandmother using a couple of medicine men. It was actually a little scary for me to watch. They would bite a chunk of birch wood or herbs and then take a drink of water. They would place their mouth wherever my grandmother was hurting, in an effort to pull the sickness out of her, and then they would spit into an empty carton. When I was younger, I thought they were going to cure her. But she was never cured, so my belief in that was shaken.

I was forced to grow up really fast. I was kind of the caregiver for all my cousins. I was seven years old when I started driving so that I could take the kids to church and my grandmother to her doctor appointments. Sometimes I felt like the Pied Piper—I was always surrounded by kids. I did all the cooking, cleaning, and laundry for them.

I felt like an old lady by the time I was eleven.

My grandmother was diagnosed with breast cancer when she was in her fifties, and the nearest radiology treatment center was in Casper. I would drive her and stay with her in a motel for weeks at a time. Growing up in that environment, I could see the help she was getting from the nurses and the kind of difference a nurse could make. It sparked my interest. She's the reason I am in nursing school.

I had to quit high school for a year to take care of my grandmother. She died on Mother's Day 1995. The school let me double up on my classes so that I could graduate with my class.

When I finish nursing school, I'd like to be a traveling nurse for a while and then possibly practice on the reservation. I think there definitely needs to be better access to health care here, especially for preventative measures.

Olivia Washington is in her second year of nursing school at Central Wyoming College and plans on graduating with an AAS in nursing in the fall of 2013. She grew up on the Wind River Reservation and has worked with the Wind River Police Department as a dispatcher and payroll clerk, with the probate clerk at the Wind River Agency, and as a case manager for the Arapaho Department of Social Services. She is currently a certified nursing assistant and hopes to one day complete her certification to work in radiology.

HERSHAW DAVIS JR.

THE JOHNS HOPKINS HOSPITAL, BALTIMORE, MARYLAND

Hershaw Davis Jr., MSN, RN, was born and raised in Baltimore; he is an only child. He received his bachelor's degree in biology, with a minor in chemistry, from Oakwood University; his bachelor of nursing from the University of Maryland at Baltimore; and his master of science in nursing, with a concentration in health systems, from the University of Virginia in the summer of 2012. He was inspired to become a nurse because of nursing's holistic approach to healing.

I am an emergency-department nurse at Johns Hopkins. This is a second career for me. I was previously in the military, serving in the warfare capacity. I came to Johns Hopkins in my last year of nursing school.

I'm from Baltimore, and a lot of our victims of violence are African Americans like myself. This is primarily the community that we serve, so when they come in, it's kind of like looking at my little brother or cousin.

When I was in training, we had a drug dealer who died from an act of violence, and I had to bring his mother and girlfriend in to see the body. The charge nurse at the time took me aside and said, "I want you there so that you can see and always remember that, despite what he did with his life, he was someone's child or brother or father. That is what you need to remember when you are dealing with a patient." That struck me right in the heart and let me know that, despite the circumstances, the patient is still a person who deserves our best attention.

Working in the ER is like being a detective. Humanity is never predictable, and some of the stories we hear, well, you just can't make up this stuff. People come in with symptoms, and it's our job to figure out what's going on. In many instances, we are the primary care in our communities.

The unique thing about this work is that we deal with both adult and pediatric trauma. It takes a strong constitution because it's not all glamorous. We see victims of car accidents, gunshots, stabbings, abuse, and assault. Our job is to navigate the patient and their family through these tragedies.

The other night, it was kind of quiet when a gentleman came in with a gunshot wound; he was a victim of random violence. We did everything we could, but he died, and that is always difficult to witness. It makes you realize that life is fleeting—and it touches you. As a health-care professional, it keeps you humble. No matter how far our science has advanced, we don't have control over life. We want to save everyone, but we just can't.

I remember the first time I saw the trauma team crack a chest: I could see all the organs and the heart was beating. The patient had been stabbed in the heart, so with every heartbeat, blood spurted out of his chest. It was rough, but somehow I got through it.

Not everyone can do emergency nursing; it takes a dedicated group with a certain sense of humor and balance. Some days you go from tragic to happy in the span of a few moments. How do you leave someone who just passed away to go tell another person that the tests are negative? You have to find a way to center yourself and truly understand why you are here—for service.

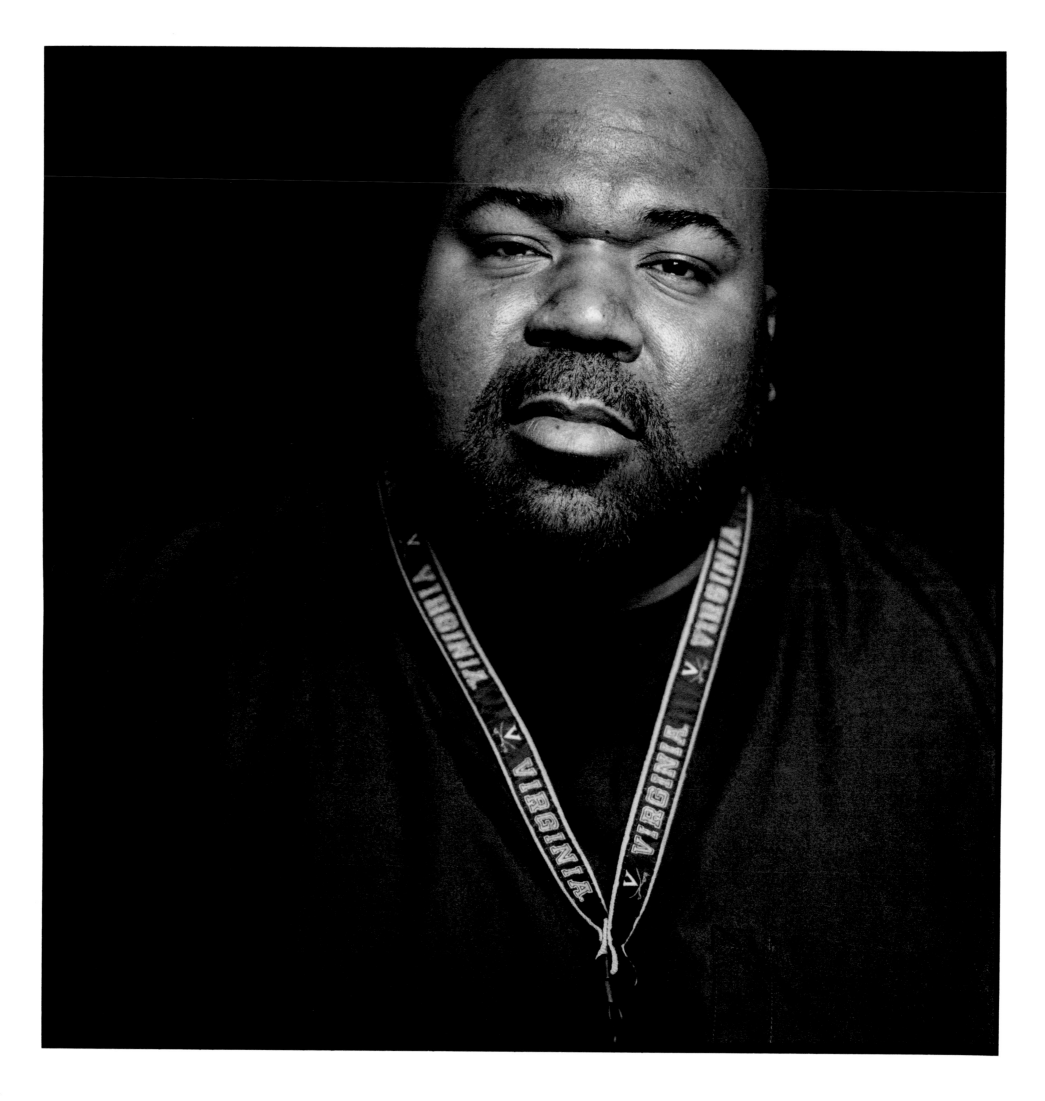

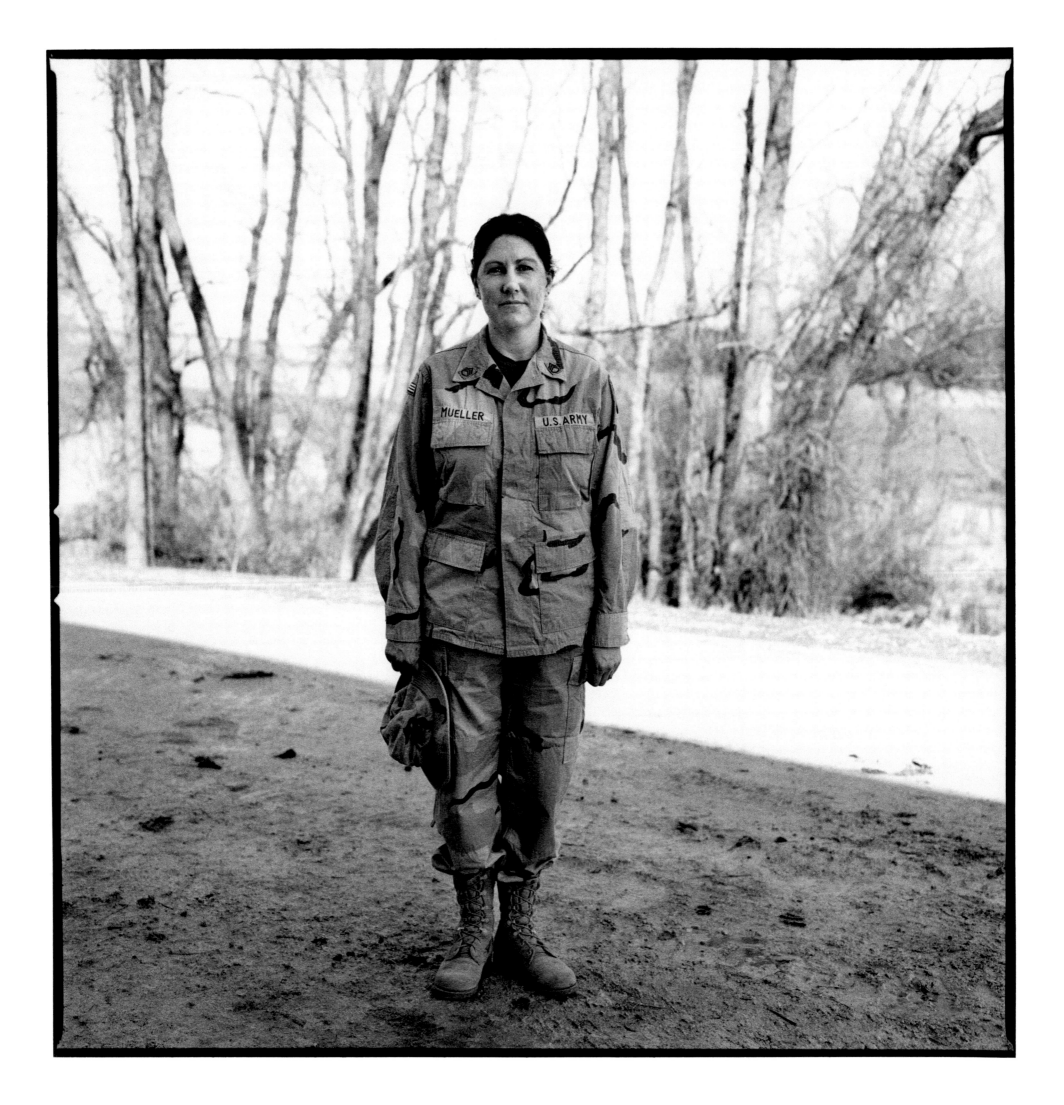

SHANNON MUELLER

AURORA HEALTH CENTER, FOND DU LAC, WISCONSIN

I am an RN and I currently work for Aurora Health Care.

I fell into nursing backward. I am not one of those people who always wanted to be a nurse. My first job out of high school was with the Army Reserves. I then worked as a CNA while I went to school for criminal justice. After I received my associate's degree, I worked in a jail.

Because I was in a medical unit, I knew the Army was looking for nurses, so I did a civilian contract and went to the local tech school. When we got mobilized, I was stationed at Fort McCoy for training.

I spent seven months in Afghanistan as an LPN on what we call an ICW (intermediate care ward). One thing that is different in the military is triage. In the civilian world, you treat the most critical patients first. In the military, we provide the most effective care that will save the most lives and return the most soldiers back to duty. We avoid expending excessive resources on patients with little chance of survival. We treat the patients who can be easily treated, get them back to duty, and then focus on those who require more care.

The triage team assigns colored tags to each patient according to their injury level. We treat the "immediate" (red-tagged) patients first and get them stable or evacuated out. Then we move to the "delayed" (yellow) patients. "Minimal" or "walking wounded" (green) patients are treated next. The last category is "dead" (black). This may seem cold or harsh, but there is logic behind this during wartime. It is a flip-flop of a mindset and very hard for some people to grasp.

I was stationed at Bagram, and we provided the highest level of care in the country at the time. We only saw critical patients—life, limb, and eyesight were the categories. Anything else, the patient would go to another facility or treatment center. We saw mainly burns, gunshot wounds, and amputations.

The country is still riddled with land mines, which can go off at any time. Many of the patients had been in their backyards when the land mines exploded. You really take your chances just walking in that country.

At Bagram, we had fifteen beds on one floor, and two were set up for either Americans or the coalition forces; the rest were for local nationals. We mostly treated the locals. There were a lot of burn victims. The people live in one-room dwellings, and at night they build a fire in the middle of the room. Many times, the babies roll into the fires. We also saw a lot of children who'd been shot or injured by a land mine. We'd give them shoes, clothes, or shampoo, and they were so grateful. It does make you appreciate what you have.

While I was stationed at Bagram, there was an accident. Many soldiers had died, and they were brought to the hospital to be evacuated. We had a second ward that we had been using to store clothes and extra equipment. After the accident, cots were set up in there, and the flaps were closed so people wouldn't pass through. But every once in a while, somebody would need to go in, and that curtain would be pulled back. I remember looking in and seeing American flags hanging over two rows of cots. If you watch any TV at all, you know what a body looks like with a sheet draped over it. These weren't bodies; they were body parts. They were just flat American flags. That was very hard to see. I will never forget that image.

I think we are doing a lot of good in Afghanistan. We are building schools, roads, and bridges, digging for clean water, educating people, and giving them health care. We drove from Kabul to Kandahar, going into local villages and setting up treatment centers for urgent care. We treated the people and brought along a vet to look at the animals. But you don't hear about that as much as the bad stuff that's happening.

Shannon Mueller, RN, was born and raised with her three siblings in Fond du Lac, Wisconsin. Her first career was in criminal justice; she worked as a corrections officer for many years before training to be a nurse. She started nursing in 2001 and, at some point, hopes to combine the two careers and become a forensic nurse. In the opposite photograph, Shannon wears her BDU (battle dress uniform).

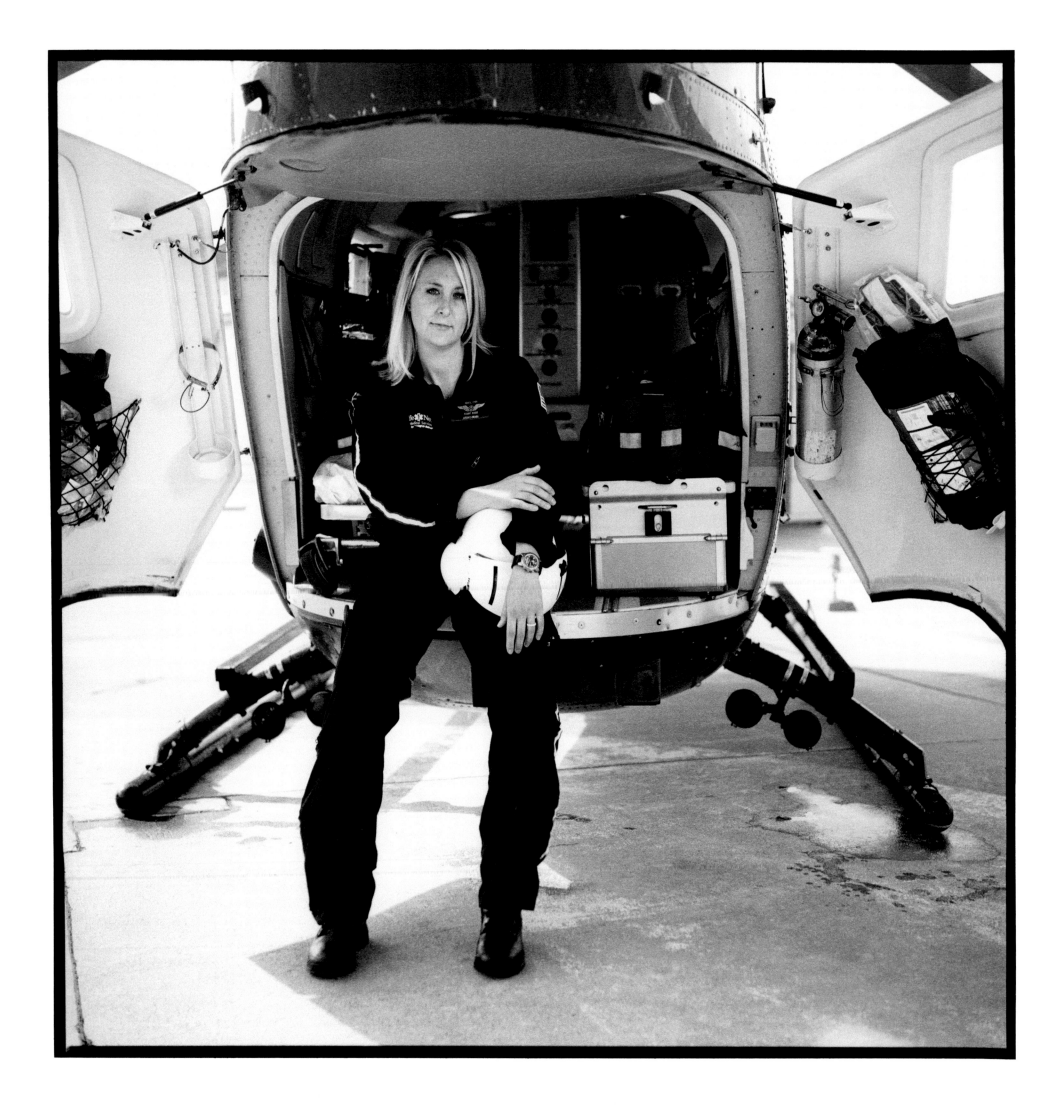

VENUS ANDERSON

NEBRASKA MEDICAL CENTER / LIFENET IN THE HEARTLAND, OMAHA, NEBRASKA

I am a life-flight nurse at the Nebraska Medical Center in Omaha, and I also work in the pediatric ICU.

I got into flight nursing when I was still in nursing school. At first, I was going to do ER nursing, but in my junior year of college, my sister was in a car accident. At the scene, they couldn't feel a pulse so they called in a helicopter team to fly her to the trauma center, and that saved her life. She is doing well today and has a beautiful little boy. But it was in that moment I realized that a flight team can change someone's life—and that's what I wanted to do.

It's been an amazing journey, even though I've had a lot of heartbreaking stories. One time we got called to a house where the kids were having a prom party. They had been playing around in the basement, just having fun, when someone found a gun in the couch. One of the kids pointed the gun and accidentally shot his best friend in the face. It was two o'clock in the morning when we got there. We worked really hard on the kid, but he died in flight. There are a lot of tragic stories of patients who did not survive, but it's harder when it's a kid.

Mortality rates are extremely high when you are involved in trauma. We had one success story with a farmer who was out in the field. His dad was driving the tractor, and not knowing his son was standing behind him, he backed up the tractor and ran over him. The gentleman was run over by both wheels. He was in his forties. His face was crushed; his collarbones and all his ribs were broken. He was in bad shape, and his father was in pieces. I can't even imagine how it must feel to hurt your child like that. I was fairly certain he wouldn't survive, but my partner and I started our protocols. We put chest tubes in, drained the blood from his chest, expanded his lungs. He made it, but he has a long recovery ahead. He's in a lot of pain and has to wear a back brace. Two weeks after the accident, I went to a benefit spaghetti dinner to raise money for him.

My father was in a motorcycle accident four years ago. He lived in rural Iowa, and he was very badly injured. Another flight team went out to get him, but he didn't survive and that shook my whole foundation. When I came back to work, everything seemed more personal to me. I think that is why I was so affected by the guy who got run over by the tractor, because he had the same injuries as my dad.

I was bitter about my dad for a long time. I felt like I would've known what to do if he was with me. I had a lot of guilt, but then I used those feelings to change the way I do things. I used to not want to know the name of the patient or make it personal in any way when we picked someone up in the helicopter. I thought it made it easier to pick them up and then drop them off if I didn't make any emotional connection. But after my dad died, I started making it a point to talk to the families before we took off. I take two minutes to say, "My name is Venus, and I am going to be flying your loved one to Omaha. Can I get your phone number? When we get there, I'll call and let you know how it went." I make sure they come into the helicopter to give their loved one a kiss good-bye or say whatever they want to say to him or her. This is something I never did before my dad died. I just didn't take the time.

This is a little piece of transport nursing that I think gets missed, because we're all about getting there and moving fast. It's very important not to waste time. But with my dad, I realized that one thing that killed me was not knowing what was going on with him during the process. I don't think of this gesture as a waste of time anymore.

Venus Anderson, BSN, CFRN, was born in Spencer, Iowa, and has one sister. She graduated from the University of South Dakota, where she started as a biochemistry major before switching to nursing school. She worked in an adult ICU in Lincoln, Nebraska, from 1998 to 2001. Since then, she has been part of a select group of about five thousand flight nurses currently working in the United States. She also works in the pediatric ICU at Children's Hospital in Omaha.

COLLEEN LEMOINE

INTERIM LSU PUBLIC HOSPITAL, NEW ORLEANS, LOUISIANA

Colleen Lemoine, APRN, MN, AOCN, RN-BC, is a cradle New Orleanian, born and bred. Her dad was a federal judge, and her mother became a nurse when Colleen was in high school. All five kids in her family went into medicine. Colleen's progression through jobs was like a tutorial in alternate ways of dying. At first, she worked on a general medical oncology unit, and then she moved to the bone-marrow-transplant unit, with more acute patients, and to hospice. She has been an oncology nurse for twenty-five years and finds nothing more beautiful than her patients when they go bald from chemotherapy. This is when, she says, you get to see the essence of who they truly are. Colleen is photographed with patient Kimberly Smith.

I am a clinical nurse specialist in oncology at what is now called Interim LSU Public Hospital.

I didn't know what I wanted to be when I was growing up. I was pretty good at science, and I knew I wanted a job that would allow me to be mobile and give me security. So when my mom went to nursing school, I thought, well, I could do that too. It was almost by chance that I landed in oncology. My grandfather had just died from lymphoma—and there I was. Working in oncology either fits you or it doesn't. It's hard work, and if it's not in your soul and heart, it's much too hard to keep doing it.

When I talk to my patients about end of life, I talk in terms of "energy dollars." Every day that you wake up with a terminal, progressive illness, your disease allots you a certain amount of energy dollars. You don't have control over how many dollars you get, just how you'll spend them.

Everything you do costs energy dollars. Breathing costs. Circulating blood costs. These are not optional expenses. When you've used up all your energy dollars, all you can do is sleep. When you wake up, you'll have a new allotment of energy dollars. I remember one young mother with cancer who was very independent. She wanted to do all that she could for herself. She wanted to use the bathroom twenty feet up the hall rather than a bedside commode. I said, "Okay but that will cost you $2.50 in energy dollars. Using the bedside commode will cost, maybe, fifty cents." She liked to watch TV with her daughter in the afternoon after school, but she'd often sleep through their time together because she had spent so many of her energy dollars getting up and down to the bathroom. Soon she decided to swap her trips to the bathroom for the commode, and reclaimed her precious time with her daughter .

There was one patient, early in my career, who helped shape how I feel about dealing with death. I hold her in my heart and love her like family. I was working on the leukemia unit, and Miss Evie was dying in an isolation room. She had two daughters who loved her dearly and wanted to be in the room with her. We sat with her, held her hand, rubbed lotion on her, and talked. I told her, "Miss Evie, you've been a wonderful mother to your daughters. They are going to carry on what's special about you as they mother their children. So whenever you feel like going, we are all okay. I am going to take care of your daughters, and if you want to go, it's safe."

Within thirty minutes she turned her head and was gone. Her daughter asked what we should do. I said, "Would you like to bathe her with me?" And so the three of us made Miss Evie look beautiful. Awhile later, the daughters sent me a note, along with a powder box, thanking me. That experience is something I take with me always. It was just one of those powerful experiences, when you feel that you are doing what you are supposed to be doing. Having learned these things early in my career was a sacred blessing.

I was on the hospital's emergency-preparedness committee when Hurricane Katrina came. We knew it was out there, but we expected it to turn north and miss us. When it didn't turn, we had only twenty-four hours to prepare. I got the car packed with food and clothes, and sent my husband and kids east toward Mississippi, where we have family. I was confident they were safe and reported to the hospital Sunday morning. We tried to discharge patients to minimize the number of people in the facility, but there wasn't a lot of time for their family members to come get them. Katrina hit Monday morning, and by Tuesday morning the water was just coming up, up, up. The hospital is relatively far from Lake Pontchartrain and close to the river, and although it took a while for it to get to us, the water came and the hospital was like an island.

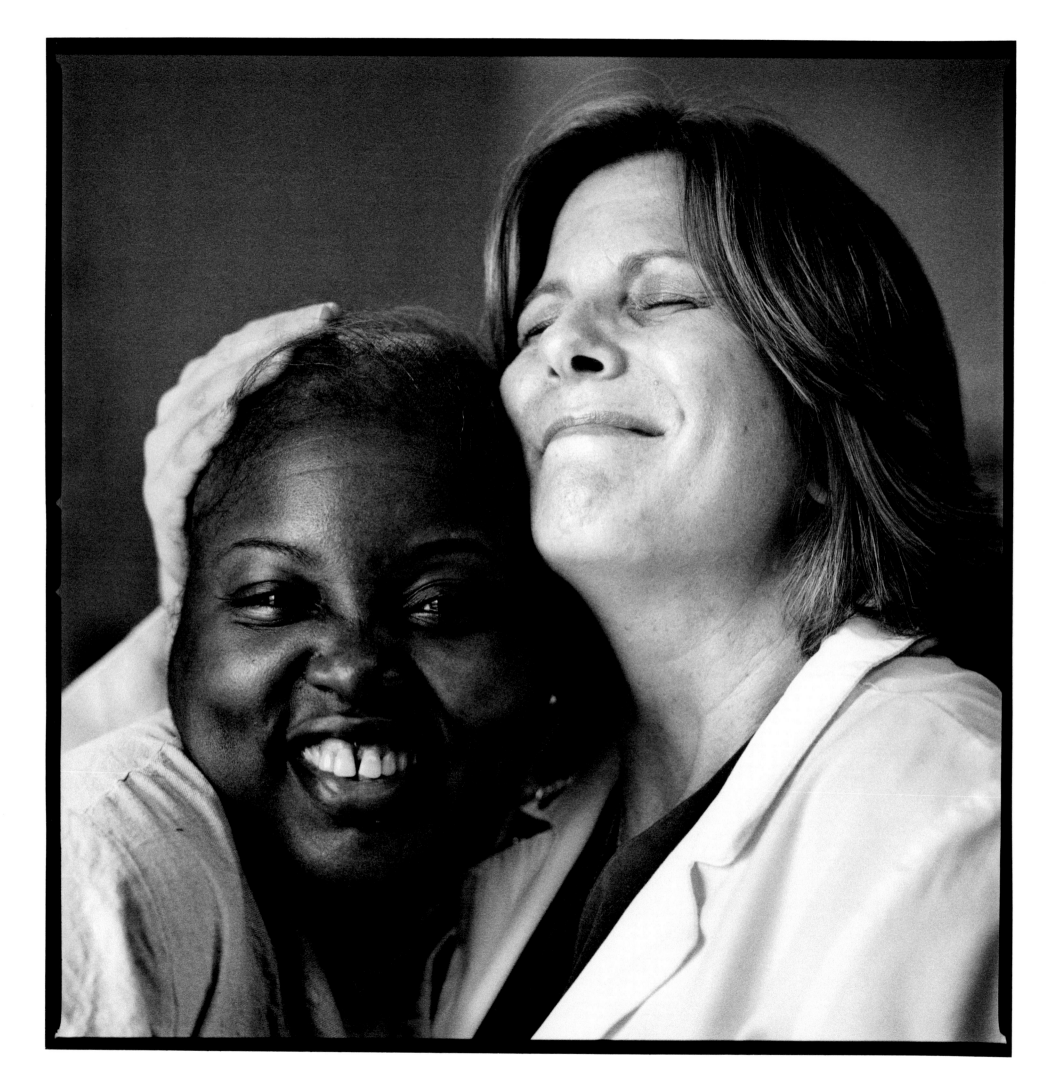

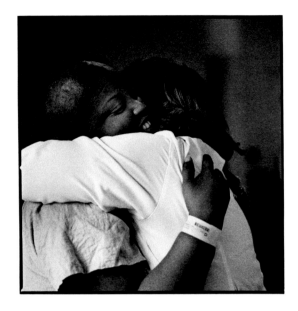

I was never afraid for my own safety, but there were a lot of unknowns. How long would we be here? Who was coming to help? When would they get here? We tried to have good communication throughout the hospital, but things changed quickly. They brought trucks to evacuate patients, but couldn't get them down the streets because of the water. So the first people who came to evacuate us were from the Wildlife and Fishery departments, and they came in boats.

The first people we evacuated were from the ICU. The elevators were not working, so they had to be carried down the stairs on body boards. It was very hard to navigate. We had to care for patients who needed dialysis and babies in the NICU.

I can't even describe the heat. I'm from here, so I'm accustomed to heat, but there was no air moving at all. No vents, AC, or fans—nothing. We broke the windows just to get some air circulating, but it was still incredibly stifling. And then there was the darkness. We only had four generators, and if you were in an internal corridor, you didn't know if it was day or night. At night it was so dark that you couldn't see your hand in front of your face. We had food, but we didn't want to eat because it was so hot.

When we finally got out, we evacuated some people from the roof on the eighth floor, and more people went out in boats from the first floor. You could hear helicopters constantly. I went from door to door throughout the hospital looking for people to make sure no one got left behind. By Friday everyone was out. It turned out we did really well, which was just the hand of God. There was cohesiveness and camaraderie, a brotherhood of people. It didn't matter if you were a CEO or a housekeeper—everyone pitched in.

When I got home, my house was four feet below water and pretty much everything was ruined, but we were blessed. We had insurance and a place to stay with my stepmother. My children went to Texas to live with my sister until their school reopened. We got back into our own house eighteen months later. You drive around today and see the remains of houses of people who were far less fortunate. We can't ever get back to normal, but it seems like now we're getting to a "new" normal. Katrina changed everything, but not in ways I could have imagined.

Because I am an oncology nurse, I'm privileged to be with people at times when they are their most authentic. They don't really care what kind of car they drive or whether they have the right shoes or purse. All of that is gone, and people are really genuine. It's a very sacred time. I think one of the things nurses are really good at is being present and sharing their life at that moment in time.

I know a lot of people think what I do is depressing, but it is really an absolute gift. You connect with people in such a powerful, intimate way, and I really had that appreciation for life before Katrina happened.

Ironically, one of the few things in my house that survived Katrina was the powder box Miss Evie's daughters sent me after she passed so long ago.

RHONDA WYSKIEL

THE JOHNS HOPKINS HOSPITAL, BALTIMORE, MARYLAND

I work in the Weinberg intensive care unit at Johns Hopkins. First and foremost, I am a bedside nurse. I am also a safety clinician on my unit and a senior research coordinator with the Armstrong Institute for Patient Safety and Quality.

In sixth grade, we had to pick a job for Career Day, and because my aunt Sharon was a nurse, I picked nursing. In high school, I thought I wanted to go into marketing and wear a business suit every day, so I took some courses at a community college. I soon realized that was not what I was supposed to be doing. My best friend suggested we go to nursing school, so I moved to Baltimore and enrolled in the Towson University Nursing Program.

From the minute I stepped through the door, I realized this was where I belonged. I graduated from Towson and began working at Johns Hopkins in 1997. I got a job in the ICU, but the building wasn't yet ready to be occupied. I worked in the neuro critical-care unit, then the surgical-care unit, and so forth until the Weinberg ICU opened. In retrospect, it was great because I got to experience a lot of different places and cultures of nursing care. I realized the ICU was the right place for me, and I have been here for the past fifteen years.

I approach each day as an opportunity to save someone's life, which is like my mantra, and kind of a joke, on the unit. Someone will say, "Rhonda, what are you doing today?" My response is always, "Saving lives, one at a time." I say it in a joking way, but everyone knows I'm very serious. My feeling is that if I can make a difference for a patient in a positive way to mitigate harm for them, then I've contributed something to saving a life.

A few years ago we had a nurse who accidentally hung a bag of a powerful vasopressor, which is for patients with critical hypotension, instead of the prescribed antibiotic. The patient had a huge spike in his blood pressure, and the complications were catastrophic. The nurse was a disaster after that and thought about quitting. We spent time trying to figure out how this had happened, and then quickly moved to prevent it from reoccurring. It turned out that the labels on both medications were very similar. We learned from this error and created "Donna's Law" on our unit. First, we put orange labels on all the vasopressor bags to distinguish them from the antibiotics; and second, we actualize the five rights of medication administration, and the nurse needs to check these before hanging the bag. The five rights are taught in Nursing 101, but are loosely enforced out of school. By implementing this intervention we have dramatically lowered our medication-infusion error rate.

In addition, I am currently working with a National Project Team that is focused on implementing CUSP (Comprehensive Unit-based Safety Program), which I helped develop eleven years ago.

Rhonda Wyskiel, BSN, RN, NCIII, grew up in Cambridge, Maryland, with her parents, an older brother, and a large extended family of grandparents, aunts, uncles, and cousins living nearby. She has been a nurse at Johns Hopkins for fifteen years. In addition to bedside nursing, she is passionate about patient safety and family-centered care, and is involved in several health and safety related programs, focusing on the prevention of hospital-acquired infections.

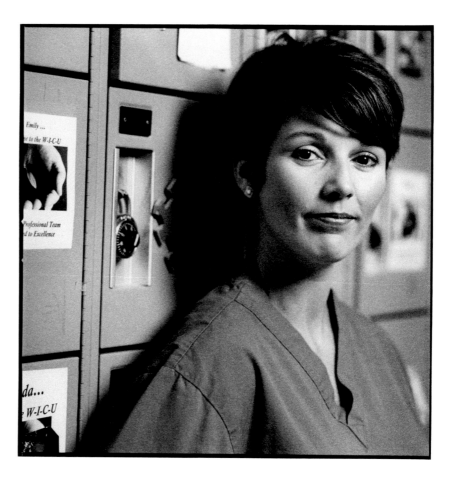

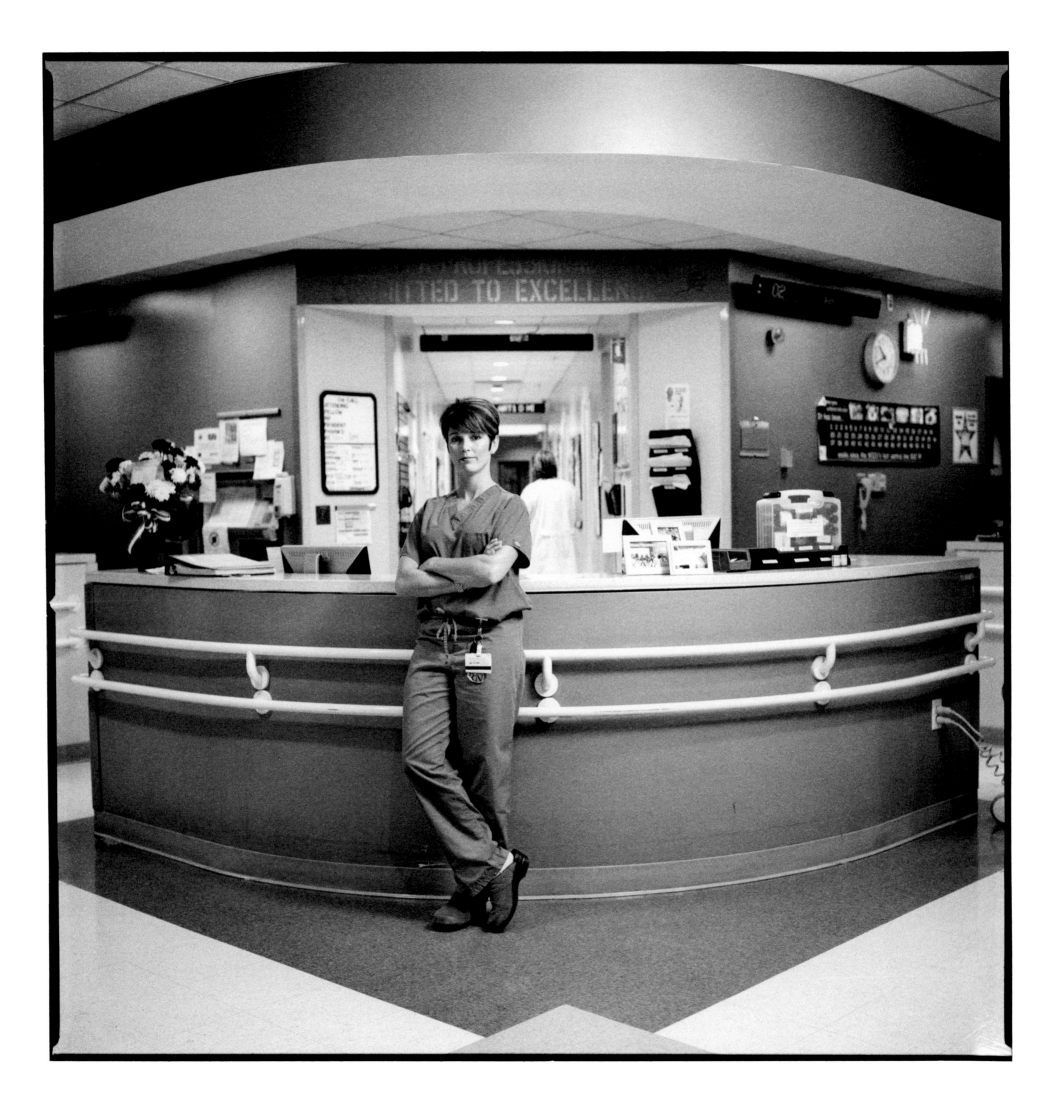

We have gone to each state in the nation implementing the program and helping to reduce catheter-related bloodstream infections. I am involved in various other projects, many focused on reducing hospital-acquired infections.

Patient safety and family involvement is a passion of mine. When I was younger, my mother was sick and spent a lot of time in the hospital, even here at Johns Hopkins. I remember when she came out of the operating room and into the ICU, and I was only allowed to see her for fifteen minutes at a time, once an hour. I was told not to touch or talk to her and to be careful around her. All I really wanted to do was crawl into bed with her. I was a very young nurse at the time, and that experience inspired me to shape my interactions with patients and families. I want to break down those barriers that we impose on the families.

Today, I am involved in innovating ways for families to engage in some of the care of their loved one. The bottom line is that the family knows the patient far better than we ever will, no matter how many hours we spend in the patient's room.

Early on I noticed that the families of the patients would sit in a corner with their newspapers and would seem anxious. I could tell they wanted to help, and some would even ask if they could. So I decided to invite them to help and began to build the family-involvement menu, a list of things the family could do with us or we could teach them—helping with ambulation, combing hair, oral care, that kind of thing. If they wanted to crawl into bed with the patient, I would make that happen too. Both the families and the patients loved it, and it has made a big difference.

This job gives me such a sense of accomplishment and reward, knowing I have the ability to affect someone's life in a way that many never get to do. I recently had a patient who really touched me; she was my age, forty, and had young kids. She was diagnosed with a devastating form of cancer, and her surgery was palliative, not curative. I spent twelve hours with her, giving her some tough love to get her out of bed. She needed and wanted to get better so she could go home to her children. I went to see her the other day because I needed to know she was okay. The doctors asked me what I'd done with her because she was a different person after she had left my floor. She was up and walking by herself and telling everyone she wanted to go home. I thought, *this* is why I do this job—because I can make a difference.

But there was another piece to it. I was doing all that because that is what I'd want someone to do for me. One day I will be the patient in the bed, and I hope that I have a nurse with the same kind of compassion that I give to my patients.

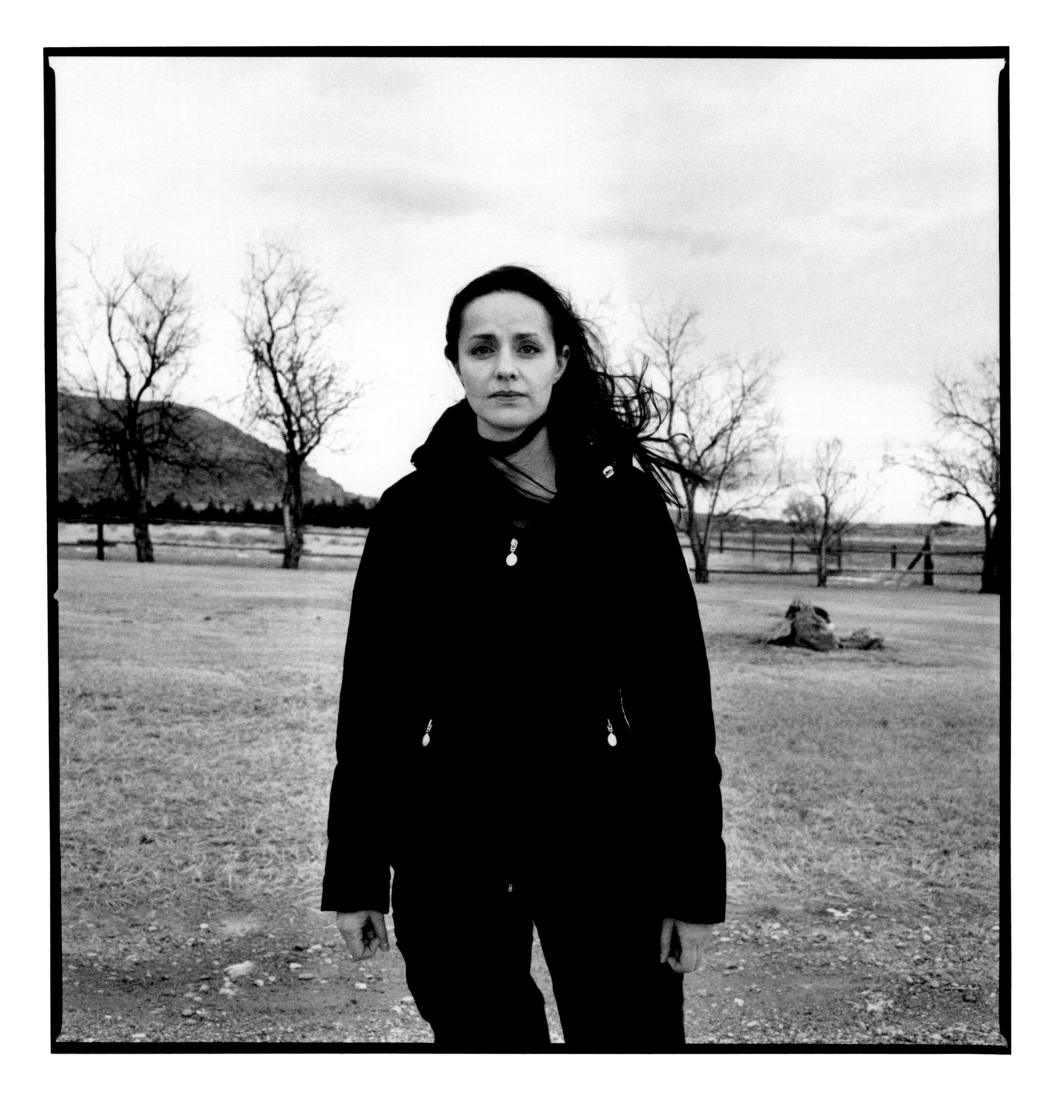

KATY HANSON

HELP FOR HEALTH HOSPICE, RIVERTON, WYOMING

I am a registered nurse and work for the Help for Health Hospice in Riverton. I do outpatient nursing, and I fill in at the inpatient facility, which has eight beds.

Wyoming is the least-populated state in the nation. I think there are half a million people here. The Wind River Indian Reservation is right in the middle of Fremont County. There are between ten and fifteen thousand people on the reservation. Some days I do 250 miles just getting out there and back.

I went to the University of Nevada in Reno on an advertising scholarship and was geared toward marketing or maybe journalism. However, my social life was more active than my academic one, so my parents moved me back home. At the University of Wyoming, I got a liberal-arts degree without doing very much. I couldn't afford grad school, so I applied to the nursing program. It wasn't a calling for me; it just kind of happened.

I've been a nurse for three years and really enjoy spending time with patients, though I didn't like working in a hospital. I was on the surgical floor, and after my shift ended I'd still be there for hours. And then something happened that ended my career in a hospital.

I was a new nurse with seven patients in my care. I had this sixty-year-old woman who I thought was a really easy keeper. She'd been kind of restless, but I assumed she was asleep and never went into her room. I was in another room when they called a "code blue." She had a fracture, and now I know that she probably had a blood clot in her lung, which is pretty common with a broken hip. If I had recognized her symptoms, we might've been able to give her some medication. I don't know. It happened so fast.

I had to call her husband at the hotel; they were in Wyoming on vacation. Seeing his face when he came in that night was awful and really tore me up. I don't even remember the rest of the night.

I felt like I wasn't doing the best job I could there, so when a full-time position opened up at the hospice, I went into hospice nursing. My patient load is lighter, and I get to be more intimate and spend time with the patients and their families. Everyone there is expected to die, so it makes it somewhat easier.

Medicare guidelines say the patient has to be diagnosed with a disease that terminates in six months. Some of our patients have been on service for eighteen months; others expire in only hours. It depends on the circumstances.

The hardest part of my job is not when people die, though that can be sad. The worst thing about hospice is that people don't die quickly enough. It's not like you see on TV. You don't just take a breath and go to sleep. It's a struggle, like when you are born. People will be making that awful death rattle, that gasping for breath, for a week sometimes. I'm not very religious, but sometimes I just pray for God to take the person.

The family will ask if we can give the patient something to end their misery. Of course, we don't do that.

My first supervisor taught me something really valuable: she said that people die the same way they lived. People don't change because they are dying. If they've been an ornery, unforgiving person, that is how they go. Mostly people just are who they are.

When people are dying, absolutely the most important thing is their family. I mean, the family may still be fighting over money or whatever, but the patient just wants to be with the people he or she loves. This has been a good life lesson for me. It strips away all the things that are not essential.

Katy Hanson, RN, BA, was born and raised in Riverton, Wyoming, with her brother and sister. She has a BA in humanities and fine arts from the University of Wyoming and an associate's degree in nursing from Central Wyoming College. She has been a nurse for three years, starting at the Riverton Memorial Hospital. In October 2009, she switched into hospice care with a full-time position at Help for Health Hospice, where she is the clinical director.

ALLISYN PLETCH

THE JOHNS HOPKINS HOSPITAL, BALTIMORE, MARYLAND

Allisyn Pletch, MS, RN, NCIII, was born and raised in Kingston, New York, the middle child of three. She attended Virginia Commonwealth University where she earned two bachelor's degrees, one in psychology and another in nursing, and a master's degree in psychiatric nursing. She worked at the Medical College of Virginia in the Department of Pediatrics while going for her master's. In January 2000, she started working at Johns Hopkins as a nurse clinician and was made an NCIII in 2005 and a clinical coordinator of the Eating Disorder Program in 2010. She has been a nurse for fourteen years.

I am a clinical nurse and am responsible from a nursing perspective for the Eating Disorders Program at Johns Hopkins.

I became a nurse because I've always been intrigued by health care and wanted to help people. Growing up, I thought about being a teacher, then a lawyer, but then I became fascinated with eating disorders. I learned about them in a health class in high school and then saw an after-school special. I just found it fascinating and decided to be a nurse, because then I could work with and take care of people and help make them healthy.

In our clinic at Hopkins, we treat people of all ages. I think our youngest was eleven, and the oldest was a seventy-five-year-old woman who had been sick since her twenties, but had moved on with her life. After her husband died, her children insisted she come for treatment.

There are studies that indicate that eating disorders have existed since the Age of Christ. Back then, it wasn't anorexia; they were trying to get closer to God. Anorexia came to be named in the 1800s. There are vivid descriptions from that time of people starving themselves for no other reason than to lose weight.

In the 1970s it was thought that the parents were to blame for eating disorders. Back then it was the "absentee father and overbearing mother" who were at fault. Now it has shifted. There is some research that indicates there is a genetic component to the disease—that some people are predisposed to it like they are to alcoholism or any other kind of disease. Some of us can go on a diet and be fine; others will develop an eating disorder. There is huge debate as to whether you can be cured. I think you can learn to live with an eating disorder, but it always lies dormant. In times of stress, it's harder to control.

Eating disorders have the highest mortality rate of any psychiatric illness. At Hopkins we treat the sickest of the sick. Many of our patients have been to other treatment centers or tried outpatient clinics. We take patients who are medically compromised. Some have a BMI (body-mass index) of 11 or 12 whereas a normal person's BMI is 20. So these patients weigh half what they should, and that means they have a myriad of medical complications.

After we address the complications, we feed them and teach them how to eat again. Often these patients haven't eaten a normal-sized meal in years; they don't even understand what a normal meal is. They've lost the concept of what it feels like to be full or even what hunger feels like. Either they're eating all day long or not eating at all. We have to give them proper nutrition before we deal with the psychological issues.

Obesity is a huge problem in our society. Our food portions are all supersized, and nutritious food is expensive. There is also that cliché, "Fat is not a feeling." But to our patients fat seems to represent *everything*. If they are feeling sad, they are feeling fat. If they are feeling embarrassed or frustrated, they are feeling fat. They have to learn how to communicate that they're having an uncomfortable feeling.

When I started working, I thought nurses would be more fit, but I'm surprised to find otherwise. I read a study that says because we work shifts we distort our normal rhythms of when, what, and how we eat. I find myself having no time to sit down for lunch, so I graze. Working the night shift makes it even harder. Also, you are so exhausted at the end of a shift that it's hard to get to the gym.

No two of my days are ever the same. I spend a good portion of every day talking to the patients. One of the biggest lessons I've learned is never to assume that I know what they are telling me. I have to let the patient show me how I can help. This has taught me to be humble and not to think that I know right off how to treat someone just because I've done this for a long time. I am constantly learning.

JOAN O'BRIEN

MONTEFIORE MEDICAL CENTER, BRONX, NEW YORK

I am director of nursing for the Wakefield Campus at Montefiore, the university hospital for the Albert Einstein College of Medicine in New York. I've been a nurse for thirty-two years, about twenty-five of them here.

When I became a nurse, my very first patient had KS—Kaposi's Sarcoma—which I couldn't even pronounce at the time. I didn't know what it was, and I was afraid. At the time, we were just learning about GRID, which stands for Gay-Related Immune Deficiency.

At Montefiore I learned that it wasn't just GRID. It was more than that. It was about people—women, children, the elderly, and substance abusers—who were all coming down with this disease that we didn't have control over. We began to understand a little bit by looking at oncology. In the beginning, no one wanted to take care of cancer patients. We thought, if I touch the patient, I'm going to catch cancer. The same thing was happening with AIDS. People thought that if they touched an AIDS patient, they'd catch AIDS. We would wear gowns, gloves, masks—everything—to go in to take care of this patient. I was really afraid. I didn't know anything about the disease itself.

I will never forget my first GRID patient. He taught me that it didn't matter who the patient was or what they had. If I could give him the care he needed and be compassionate and understanding, then I could be any kind of nurse I wanted to be.

I am Irish Catholic, and I am also an Extraordinary Eucharistic Minister at Montefiore. I see Christ in everyone. It doesn't matter who they are or their religion. In my eyes, that person is number one.

What I've learned is that when people come into the hospital, they are here to find out what is wrong. If you keep things from them, they're more apt to be afraid, get angry, and not trust you. They want answers—good, bad, or indifferent. When they get an answer, they are relieved because then, whatever they are feeling, they can talk about it.

There's another part of nursing that people talk about—the sixth sense. It really exists. The patient may be here for one thing, but if something else is just not right, a good nurse can sense that. For example, I had a patient, a man named Louis, who was in his early twenties and came here for chemotherapy. One day after his treatment, I walked into his room and something was just not right. He couldn't stay focused. I didn't know what was going on, so I called the oncologist, and he came right down. It turned out that Louis was in the early stages of sepsis, and we were able to treat him very quickly. His disorientation was a symptom.

I believe tremendously in going by your gut feelings. The really good nurse has a sense of what is not working: even if you can't explain it, you have to get someone in to see the patient.

My role is to maintain the standards for the practice of nursing as defined by the American Nurses Association Code of Ethics, Nursing: Scope and Standards of Practice, and Nursing's Social Policy Statement. I am also responsible for ensuring that quality, compassionate, culturally competent, effective, and efficient patient care is delivered in compliance with the standards and regulations of the Montefiore Medical Center and regulatory agencies.

I enjoy what I do. Having the ability to meet and have a relationship with patients is a privilege. It is a privilege to always be learning from others. I like to stay quiet and watch, listen, and learn.

Joan O'Brien, MSN, RN, NE-BC, was born in New York City and raised in the Bronx, the third oldest of ten children— five girls and five boys, all single births. She has an older brother and sister who have epilepsy, as well as a sister who is handicapped, so from a young age, she had the opportunity to help people. She graduated from Hunter-Bellevue School of Nursing, where she earned both her BSN and MSN. She joined Montefiore twenty-five years ago and has held many different positions in the thirty-two years that she has been a nurse.

JUDY RAMSAY

THE WINDY CITY ROLLERS, CHICAGO, ILLINOIS

I have been a nurse for forty-nine years. Since 2001, I've been a staff nurse at North Arlington Pediatrics. I volunteered with the American Red Cross and the American Heart Association and do so now with the Windy City Rollers.

I am married to a pediatrician, and except for about ten years when I was raising my children, I've always worked full-time in pediatrics. I worked in the ICU at Children's Memorial Hospital and, after that, in a long-term care facility for children with developmental disabilities.

I can still remember patients from the beginning of my career. At Children's, I took care of a little red-haired boy with brown eyes—the cutest little guy in the world. He had a desperate time with heart problems, but was a pleasure to care for. He taught me never to promise anything to a child that I could not deliver. He is now in his late forties, maybe early fifties. I last heard from him about forty years ago. I wonder if he still has red hair.

Pediatric nursing can be very difficult. For twelve years I took care of children who would never get better. Most of them would only live for ten years. People ask how I could do it, but it was the most fulfilling job of my life. We couldn't cure these kids, but we could give them a better hour, or even a better minute, of life. All we wanted to do was make their day a little brighter. Every minute that I was there, I had the joy of seeing children who had no lives be a little bit happier. I only stopped doing that work because the school closed due to lack of funding.

I think you have to do difficult things in life because it makes you grow, and once you get through those difficult things, you can go on to the next thing.

All I can tell you is that some people go into pediatrics because they really want a one-to-one connection. You have to accept children for who and what they are. You can't expect a lot from them. They can't tell you anything about what is happening to them. Often they don't even know where it hurts. It's a very big challenge.

My daughter is thirty-four years old now, and she has been with the Windy City Rollers since 2004. She started Roller Derby as a new form of exercise and just loved it. I went to see her a couple of times, and one evening she asked me to help one of the girls who needed some ice for a sore muscle. I started bringing Band-Aids to the meets. I asked my husband to join us because the girls needed more help than I could give. So now my husband and I—along with a sports medicine specialist who is a physical therapist—are the medics for the Windy City Rollers. We travel with the team and provide their medical care.

I do get nervous watching my daughter out there; my pulse starts racing. She has broken her nose, her leg, and her collarbone, but I don't ever want to inhibit her from feeling that she could do everything she wants in her life.

Most of our girls are in their twenties and thirties, and they are all wonderful. They call me "Mama Doc," and they can ask me whatever questions they have, even on sensitive topics. I don't care if they swear. I don't care about their backgrounds. They can do anything, and it's all right with me. I just learn to accept all of them because it is so enriching to have all these young people in my life.

Judy Ramsay, RN, PEDS-SPEC, grew up in Joliet, Illinois, with three sisters, including her twin. She received her nursing degree from Rush-Presbyterian-St. Luke's School of Nursing. For almost fifty years, she has worked in pediatrics in the Chicago area and was one of the first of nine nurses in the US to get certified as a Developmental Disabilities Staff RN. She and her husband, a retired pediatrician, are the volunteer medics for their daughter's Roller Derby team, the Windy City Rollers, attending all the matches while dispensing Band-Aids, ice packs, and advice.

KAREN FRANK

THE JOHNS HOPKINS HOSPITAL, BALTIMORE, MARYLAND

Karen Frank, RNC, MS, CNS, was born and raised in Baltimore with her three sisters and a brother. Her extended family includes sixteen aunts and uncles. She has made Maryland her home for her entire life. She started her nursing education at Saint Joseph's School of Nursing and has a master of science in nursing degree with a minor in education. Since 1989, she has been with the NICU at Johns Hopkins Hospital, where she has performed many different roles, all in the care of newborn babies and in support of their anxious families. She is currently enrolled in the Doctor of Nursing Practice program at the University of Maryland School of Nursing.

I have worked in the pediatric area at Johns Hopkins for twenty-five years, all but two of those years in the neonatal ICU. Now my role is clinical nurse specialist, where I do a little bit of everything.

I've always absolutely loved babies, so that was my path into nursing. The newborn ICU is where babies are brought for specialized care. There is no norm for the children—it depends on their diagnosis. This includes any baby who is in trouble, needs surgery, was born too early, or has cardiac problems. Our patients are not just the babies; we treat the entire family.

The hardest part of my job is not being able to give a family what they hoped for. Every family has a dream before their baby is born. And that dream is shattered when their baby comes into the NICU. They don't get to take their baby home the way they expected. If they ultimately don't get to bring their baby home at all, that can be the most difficult thing ever. Whenever a baby dies, it affects everyone. You see the physicians crying as well as the nurses. We try to help the families work through that.

Recently we delivered twins, one of which was healthy, but the other had a birth defect incompatible with life. The baby died shortly after surgery. It was challenging emotionally to see what the parents went through.

Every patient is special, but for some reason, there are some patients with whom you just bond for life. There are days when I can't leave the patient's bedside, days when I just sit and cry with the family. I get very involved. Fortunately, most of the babies don't die in the NICU; most of them do extremely well. In my career, I personally had to deal with a baby dying maybe ten or fifteen times at most. I could probably tell you the details about at least ten of those babies.

Obviously, the happy times far outweigh the difficult times, or there wouldn't be any nurses who'd want to do this type of work. The best part of the job is when the parents come back with the kids to show us how well they are doing. Every year we have what we call a "NICU grad party," where all the graduates of the unit come back so we can see them. I think our oldest is in his twenties now. I still get postcards and Christmas cards in the mail. Two of my previous patients recently graduated from college.

One of the things I find so interesting is that, while I've taken care of a lot of patients in twenty-five years, there are a handful about whom I can remember everything—their names, diagnoses, even specific details that I probably couldn't remember about my own children. What is it about those patients? I didn't treat them any differently, but there was something about our bond that was so tight compared with the other five hundred or so patients I've treated in my career. I guess there are some people you naturally gravitate toward, and those bonds just stick.

Technology in the newborn ICU has changed dramatically over the last twenty-five years. We have wonderful incubators and cardiac monitors. The technology has allowed us to do our job in a very efficient manner. But there's always a downside to technology. One is that computerized charting is very time-consuming and takes away from your bedside time. This is especially true for the older staff that isn't computer savvy. The technology is easier for the younger staff, but their skills are not as good, so the older nurses are their mentors, and that kind of balances out.

I'm currently back in school for my doctorate. As much as I love bedside nursing, there's another calling that's important for me. I think I'll always stay in the NICU. My role may change, but I love taking care of patients.

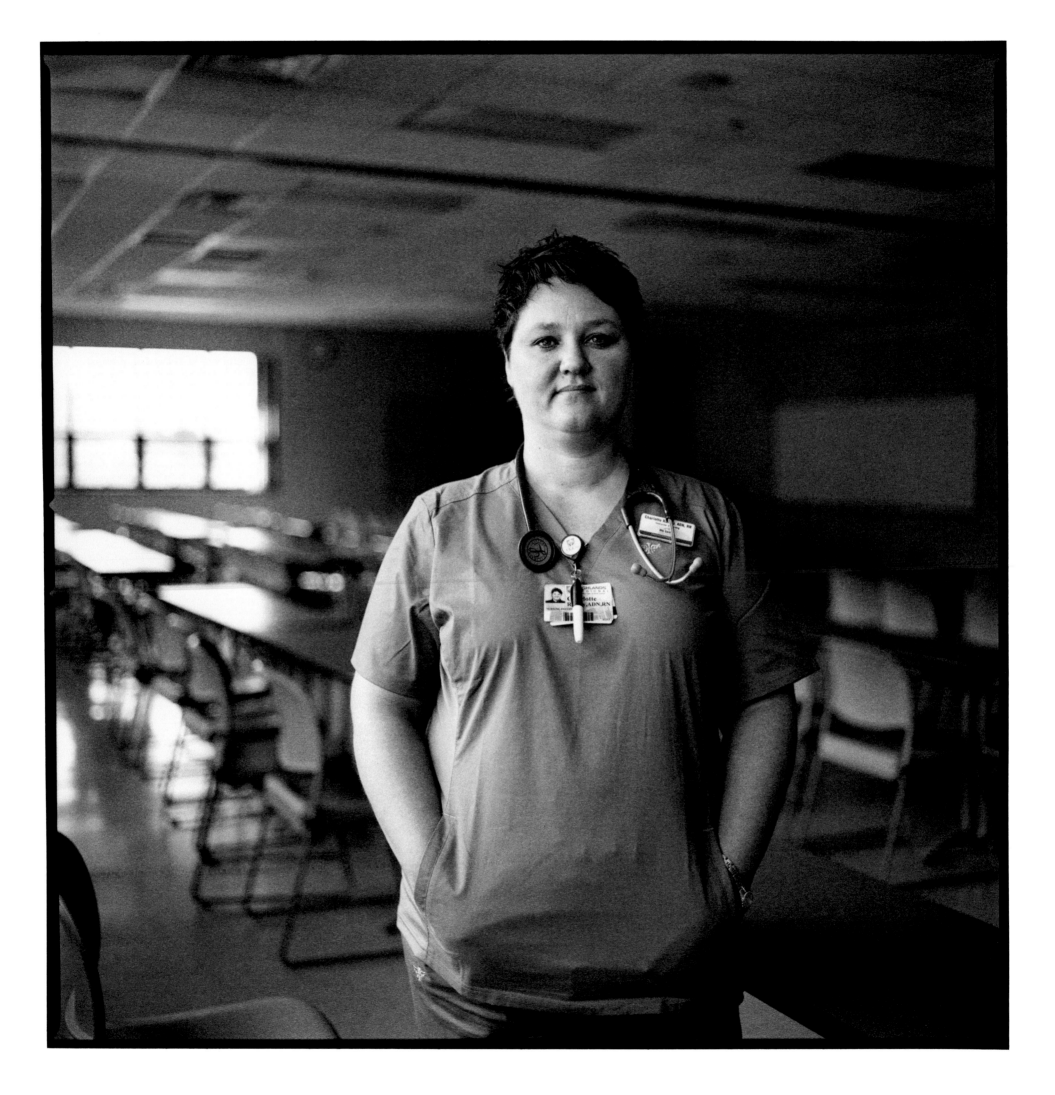

CHARLOTTE RAMEY

BIG SANDY COMMUNITY AND TECHNICAL COLLEGE, PRESTONSBURG, KENTUCKY

I am a nursing instructor at the local community college here in Prestonsburg, Kentucky.

I am one of those who swam away and then came home again. I got a degree in social work from the University of Kentucky and then moved to Tennessee, where I lived for fifteen years. I did home-care work and got to see the social impact of disease. Then the Medicare cutbacks started, and care was cut because of a lack of funds. I went back to school and then returned to Kentucky to teach nursing.

I love the area and the people, who are all very caring and family oriented. My mom and dad are here, as are my aunts, uncles, and grandmother. It's a small-town mentality. I walk into the school, and the secretary knows which ones are my children. We didn't get that in Tennessee.

I wanted to give back to my community. I've seen the other side of the mountain and wanted to bring back some of that knowledge to help other people become nurses.

I've done some hospice work in an Appalachian hospice, so I've dealt with a lot of respiratory disease. It's very hard here in eastern Kentucky because people want to work where they live and were raised, and coal mining is where the money is for these people. It seems like everybody around here is touched in some way, shape, or form by black lung disease. No one in my immediate family worked in the coal mines, though my dad sold and serviced coal trucks. I have some uncles and in-laws who were miners and are now suffering from black lung.

As a college instructor, I advise the students. At the local community college, we have probably six to seven hundred students awaiting entrance into the nursing program. The students, especially the young men, say that it's either nursing school or the coal mines for them. It really pulls at my heartstrings because those boys who don't get into the program are going back to the mines. I envision them, twenty years down the line, lying in a hospital bed being cared for by somebody they knew who made it into the program, while they didn't. It's a sad situation.

For my own children, I hope they get a college education and attain some kind of job not related to coal.

I like teaching young people because I think nursing is a dying art. It has become so much of a business. Patients come in and go home so quickly that we have forgotten the caring side of what they need. The analogy I use with the students is to treat the patient like your mother or grandmother. How would you want your loved ones to be treated? I think some of it has to be learned, but I don't think you can teach a caring attitude—that has to be inherent in a person. Sometimes the key thing is just being the person that the patient can talk to.

Having worked in hospice care, I know how difficult that can be. I encourage my students to talk about death in my mental-health lectures. The first time you witness the death of patient, it is a shock. It can be an eye-opening experience for the students, and it can be very empowering.

I've seen timid nineteen-year-old girls blossom into empowered women after two semesters. When you walk into a hospital room, all eyes are on you. They are looking to you for answers, and that can instill confidence.

I tell my students there is nothing more satisfying than when a patient says, "I don't think I could've gotten through this if you hadn't been my nurse."

Charlotte Ramey, BSW, ADN, RN, was born and raised in Prestonsburg, Kentucky, with one sister. She graduated from the University of Kentucky with a degree in social work in 1991 and started working in home health. She transferred to patient services in 1997 and then worked in nursing homes as a social worker. She went back to school in 2004 and graduated with an RN degree from Lincoln Memorial University in 2007. She is currently attending Northern Kentucky University for a BSN and is also an assistant professor of nursing at Big Sandy Community and Technical College.

JEANNE SARMIENTO

VA SAN DIEGO HEALTHCARE SYSTEM, SAN DIEGO, CALIFORNIA

Jeanne Sarmiento, RN, MS, BSN, was born in Manila, Philippines, where she grew up with her five siblings, four of whom are also nurses. She joined the US Navy in 1983 and earned her bachelor's degree from Norfolk State University in Virginia. A nurse for eighteen years, she has lived and worked in many places, including California, Illinois, Virginia, North Carolina, Saudi Arabia, and Kuwait.

I am the registered nurse on a Patient Align Care Team providing primary care at the Oceanside VA Clinic.

I'm a Filipino and came to the US about twenty-nine years ago because my brother and sisters were here. I grew up in a family of nurses; even my brother is a nurse.

Many people from the Philippines use the health-care profession to get out of the country, but I always wanted to be a doctor. My family didn't have the money to send me to school for that, so I became a nurse through the military. I share the passion of my brother and sisters for the profession. We all have a nurturing and compassionate attitude, and we all like teaching, which is an important part of the profession.

I started in the military in 1983 and was a corpsman for eleven years. I was an EMT (emergency medical technician), and when I was deployed in Operation Desert Shield/Desert Storm, I worked in casualty receiving and drove an ambulance. I was working nights for six and a half months, and when the war broke in February 1991, we were getting bombed every single night. We were trying to revive these blown up bodies even though they couldn't be revived, and we had to wrap and pick up these burned bodies for transport. It really took a toll on me, especially as I was separated from my newborn baby. I only got through the family separation and deployment with my faith in God and by reading the Bible and running six miles a day.

The Navy put me through nursing school at Norfolk State University. I graduated in 1994 and was commissioned as a Navy nurse. Afterward, the Navy sent me for my master's at the Naval Postgraduate School in Monterey, California, where I completed a degree in manpower systems analysis. After graduation I was sent to Camp Pendleton Naval Hospital for five years, then to Balboa Naval Medical Center for three years, and then back to Pendleton for another three years. When I was deployed to Kuwait, I was in charge of one of the biggest clinics, seeing two thousand patients a month and managing a staff of fourteen hospital corpsmen and six providers. The patients were a combination of active-duty personnel, retirees, and American civilians who worked for the Kuwaiti government. We were always on the alert for terrorists. We were in constant awareness and readiness at all times.

I retired as a Lieutenant Commander from the military in January 2011.

Having served as a Hospital Corpsman and a nurse, I love the Marines and the people who are out there on the front lines. It's an awesome feeling to care for someone that you may never see again. Also, I have a son on active duty. I think that if I care for others, then someone will care for him.

Here at the clinic, I treat veterans from all different generations and wars—World War II, Korea, Vietnam, Bosnia, Gulf War, Iraq, and Afghanistan. It's important to understand their experiences in life. I have a master's in human resources so I can assess the patients and give them better care. Those who grew up during the Depression are a lot different from those who were spoon-fed as children. The WWII vets handle hardship better than the younger ones.

Today, the hardest part of my job is putting together different specialties to provide the best possible spectrum of care for each patient. I provide my utmost care, and the patient has the final decision. I strive to provide excellent care to my fellow veterans, who gave their lives for the freedom we have now, by educating and supporting them in their health-care needs.

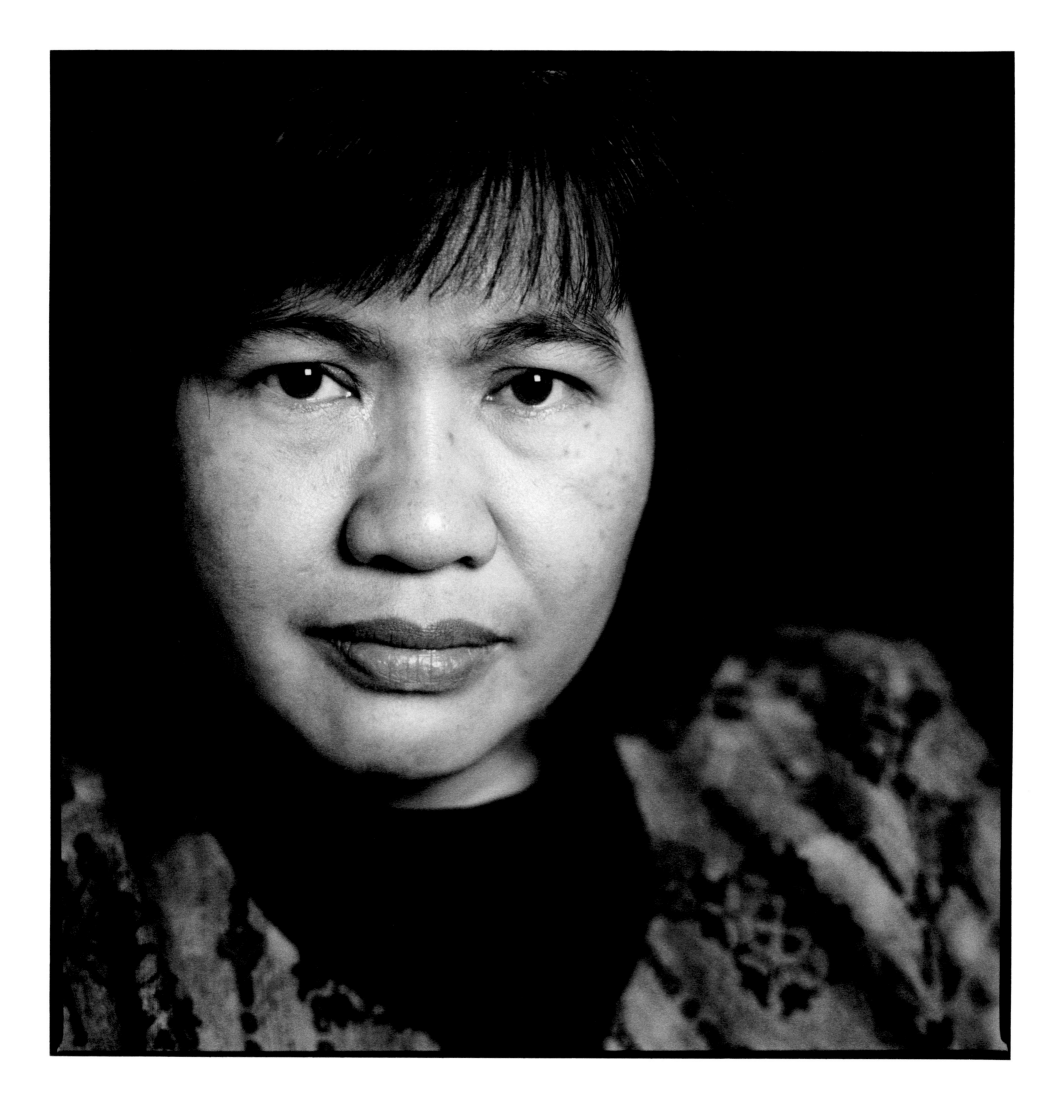

JASON SHORT

APPALACHIAN HOSPICE CARE, PIKEVILLE, KENTUCKY

Jason Short, RN, BSN, was born in Paintsville, Kentucky, during the coal boom and grew up with two sisters. As a garage mechanic, he had his own business from 1991 to 2003 and then worked as a commercial trucker. He was inspired to become a nurse after a motorcycle accident left him in a wheelchair for six months. In 2005, he went back to school. He worked in the ER and as a critical-care nurse for two years. A nurse for the past six years, he now works at Appalachian Hospice Care, often traveling to remote places that ambulances can't reach.

I'm a registered nurse with Appalachian Hospice Care.

I used to be an auto mechanic and had my own garage in Paintsville. When the economy went downhill, so did my business, and I thought it would be a good idea to get into health care.

I am in school now, and if I can continue, I hope to become a nurse-practitioner, which is a lot like being a doctor. A nurse-practitioner can prescribe medication, with some limitations on hardcore narcotics. Also, they can bill Medicaid up to 85 percent of what a physician does, so it's a pretty good income. I am almost ready to graduate with my bachelor of science in nursing. I work the night shift in Pikeville at the medical center, and five days a week, I am working the day shift at hospice.

I love working the ER. It's exciting and you get to work with different kinds of people. We see a lot of motor-vehicle accidents, and of course there is a drug problem here, mostly prescription drugs.

It was important for me to stay here because I love the people in this area. I want to help them. I love going to these houses in the woods because no one else can get there. We've got four-wheel-drive vehicles. It helps that I used to be a truck driver and that I like a challenge.

It's a very treacherous drive to get to our clients. It may only be one county over, but it can take two hours. We have houses that are entrenched in the hillsides. You have to drive about a mile up a creek, go up over these rocks, past these huge waterfalls. I don't know how they built the houses. They are on a sheer cliff, and the dirt gives way. Sometimes we can get a car up, but not an ambulance. Sometimes we have to rappel them down the cliffs to get them out.

Around here, generations of people live together under one roof. You go into a home, and there are the grandparents, their children, and the grandchildren all living together.

It's hard to make a living here. There are not a lot of factory jobs; mainly it's either the coal mines or the medical field. Some go off to college, but not many.

Obesity is a huge problem here. It's a national epidemic, but here it seems like really young people are suffering from it. I had a close friend who just died at the age of thirty-four from diabetes. He just couldn't adhere to the diet. Everything is celebrated with food—funerals, weddings, church, and everything in between. People eat mostly fried foods, cakes, and a lot of cheap, sugary food.

There are so many people who suffer needlessly because of lifestyle choices. Some people say it's caused by ignorance, but I think it's just that these folks are set in their ways. It's an uphill battle, but there are people who are willing to change. You're not going to help anyone who flat out refuses, of course. But there are some people who just don't know, who are uneducated about diet and things that cause disease.

My dream is to have my own clinic and truly help people. Not just hand out pills, but help them with their dieting issues, with weight loss and controlling diabetes, especially in children. I also want to keep working hospice care. I get to help people in their own homes, in their environments, where they feel comfortable and where no one else is able to get to them.

I have found that once you get a taste for helping people, it's kind of addictive. You want to empower yourself to be more and more helpful.

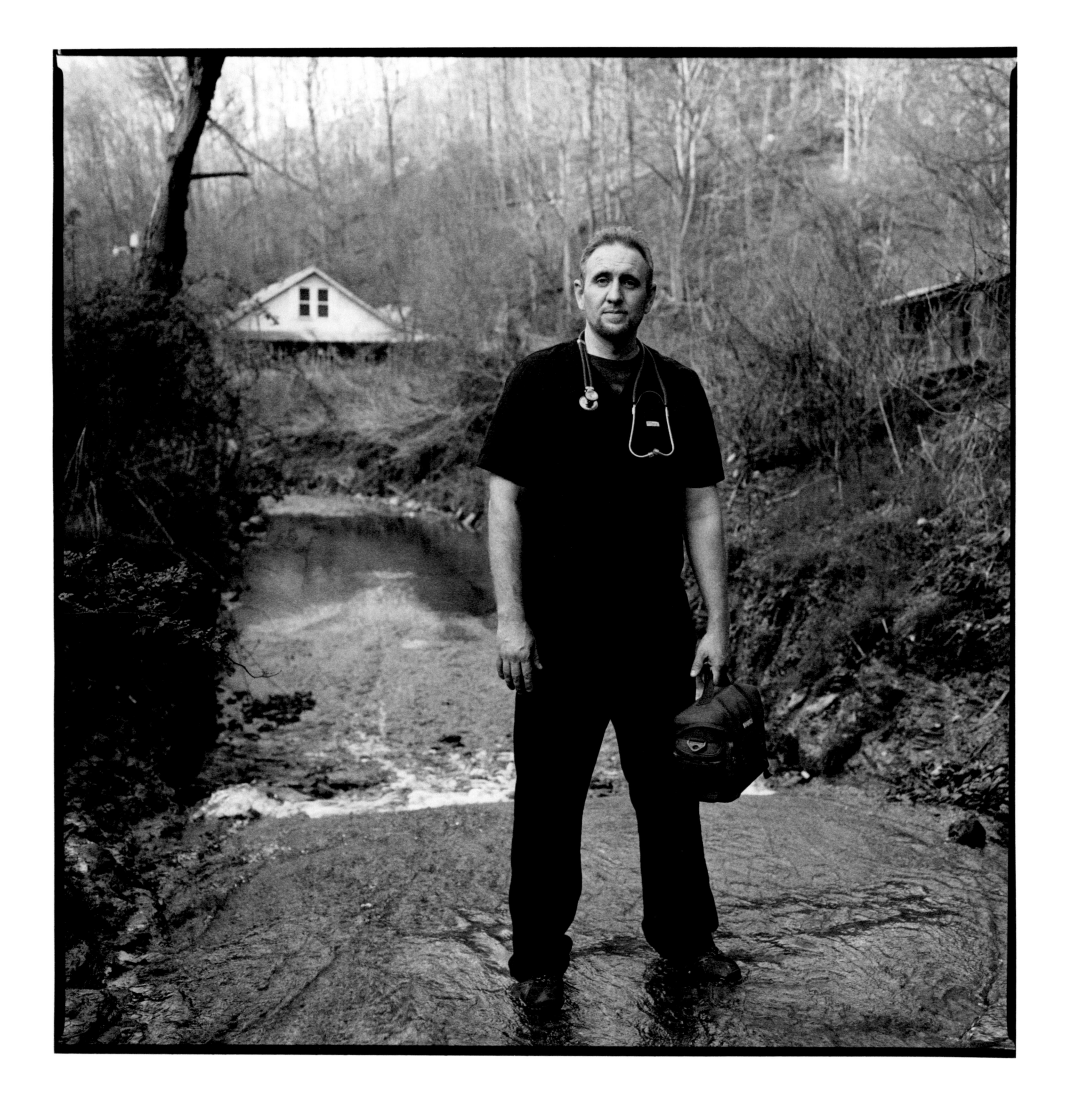

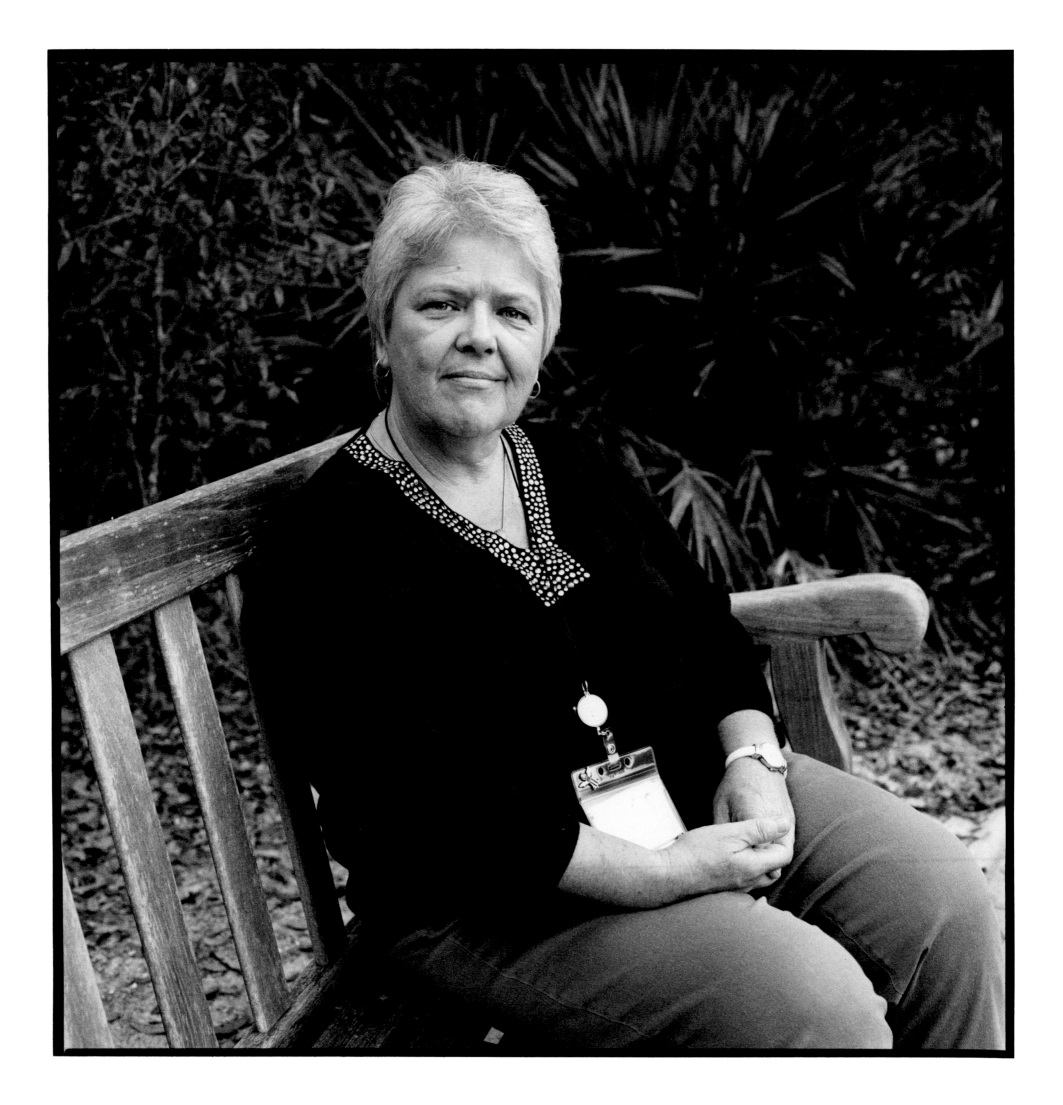

JOANNE DeANDRADE

TIDEWELL HOSPICE, PORT CHARLOTTE, FLORIDA

I am an RN case manager for Tidewell Hospice. I've been here for a little more than eight years. I came into hospice work after more than thirty years in the OR.

When I was a teenager, I told my father I wanted to be a teacher. He said, "No, you want to be a nurse." My aunt was a nurse, so I said I'd try it, and it just fit. In the end, I am a teaching nurse, so I get the best of both worlds.

In the OR, I was called the "RN circulator." I ran the schedule and took charge of the patient. I was also called the "patient's advocate." I watched over the procedures and was responsible for the safety of the patient. I loved it.

As the years passed things changed, and I felt the focus was moving away from the patient. This was the late 1990s, and, for example, the turnover time between patients in the OR went from thirty minutes down to twenty. Then it shot way down to twelve. This meant you had no time to introduce yourself and make sure the patient was okay before the anesthesia. I think people should be treated better. I didn't like that the rules were being dictated by people who didn't know how the patients were being affected. Everything was so money-driven, and that was a big turnoff for me. I needed to find a new arena where that wasn't happening.

Someone suggested I try hospice; they were looking for nurses. I didn't think that was for me, but my friend said it was a good job and really rewarding, so I tried it. I discovered that hospice is really patient-directed care. I go into a patient's home, and it's their agenda, not mine. We figure out what we need to accomplish in their limited time.

We take care of unmanaged symptoms and help manage and improve quality of life. If it's pain, we get that under control. If it's a spiritual issue, we refer our chaplains. If it's an emotional issue, we have social workers. I've had some patients for two years, some for a couple of months, and some for two hours. We do the best we can with whatever time we have.

One of the problems is that the patients are not referred to us soon enough. Too often, they wait until they are really sick.

We deal with a lot of fear. People think coming to hospice means giving up hope, but that's not true. Hope is redirected. Once people are more comfortable and their pain is under control, they can resolve problems.

At the end of the day, I think the most important thing is how you make people feel. It doesn't matter what you do or say; people will forget those things. But they will always remember how you made them feel. I try to always remember that—always.

I am a cancer survivor myself, and it was fairly recent. I didn't have a very nice cancer, so I have that dark cloud over me. I don't know when it's going to hit again. So I know what the patient means when she says she wants to feel well enough to spend more time with the grandkids. I know how important that is.

In other cultures, they prepare their whole life for death because they know it is coming. It's inevitable. Americans think death is optional, but it's not. I had to learn that myself. And, yes, like many of my patients, I am working on my bucket list. I want to start piano lessons, visit the Chesapeake Bay, attend my high-school reunion this summer, go on a cruise to Alaska, and ride Dumbo at Walt Disney World.

Joanne DeAndrade, RNCM, grew up in Taunton, Massachusetts, the fourth child born into a family of six. She graduated from the Fall River Diploma School of Nursing. She was hired by Morton Hospital, where she remained an RN in the OR for twenty years before relocating to Florida with her husband and two sons. She continued working in the OR for another eleven years, then decided it was time for a change, and signed on with Tidewell Hospice. For the past eight years, she has been an RN case manager devoted to caring for an average caseload of twelve home-team patients (hospice patients who choose to remain at home).

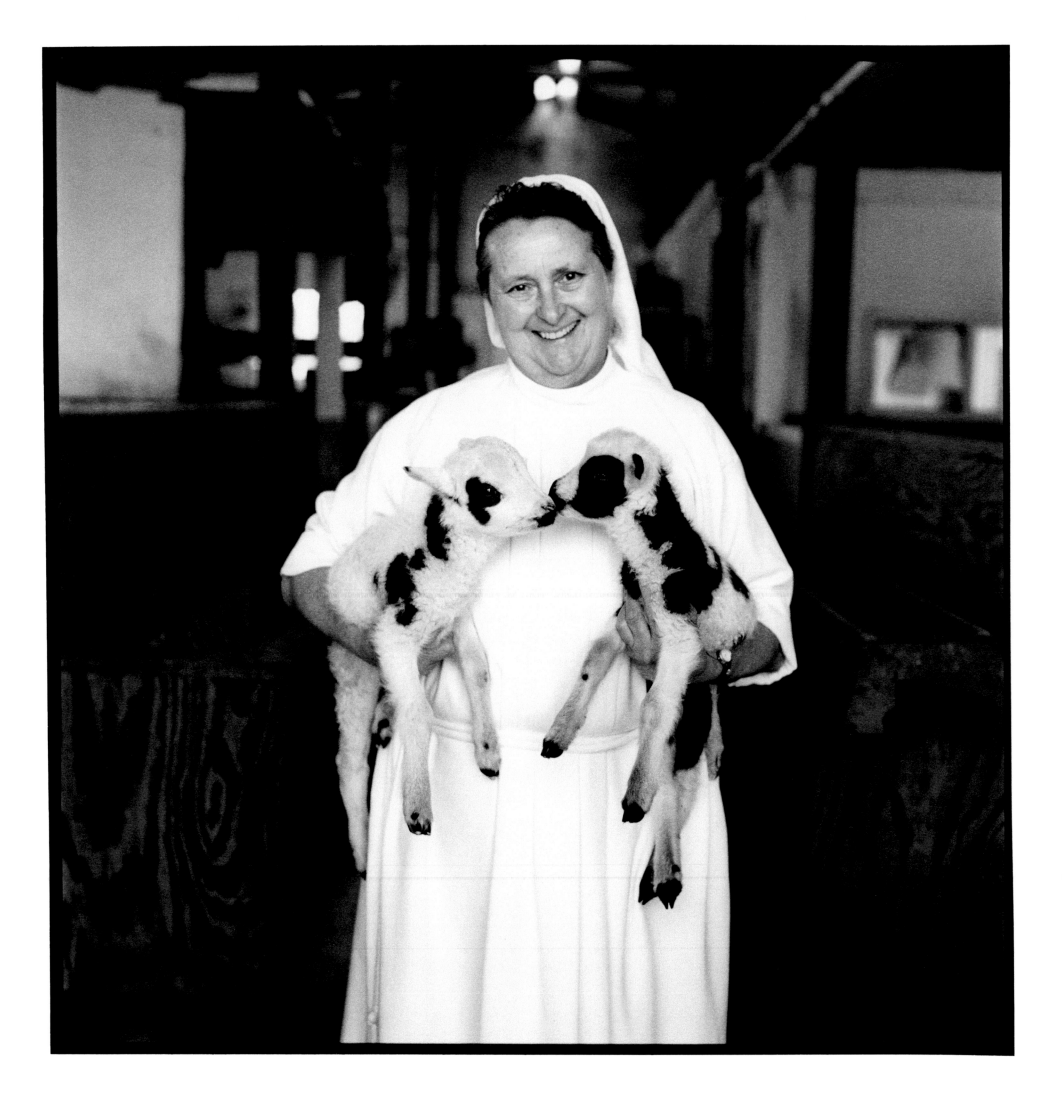

SISTER STEPHEN BLOESL

VILLA LORETTO NURSING HOME, MT. CALVARY, WISCONSIN

I am the director of nursing at Villa Loretto, a skilled nursing facility, and Villa Rosa, an assisted-living facility.

Our sisters came to this place from North Dakota in the early 1960s. We were working at the St. Lawrence Seminary in Mt. Calvary, doing domestic work and preparing meals for the seminarians and priests. The sisters were asked if they wanted to start a nursing home; there was such a need for it here, and Mother Rose, our founder, was excited about the idea. We traded the property that we owned in the village for the land, raised money, and opened Villa Loretto in 1965, which is when I arrived.

We have 120 acres, but there were no animals when I got here. One day I saw a goat in a pet store, and we purchased it. We had another sister who had grown up on a farm, and so when we were offered an orphaned lamb, we took it and that got the ball rolling.

Little by little, we began acquiring more animals. We got a donkey named Milton Berle. We got some llamas and potbelly pigs. Then we started rescuing animals: rabbits, birds, whatever. So now it is quite lively around here. In the early 1970s, they began closing county homes, and some of the men who'd been institutionalized were admitted here. They liked working on the farm and helping raise the animals.

I thought about joining the convent in grade school, and then forgot about it. In high school, I got into a little bit of trouble, nothing serious. I was dating and doing some other different things, but I had this empty feeling inside. I came to Mt. Calvary for the summer retreat and met the Sister Servants of Christ the King and realized that this is where I belong.

I felt that I wanted to give myself to a bigger cause and not be confined to marriage and one family. I had this nagging feeling inside that God was calling me to embrace something bigger. All through high school I had this feeling, and it only went away after I decided to live out His plan for my life. I've never really doubted my vocation or questioned whether I made the right decision. I am blessed.

I worked for several years as a nursing assistant and was happy doing that. Then Mother Rose approached me with a scholarship to enter nursing school. I was scared to death about the tests and all, but decided to give it a shot.

For the first several years I was a charge nurse, and things were much less complicated than they are now. I worked five days a week and had another RN who filled in on the other two days. I did a lot of direct care, which I loved. I've been the director of nursing since 1975. Things have become more regulated today, and most of my time is spent doing paperwork.

When I first got here, I was working with the elderly, which was fine. I loved it. But then I talked to the sisters about working with kids, and we contacted social services. We started doing respite work, taking foster kids for the weekend. Our license is for kids from newborn to age eighteen. Now we usually have four kids every weekend, and it is such a great thing for them and for us. We get to spend one-on-one time with the kids, and of course they love all the animals.

About fifteen years ago, the parish priest asked if we could put up an African sister, Sister Sam, who was here on a mission appeal, talking to the parishes. We had a lot of discussions with her, and then we got the idea that maybe we could get more sisters from Africa to come because we were very short on nursing assistants

Sister Stephen Bloesl, RN, BSN, was born in Oshkosh, Wisconsin, and is the oldest of three children. She has a BSN from Marian University in Fond du Lac. She joined the Sister Servants of Christ the King in Mt. Calvary, Wisconsin, in 1965 and has been bringing joy to the residents of Villa Loretto Nursing Home ever since. One day she fell in love with a baby goat she saw in a pet store and proposed to the sisters that they begin raising animals. Today, Villa Loretto is home to numerous exotic animals, the five remaining nuns, and three nuns from an African congregation known as the Little Sisters of St. Francis.

back then. So they began sending them. We'd train them, and that has been going on ever since. Many of the sisters wound up going to school to become nurses or social workers; some returned to their country and some stayed here.

I do a lot of end-of-life work, and I really love it. I feel like the neat parts of life are when you bring babies into the world and when you usher people into eternity. We do some great things with the families. One of our residents had been a long-time employee, and she loved music. So when she was dying, we called together the staff, and we all sang to her. Now it has become a tradition that when our residents are dying, we sing to them. It gives the staff something to do to help, and the families really appreciate it in those last days or hours.

After they do pass away, the sisters spend time in the room, praying with them and the families. Then we have a departure ceremony. We have a white-embroidered covering that was made by one of our volunteers, which the family puts over the body. We give everyone a candle, and we sing as the procession leaves the room with the gurney. It gives our staff a chance to grieve with the family and express our condolences. It is one of my passions to serve in this way.

We've learned a lot about helping people with the end of life. We talk to families from the very beginning to sort through the palliative options. We help them understand that the most important thing at this point is making the patient feel comfortable and secure, and helping them to see that they are surrounded by people who know and love them. We try to avoid having them die in a hospital.

We've learned that when people stop eating, they are telling us something. We no longer try forcing food or liquids; the body is telling us that maybe they are entering into the dying process. In the past, we'd encourage them to eat more or try to get them to drink, but that makes dying more difficult because the body cannot assimilate the nourishment anymore.

I've seen residents who hang on and hang on until someone arrives—a son or daughter who maybe lives hundreds of miles away. And when they finally arrive, the resident passes. We've seen other residents whose families hover over them and will not leave the room because they want to be there at the moment of death. And then, for some reason, they walk out of the room for just a minute, and that is when the resident passes. We've seen other residents who die on a specific special date—an anniversary or the day their spouse died.

I am not sure I could work with young children dying, or even cancer patients who still have a life to live. When our residents get to a certain point, the majority of them are ready to die. They don't want to be sent back to the hospital. They don't want any more procedures. Mostly, they say, "I've lived a long life. I'm ready to die."

I've seen residents who open their eyes, like they are seeing something, and then pass. It's never frightening. I've never witnessed someone being afraid at that moment. There are others who just slip away. Everyone seems just a little bit different. I've read and heard a lot about after-death experiences, which always seem to be the same. I believe Jesus brings us home to him, and I believe it is better than anything we could imagine.

My dream is that this work will continue on, with more and more sisters joining our congregation. Even if we have to become part of another health-care group, I hope we can still somehow have influence here—maintain the farm, the therapy with the animals, and the foster program for the children. I think we have a lot to offer. I just had a note from the daughter of one of the men who came here quite reluctantly. She wrote that she had a great feeling of peace from seeing how well he was adjusting and how well we understood her pain.

My biggest dream is for us to continue to be part of the community. It is all part of God's plan. It is the way it is.

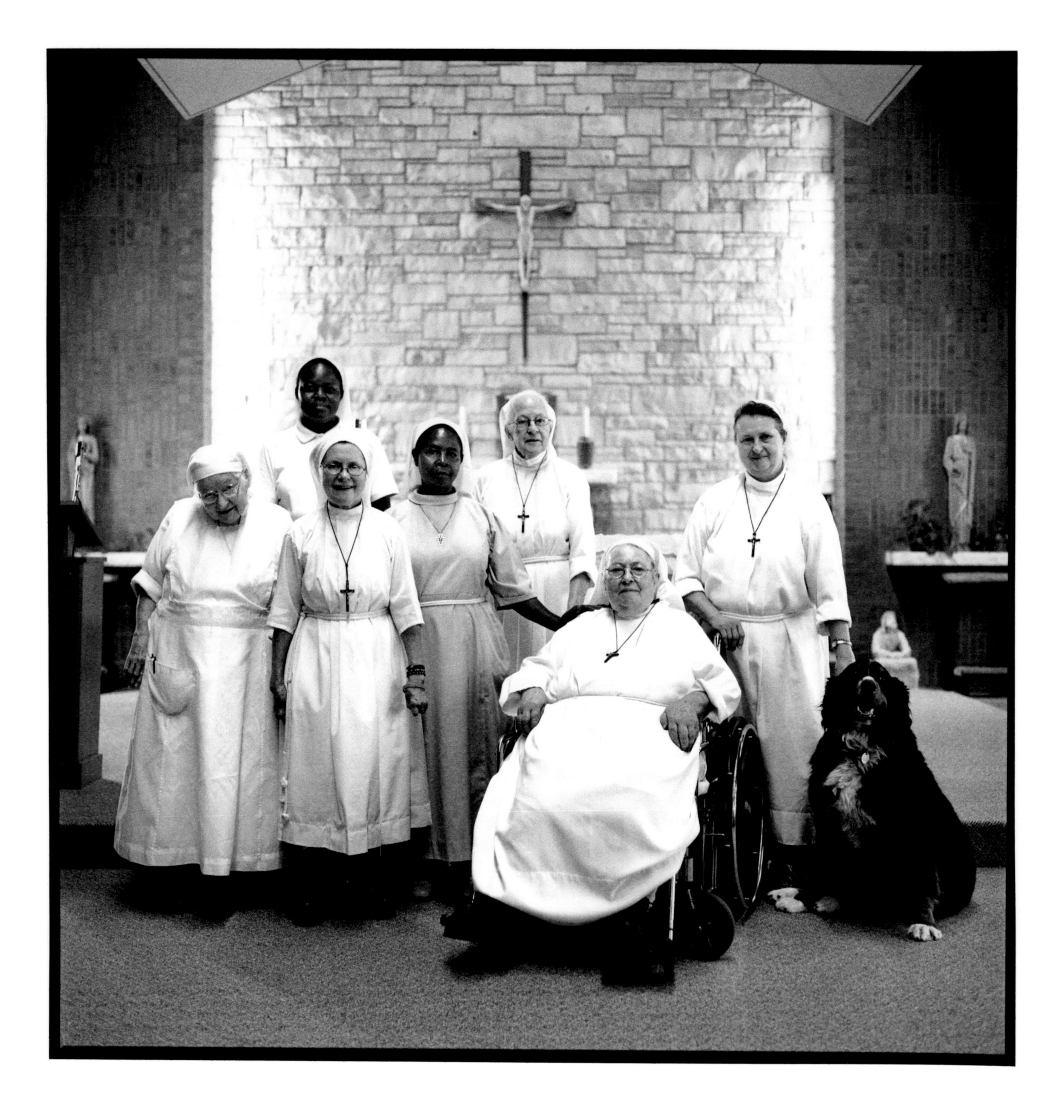

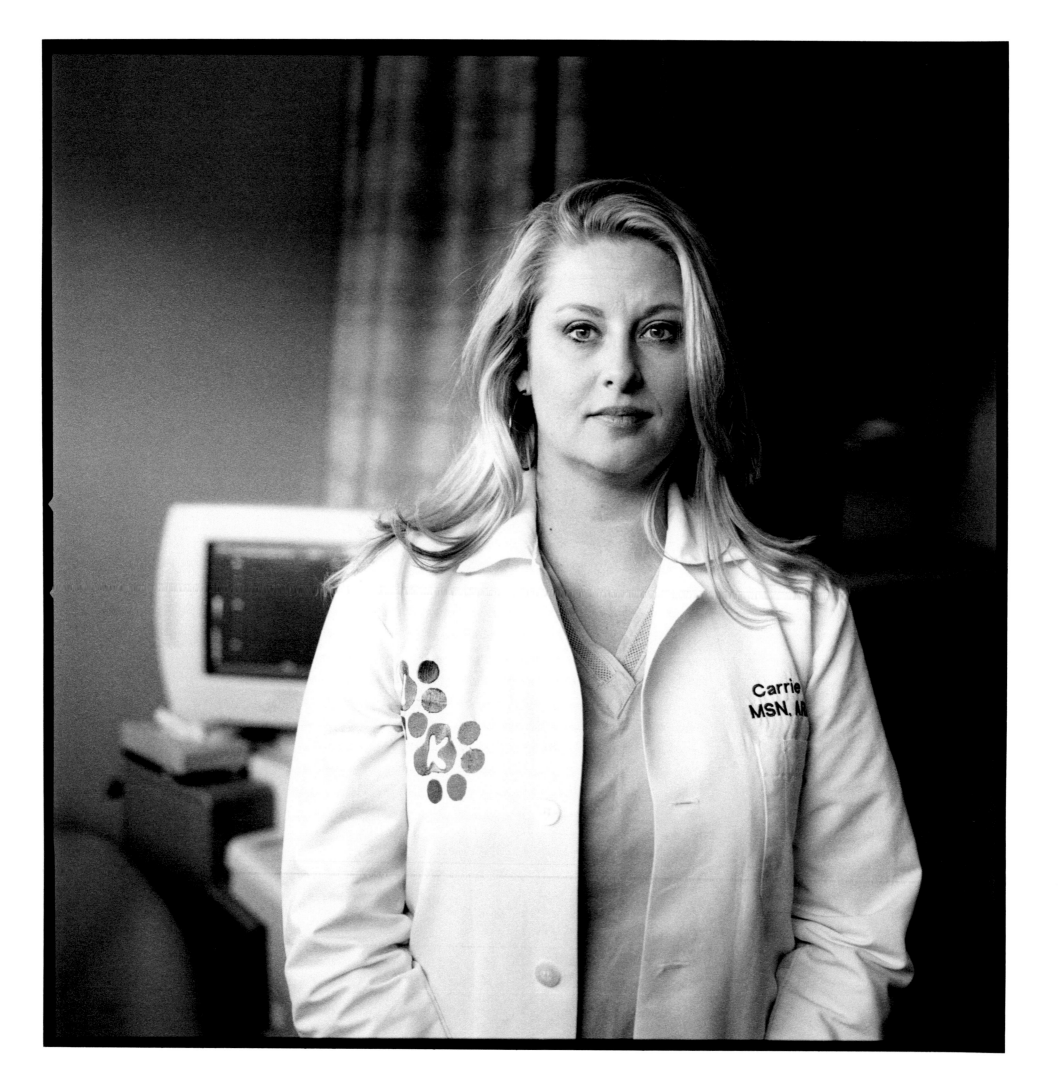

CARRIE LEE-HALL

UK NORTH FORK VALLEY COMMUNITY HEALTH CENTER, HAZARD, KENTUCKY

I am a nurse, a midwife, and a family nurse-practitioner currently working for the University of Kentucky.

When I was twelve, I helped care for my terminally ill great-grandmother, and she inspired me to be a nurse. She told me that I was very caring. My strongest memory of that time was this cowbell that we tied to her bedpost; she would ring it when she needed something. That image really sticks in my head.

My family prepared me for her death, and I feel like that made me a strong person. She was so appreciative of me, and she taught me a lot about life. I think she really helped me become the person I am today. I definitely plan on preparing my children for death and dying. I think it's a privilege to do that.

I saw my first birth when I was fifteen. I had the privilege of being with my older cousin when she gave birth, and from then on I knew I wanted to be an obstetrical nurse or a nurse midwife.

I am from a small but very close-knit family; we have dinner together every Sunday, and that's how I want my boys to grow up.

I always wanted to live in the mountains here and help serve the low-income and underserved patients who have stolen my heart. When I was growing up, one of my neighbors stepped on a rusty fence post and had a laceration on his foot. He didn't have the money or insurance to see a doctor, and he ended up in the hospital with a bad infection that could have killed him. Worrying about money keeps a lot of people from getting health care.

I knew social work wasn't for me after about one semester, so I went straight back into nursing. My family is quite religious, and my mother felt that God was leading me into the nursing field. I finished my bachelor's degree and went straight into nurse-midwifery school. I did feel a void, even after I graduated, so I returned to the Women's Health Care Nurse Practitioner Program at Frontier Nursing University. I furthered my education so that I could expand my knowledge about how to treat women for things like menopause and sexually transmitted disease. But after completing that degree, I still felt a void because I couldn't treat the babies I helped deliver. I finished my third master's degree so that I could provide holistic care for the whole family, and that definitely was what was missing.

I have been a midwife for eight years, and I still cry with my patients. It is so touching. Just today I helped deliver a baby to a couple who had tried to get pregnant for seven years. It was very, very special to see that little miracle come into life.

I admire my job because it is so versatile. Every single day, I don't know who I am going to be seeing—a pregnant woman, a baby, or even a man.

The hard part in obstetrics is when I see patients lose their babies. I don't understand why that happens. As a nurse, I cherish my spiritual life and the strength it gives me to offer words of comfort.

My commute to work is a forty-five minute drive, so I use that time to unwind. I turn up the radio and think about the whole day. I try to clear my head before I get home to my family. Usually I'm successful, but on harder days, I'm not. My twin boys always pick me up, though—just knowing they're there waiting for Mommy, after a hard day at work.

Carrie Lee-Hall, MSN, CNM, WHNP, FNP, SANE, graduated from Eastern Kentucky University. Her first major was social work because she wasn't sure there'd be nursing jobs available in the rural part of Kentucky where she lived. Most of the people in her town tended to stay where they were raised, so jobs were hard to find. After finishing her bachelor's degree, she attended Frontier Nursing University to study midwifery and continue her education, taking twelve years to earn three master's in nursing. She plans to return to school for her doctorate of nursing practice.

JESSICA GRAEF

CHILDREN'S NATIONAL MEDICAL CENTER, WASHINGTON, D.C.

Jessica Graef, BA, MA, MSN, RN, CNL, grew up in the Washington, D.C. suburbs and lived in Geneva, Switzerland, for four years with her parents and brother. She has a BA in international studies from Colby College and an MA in population geography from the University of Maryland, College Park, and worked in international development for ten years. After being a stay-at-home mom for five years, she earned an MSN from the University of Maryland, Baltimore, when she was thirty-six years old and has worked at Children's National Medical Center in D.C. ever since.

I work as a staff nurse, an RN2, on the hematology/oncology unit at Children's National Medical Center. On this unit we treat children with cancer and blood disorders. I started here four years ago as a new RN.

Nursing is a second career for me. As a kid, I never would have predicted I'd grow up to be a nurse. Never played those pretend doctor-and-nurse games. I was interested in developing countries and famine relief because my dad did that kind of work. I lived overseas as a child, and after I got married, my husband and I moved to Mexico City. He was a professor in Mexico, and I started working at the US Agency for International Development.

In 2001, while we were living in Mexico, I was pregnant with twins, on bed rest for two months, and in and out of the hospital. My kids were born ten weeks prematurely and put in the neonatal ICU. Thankfully they received great care there, and it started me thinking. We moved back to the US when the kids were about a year old, and for a while I was a stay-at-home mom. When I thought about going back to work, I kept finding myself drawn toward the health field. I should add that when I was working in international development, I was most interested in health projects such as the TB and nutritional deficiencies programs, but I had no applied skills. I was just pushing paper.

I considered physical therapy, but it was too close to home. My daughter has mild cerebral palsy and does physical therapy. So I kept coming back to nursing and pursued nursing school when the kids started kindergarten.

I came to Children's National because my daughter had been treated here and I knew I wanted to work in pediatrics. The pediatric intensive care unit wasn't hiring for six months, so I decided to try hematology/oncology. My original plan was to put my international experience and nursing together to do development work again, which I may still pursue. But as I am now forty, I realize that life changes, as do one's plans. I had no idea I'd be interested in nursing or stay home with my kids. Life takes you to funny places, but I'm very happy where I am; nursing is a great profession.

I used to think that nurses only did what they were told, but I've learned that it is quite autonomous. And I like the interpersonal relationships. As a parent, I can relate to the parents here. I've had some harrowing hospital experiences with my children, so I know what it's like, and that makes me more comfortable dealing with families and patients. When you walk into a patient's room, you are walking into their world. I don't expect to change it. I'm just trying to make it a little bit better for that particular day, for that particular shift. The kids on my floor are not looking for pity. They want a sense of normalcy. They want to play and get their mind off their medical issues.

Nursing is the perfect fit for my interests. I am challenged intellectually by the physiological critical thinking I do on an everyday basis. And I am able to help my patients emotionally. I am doing hands-on, life-changing work. What I've learned about humanity through this job is the strength of families. I thought I'd see people just losing it, but these families are tremendously strong. I'm sure they go through their breakdowns, but they come back with incredible strength and love. They deal with some really hard issues and somehow hold it together. They are there for their children, and pull from their inner strength to cope and to help their children.

I've learned so much about myself from seeing how other people interact, how they deal with things like this, and how they are able to come up with compassion in the most horrendous situations. I always try and have a sense of hope because without that, what do you have? Some people think that pediatric oncology nurses are angels or saints, but I have to say that I have learned and gained from my patients and their families just as much as I have given to them.

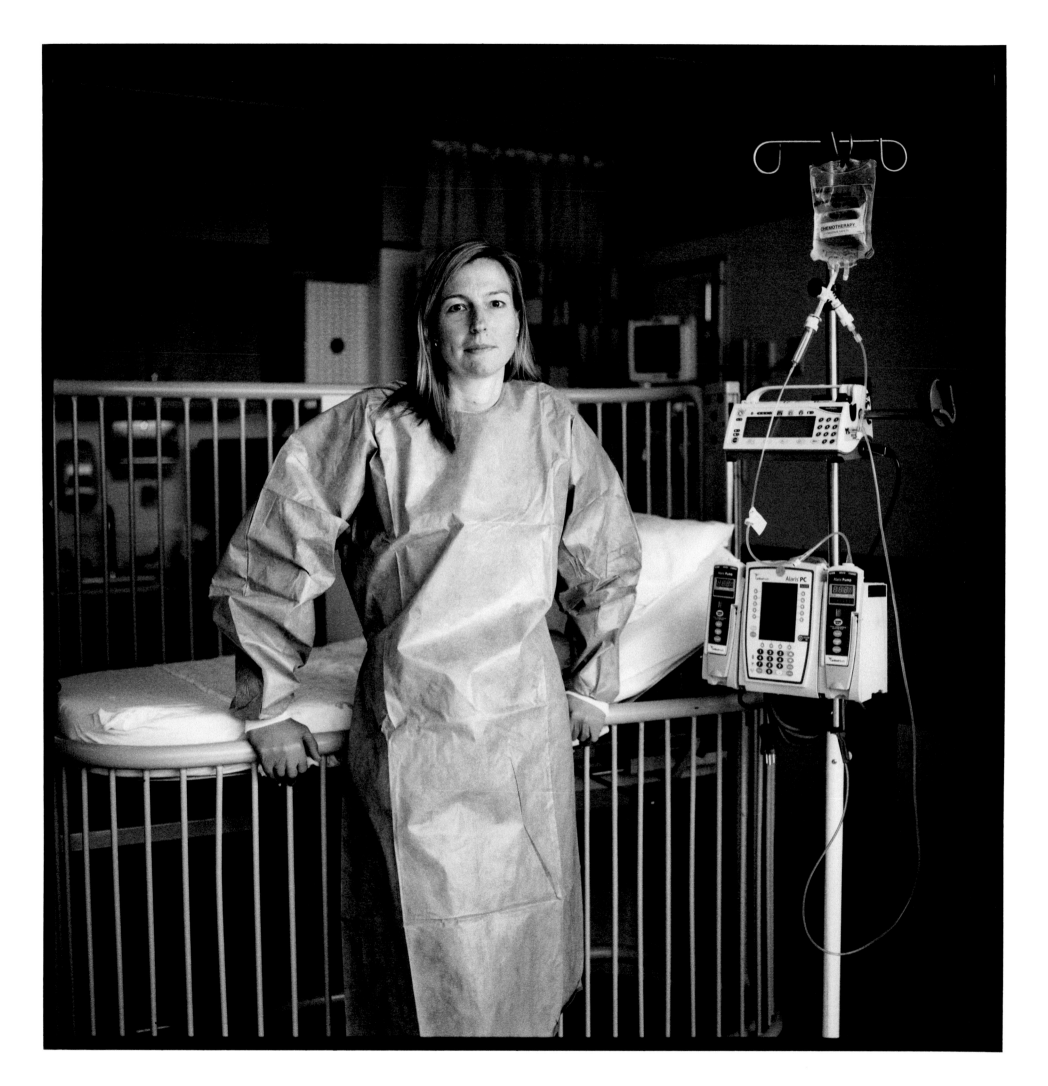

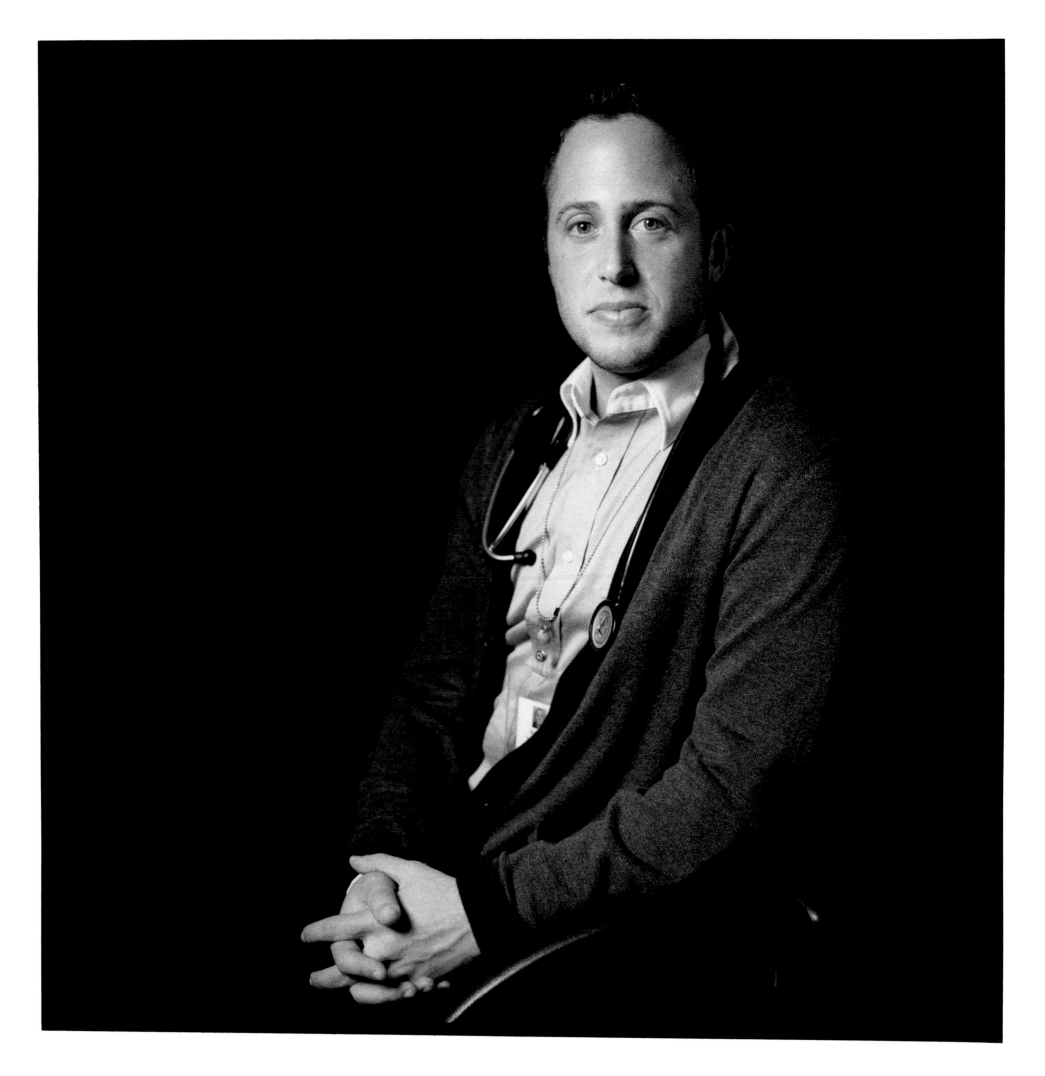

NATHAN LEVITT

CALLEN-LORDE COMMUNITY HEALTH CENTER, NEW YORK, NEW YORK

I am the Community Outreach and Education registered nurse at Callen-Lorde Community Health Center. I do both nursing functions and outreach and education work on LGBT (Lesbian, Gay, Bisexual, Transgender) health with hospitals, health centers, nursing and medical schools.

I am a transgender-identified person. I transitioned from female to male about ten years ago. Identifying as transgender and gay impacts how I work. I've experienced a lot of discrimination and had to cope with doctors and nurses who had no idea how to address my health-care needs or understand my identity.

I did not know I wanted to be a nurse early on. I always wanted to be a teacher in some way. I did a lot of LGBT-advocacy work and started working with doctors and nurses in San Francisco. That pushed me further to be a nurse because I wanted to help remove the barriers to care that I had faced myself.

I grew up in Fort Lauderdale, Florida, and went to college in Atlanta, where I came out as a lesbian. In San Francisco, I started working with LGBT youths who'd been kicked out of their homes. I met transgender people and began to realize that that was something I fit into and identified how I felt inside. I began transitioning. These experiences helped make me who I am today, and my personal story helps people put a face to the identity.

I work with health-care professionals on how to provide affirmative and informed LGBT health care and how to ask sensitive questions and not make assumptions about a person's gender, which you can't always tell by appearance. It is best to ask, "How do you identify your sexual orientation?" or "How do you identify your gender?" or "What pronoun would you like me to use for you?" LGBT people face discrimination and fear in health care. The lack of informed care and sensitive language prevents access to routine care and screening. There are very few health centers and hospitals in the country that have supportive and sensitive health services for LGBT people, especially transgender.

I never got any information about transgender health in nursing school, and I experienced a lot of ignorance. My journey through hormones and surgery allows me to provide better care for my patients. The patients who are starting on hormones, for example, can see in me not only a nurse, but also another transgender-identified person to talk to about their health. As nurses, we always try to make our patients feel more comfortable, but there is an added comfort when patients can see themselves reflected in us.

I also work the night shift on an oncology unit. In oncology, end-of-life care is a big part of the job. It's my first time dealing with death in this way, and I've learned a lot from it. In those final moments when a patient is dying, it is really about who is there for them. Some of our patients have no family or friends with them, and I am the only one sitting by their bed. I try to provide the best and most compassionate care I can.

What I love about nursing is developing trusting relationships with patients to help them feel more comfortable in an environment that may feel alienating and discriminatory.

I am scared a lot more than I let people know. I find that a lot of times my job is to help people feel less scared by hiding my own fear. I try and help by being there. I am lucky to have a community of friends and colleagues who help me feel strong. I have a loving partner of more than eight years who is also a nurse. I have a very supportive family. This is what helps me get through it all.

I just need more hours in the day and night to do the work I love.

Nathan Levitt, RN, MA, BSN, was born on Long Island, New York, and grew up in Fort Lauderdale, Florida, with a younger brother. He has a bachelor's degree in psychology and women's studies, a master's in gender and cultural studies, and a bachelor of science in nursing. He is currently an RN on an oncology unit in Brooklyn and a Community Outreach and Education nurse at Callen-Lorde Community Health Center, in the field of LGBT (Lesbian, Gay, Bisexual, Transgender) health.

JOHN RUSSELL

LOUISIANA STATE PENITENTIARY, ANGOLA, LOUISIANA

John Russell, RN, BSN, was born in Winnfield, Louisiana, and grew up in the college town of Natchitoches with three younger sisters. He went to school in Shreveport, which is the northernmost city in Louisiana, and his first nursing job was in the ER at a local charity hospital in Baton Rouge. He then moved to Baton Rouge General, where he worked with some of the top heart surgeons in Louisiana. In 1995, he began working with the inmate population at the Louisiana State Penitentiary.

I am the RN night-shift supervisor at the Louisiana State Penitentiary. I started in 1995 and have been here ever since.

I was two and a half years into nursing school when my dad died of cancer. Because of my training, I was able to be there in the room with him when he took his last breath. I was the only one in my family who was there at the end, and that experience gave me a strong motivation to finish school. I had a close friend in high school whose dad was a nurse anesthetist, and that is what I thought I wanted to do. However, the more I talked with patients and their family members, the more I moved away from the idea of being a nurse anesthetist. I decided I didn't want to sit behind someone's head for two hours and then never see them again; I wanted to stick with bedside nursing.

I worked at a lot of hospitals, always chasing a bigger paycheck, but then I decided I wanted to find a job I really liked. I saw an ad in the paper for a prison-nursing job and decided to apply. I didn't hear back for four months, and then they offered me the job.

You have to be a certain kind of nurse to fit into the mold up here. You can't get too attached to the inmates—that is frowned upon. We have certain rules and regulations that at first seem stupid, but then you realize it's all about security. For example, we can't bring in more than a small amount of hand cleaner because if you mix it up with salt, the stuff can blow up. Or, if you drop a needle, someone will pick it up really quick and hide it in the hem of their jumpsuit. My job is health care, of course, but over the years I've learned to be security minded.

We've had some rough times here. One guy got a forty-five-pound weight dropped on his face, and it crushed his sinuses. The guy lived, but he was in bad shape and had to have a lot of reconstructive surgery.

We treat a lot of inmates for hepatitis C, which they get from tattooing or sexual transmission. It is less rampant than when I first came here in the mid-1990s, but we still see a lot of it. We have a lot of deaths, sometimes three or four in a two-week rotation. There are five thousand inmates, so that is a pretty high number.

Medically, we do everything we can for the inmates. They are sent to LSU if they need hospital treatment. Several of our inmates go all the way to Baton Rouge for treatment. We have a few quadriplegics who we treat and at least three inmates who died of Lou Gehrig's disease. We have some hospice care going on here too.

I was recently trained to do dialysis, which is pretty much a whole subgroup of nursing. I was thinking about getting a job closer to my home, but then I realized that after twenty-nine years, I have become so accustomed to this place that it is almost like I am institutionalized myself.

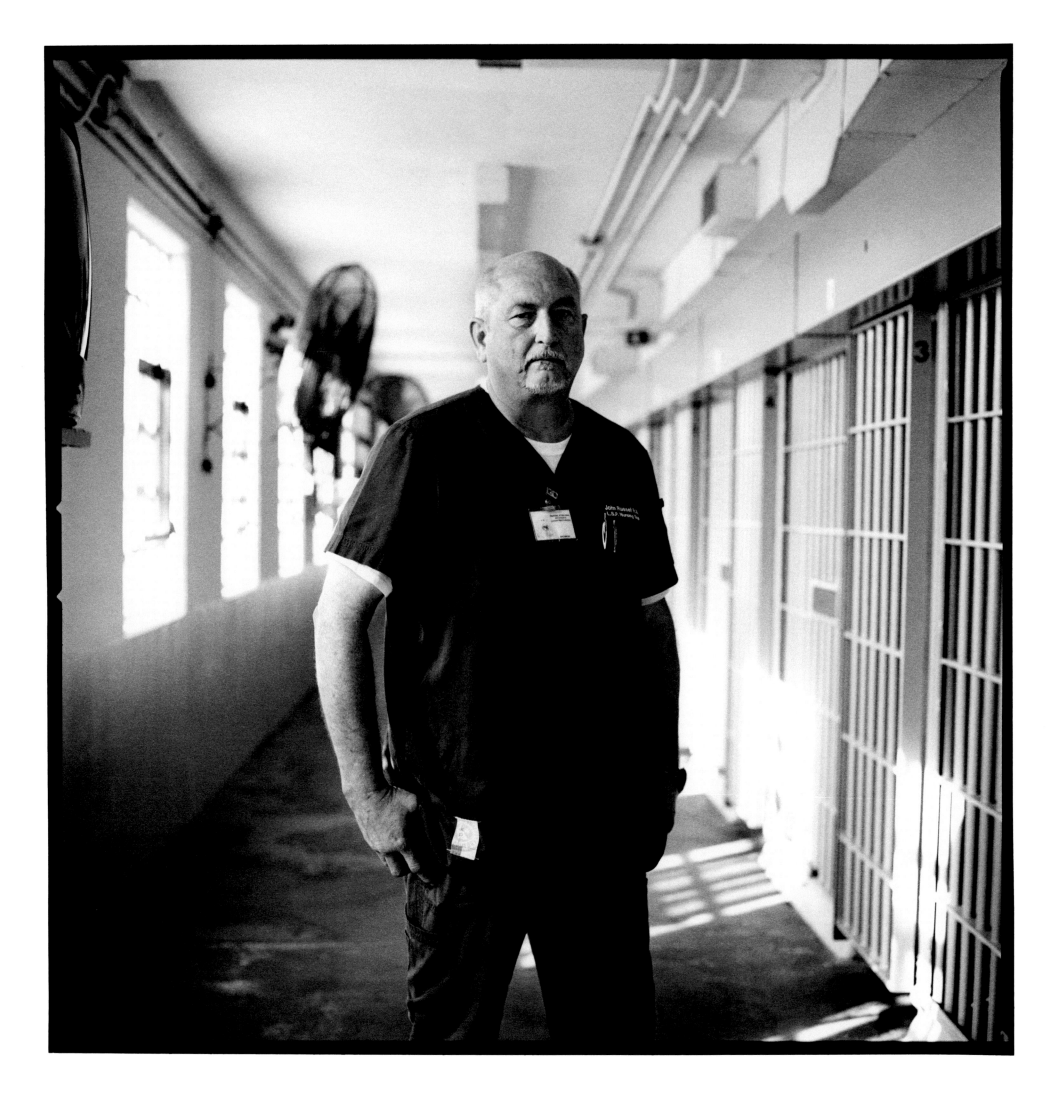

MARY KATE WALKER

MONTEFIORE MEDICAL CENTER, BRONX, NEW YORK

Mary Kate Walker, BSN, RN, grew up in Warwick, New York, with two sisters and received her BSN at the College of Mount Saint Vincent in the Bronx. She started at the Children's Hospital at Montefiore (CHAM) in August 2009 and has been a nurse for three years. She values the nurse/patient relationship and hopes to one day be as good a nurse as her godmother, who was her original inspiration for going into nursing.

I am a pediatric hematology/oncology nurse at Children's Hospital at Montefiore in New York.

I have many family members who are in the medical profession. As a child, I would listen to their stories and noticed that the doctors would focus on the disease or different conditions, but the nurses would always tell stories about their patients or the families. It helped me realize that I wanted to be telling stories about my patients, not what brought them to the hospital.

I love working with kids, and I learn so much every day. I love my job and couldn't imagine doing anything else. I know that this is the job I was made for. It is what I was born to do, but some days are rougher than others. Since I started working here, about fifteen of our patients have passed away. In general, I think we need to come to terms with the fact that people are dying and let go a little sooner than we do. It's so hard to say that because I watch them and I hold out for every one of my patients to survive. And I never, ever want to see them pass away. But I think we have a very hard time with death in this culture.

It's insanely hard to be there when a child dies. Fortunately, I have great colleagues who help me deal with it. Some of them have been in the profession for twenty years, so they have a lot more experience than I do. I have a very strong belief in the Catholic Church, which helps me enormously.

Technology is a big part of my job, and I really like that. We have the technology to store all of a patient's medical history in one place, which I think is amazing. Now we can scan the patients to make sure that they're getting the right medication, and that's great. I've basically grown up on a computer, so I can help my older colleagues with the technology part of nursing. In return, they can help me with any of my questions; for instance, how do I comfort a family who has learned that their child has cancer?

In addition to my regular duties—hanging blood products, administering medications, and delivering chemotherapy—I try to make the lives of my patients as normal as possible. For example, we were slow the other day, so I grabbed some nail polish and we painted everyone's toenails while listening to Justin Bieber on my iPhone. One of my patients said I could always go work at a nail salon because I'd given her the best pedicure ever. It was one of the best compliments I've ever received.

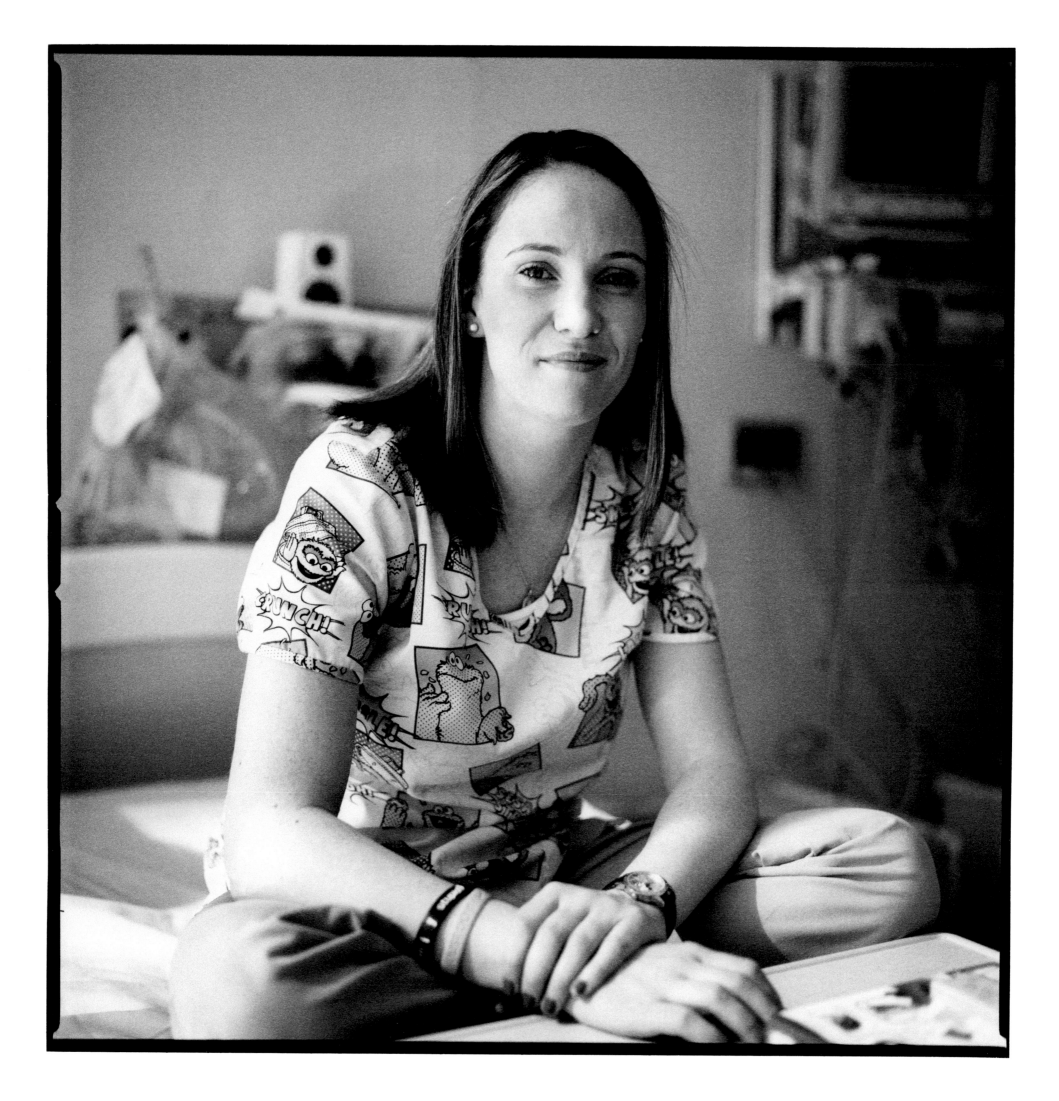

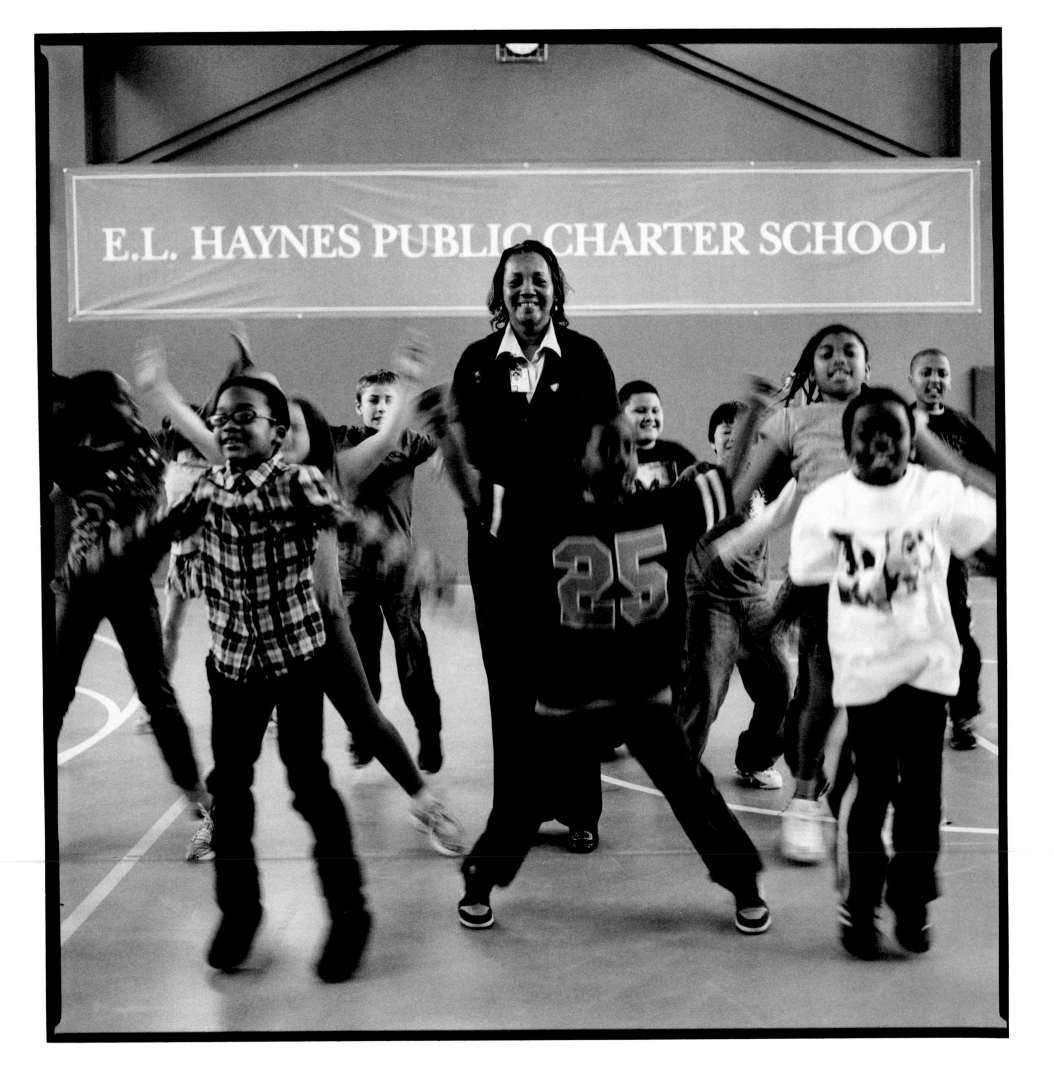

DOLORES CROWDER

E.L. HAYNES PUBLIC CHARTER SCHOOL, CHILDREN'S SCHOOL SERVICES, WASHINGTON, D.C.

I am an RN community-health nurse. I work as a school nurse at E.L. Haynes Public Charter School in D.C. They call me "Nurse Crowder," and I've been here three years.

My mother's oldest sister was a nurse. To me, she looked like an angel in her uniform. Everyone was so proud of her, and I hoped to be just like her. After high school, I wasn't sure I wanted to put in the work required to become a nurse. I thought it would be easier to become a social worker. However, I knew right away that wasn't the job for me, so I went back to school to become a nurse. I was twenty-four when I graduated.

I started on a surgical floor. After a year and a half, I transitioned into the PACU (post-anesthesia care unit), where I worked for five or six years. I began to realize that my heart was in working with kids and their families. I transferred to an outpatient unit, where I gave pediatric chemotherapy for about five years. This gave me the chance to become an important person in the life of a child who had a chronic disease.

When kids and their families come to the hospital on a regular basis, it becomes their second home. As a nurse, you have to help them feel comfortable and give the parents a break, if only to go eat or have a manicure.

It was a hard job, especially when you lost a child, but you had the satisfaction of knowing you helped make whatever time they had a little bit brighter.

I came to work at Children's National Medical Center and Children's School Services because I was fascinated that a major national medical center was connected to the school system. Also, I needed a new challenge in my life. I was assigned to this school, and they'd never had a school nurse. I had never been a school nurse, so we went through our growing pains together.

For this job you need to have excellent assessment skills and be very strong and confident. In some cases, you are the only health-care provider in the school. There is no typical day here.

We are advocates for the child. Sometimes we have to call the pharmacist about the child's medication. One of my boys had such bad chronic asthma that I spent three months getting approval for him to get transportation to and from school to avoid his attacks. Since then, he has not been to the emergency room. I get the health forms, and I try to assess the kid in terms of homelessness. It makes a big difference when the kids and their families know that there is someone here who is fighting for them.

Confidentiality is also important for a school nurse. I formed a girl's group so that the kids could come talk to me before school starts. Soon after, I had some boys who also wanted to talk.

This year my biggest goal is to work on nutrition and exercise, to teach both the students and their families how to fight obesity. I teach healthy eating, cooking lessons, grocery shopping, and hygiene. I am promoting the First Lady's initiative of sixty minutes of exercise every day. I am also pushing to get the school peanut-free because of all the allergies.

All the nurses I've admired have a compassionate, loving, caring spirit, and they want to give back. Nurses hold each other up, and we share a genuine love for what we do. The money is usually secondary. Nursing is something that requires dedication, and it becomes part of you.

I am not just a nurse when I am in school. I am a nurse wherever I go. It's deeper than just a job. Whenever I sign a legal document, I write, *Dolores Crowder, RN*, because that's who I am—through and through.

Dolores Crowder, BA, RN, was raised in Roxboro, North Carolina, and grew up in a loving, nurturing environment. Her fondest memories are of summer vacations and Sunday dinners with her extended family. An RN since 1984, Dolores is currently a school nurse whose primary role is to identify, care for, and prevent any health-related barriers to learning.

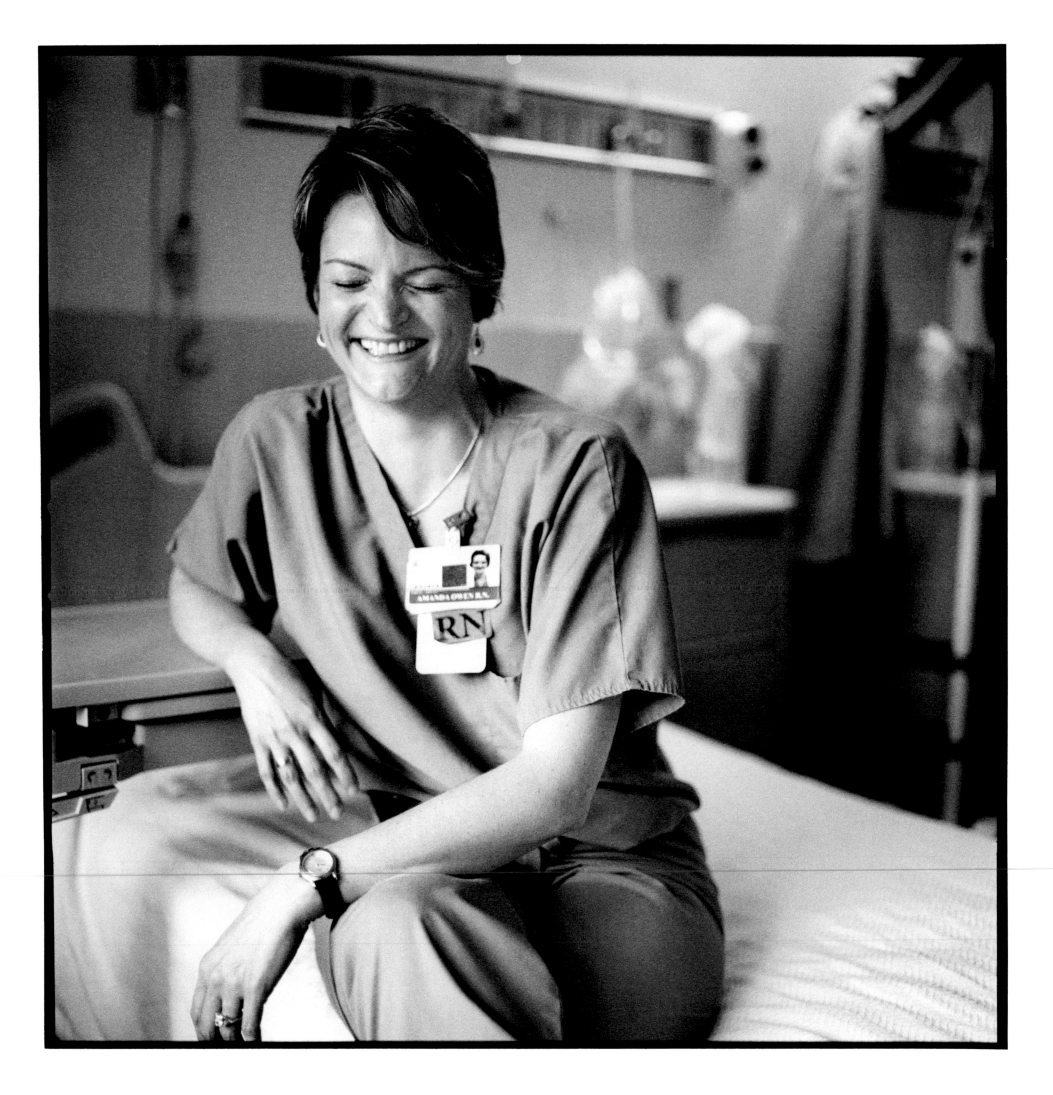

AMANDA OWEN

THE JOHNS HOPKINS HOSPITAL, BALTIMORE, MARYLAND

I am the wound nurse for the Department of Medicine at Johns Hopkins. I see all the inpatients who have wound-healing problems. We have people come from all over the world with very unusual autoimmune diseases or dermatological conditions. So I get to see a lot of things that other people generally don't see. I tell people I went to school to become this glamorous looker of disgusting things.

My nickname here is "Pus Princess." I don't talk about my work at cocktail parties because people think a wound nurse deals with gunshot wounds. I say, "Not so much; more like chronic, non-healing things." That usually ends the small talk.

I didn't choose wound nursing; it chose me. I was a nurse on a medical nursing floor where I saw all kinds of patients. My first successful wound patient was in the hospital for six months. I was able to try every wound product and technique on her to see what worked and what didn't. I am still in contact with her. Then we had another lady who had this horrible disease and who shouldn't have healed, but she did because she had specialized care. At the time, the department did not have anyone who specialized in wound care, so that became my specialty.

My work gets personal more often than I'd like. I have a fair amount of patients I see only one time during their stay, so I don't get close to them. But then there are some patients I consider mine. I've had one patient for more than nine years. She has sickle-cell disease and sickle-cell ulcers, and she has had every kind of therapy.

We are dealing with a lot of really sick patients, so often we lose them. We have a little saying in our community: "Oh, but they didn't die of their wounds." It's not a joke, but it does make us feel a little bit better.

Sometimes after a patient dies, we have formal debriefings with pastoral-care people, if it was a particularly tough case. Other times it's just the nurses sitting around at lunch talking about the patient and remembering what they went through. I don't know how some of those patients handle their wounds; they deal with it so much better than I ever could. I have a lot of faith, but it is hard to understand why there is so much suffering.

The hardest part of the job is dealing with a patient's pain. There is no getting around causing some pain during a dressing change, and I have a hard time when people are in pain. I try to be very gentle, take my time, and talk them through it, but it can be a very intense situation.

The patients have to trust me, and I have to establish that trust. We have all kinds of tricks to cut down the pain, but it's naïve to say that there's no pain. My style with patients is pretty informal. I try to use a lot of humor and connect with them.

Last spring I came close to burning out because of one patient. He was in the hospital for nine months, with a lot of complications. Everything went wrong for him. Toward the end he weighed about seventy pounds and had about thirty pressure-ulcer wounds and two surgical wounds. Everyone knew he was not going to heal. He was in excruciating pain, but he was always upbeat. I was the only one that he let do his dressing, because we had a system and he trusted me. He knew I wasn't going to hurt him. He would always ask about my son and be cheerful. He was only forty, and he had a three-year-old son. His wife really wanted him to

Amanda Owen, BSN, RN, CWCN, was born in Houston, Texas, and grew up an only child in Reston, Virginia. She earned a BA in biology and a BSN from the University of Virginia. Johns Hopkins was her first job straight out of school and is where she has remained for the past fifteen years. Today, she is a consultant for complicated and chronic wounds for medical inpatients. She teaches, writes, and updates policies on wound care and is the chair of the health-system committee for wound products.

stay alive, even though we all knew it would be more merciful for him to die. It was the most intense patient situation I've ever had.

Every day I would pray for him to die because no one should suffer like he did. It got to the point where it was too upsetting for his little boy to see him. One morning I came to work and discovered that he'd died at four o'clock in the morning. I just cried; I was no good for the entire day. I'll never forget him. Despite his pain, his attitude was unbelievable.

Nothing prepares you for that kind of situation. Toward the end, it was even too much for me. I couldn't sleep, and when I did, I dreamed about him. I wanted to shake his wife. I mean, I understand, but I believe in a merciful death. Sometimes I think we are less kind to people than we are to our animals—forcing a quality of life on patients instead of allowing them to die.

No one wants to tell the family that there's no hope, even when we know there isn't. We have a palliative-care specialist here who has a way of talking to the families that I could never do. She kind of pulls out of them what they think the patient would want by asking, "Have you ever talked about it? What do you think is going to happen?" She has a gift most people don't have.

Since we are a teaching hospital, a lot of our physicians are young. So the doctors are thirty-ish, and they've never had to deal with that kind of intensity. Older doctors have seen it all a million times.

I don't think we talk about it enough. I don't think we embrace it. In certain cultures, even our own a long time ago, people died at home. It was part of life. Now we have these expectations that people will live forever and survive all kinds of illnesses. Also, there are these TV shows—*Grey's Anatomy* and *House*—that raise people's expectations. But life is not like TV. We have these euphemisms for disease and death, and there's just a certain immaturity, I think, across the board with this topic of death and dying.

Even though it is very hard sometimes, I never think of quitting my job. I'm a lifer. I'm probably a lifer here at Hopkins. I keep moving farther and farther away, and commuting longer distances to get to work. Now I live about an hour away, but the last ten miles I drive by horse farms. On the way home, I get to decompress. I can be wound tight as a drum when I leave here, but the drive helps me. I make calls while I drive, and once I get home, I'm ready to start dinner and my nighttime ritual.

I can't imagine what else I'd ever do with my life.

ROBIN McPEEK

HOME CARE HEALTH SERVICES, PIKEVILLE, KENTUCKY

I am the clinical director at Home Care Health Services, and I also work in conjunction with Appalachian Hospice. For twenty-one years, I've been with Home Care, which has a home-and-community-based waiver program. We provide homemaker services, personal-care services, and some home modifications to Medicaid clients. I work with scheduling patients, insurance, and all the day-to-day things needed to keep it all functioning.

After I finished high school and college here, I married into a coal-mining family. At first, I went into neonatal intensive care, where I stayed for several years; I really liked it. Then I had a child, and my mother got sick, so I didn't work for a while. After my mother died and I was ready to go back to work, I didn't want to go back to a hospital situation, so I decided to try home health care. I thought I'd be there for a few weeks, but it's been more than twenty years.

After the first two weeks, I was hooked. I would go see these old people, and they would be so happy to have some help because they were so sick and alone. They couldn't drive, and no one came to visit. Sometimes I was their only visitor in a week. They appreciated me, and I could see I was making a difference.

This area is rural Appalachia, and we have a lot of respiratory-related disease. Black lung is prevalent because of the coal-mining industry and the large cigarette-smoking population. We see a lot of congestive heart failure in relation to black lung because the heart is working so hard to pump blood and get more oxygen. We also see a lot of diabetic wounds. Though we try to educate people, they often don't put the information to use. You walk into the home where you are prefilling insulin syringes and find a box of Little Debbie cakes on the kitchen table.

The mining and medical industries are the two biggest employers around here. Many young men go into coal mining right from high school. A coal miner makes decent money and that looks good to someone who is young. After about ten years, they start experiencing shortness of breath, and by forty they are having serious respiratory problems. If they reach their sixties, they are dependent on oxygen. As it progresses, they can't even lay down at night; they sleep sitting up or leaning on something just to breathe.

In the course of all the years I've worked for Home Care Health, I've seen some really shocking home situations. We have homes where you have to walk on the floor joists so you won't fall through the floor. We have homes where the refrigerator has fallen through the floor, and the family keeps using it that way, or homes that are heated completely by coal fireplaces. I've been to places where I had to flush out maggots from people who had bedsores. Sometimes, in warm weather, I walk out of a house and there are fleas on my clothes.

Robin McPeek, RN, was born in eastern Kentucky, the fourth of five children, and moved to Michigan when she was two years old. At ten, the family moved back to Kentucky. She has an AD in nursing from Prestonsburg Community College. She started working as a nurse at Pikeville Medical Center and moved on to Home Care Health Services after they cared for her mother when she was dying. She's been with Home Care for twenty-two years. As the clinical director, she supervises the nursing staff, handles scheduling, and deals with insurance, among many other duties.

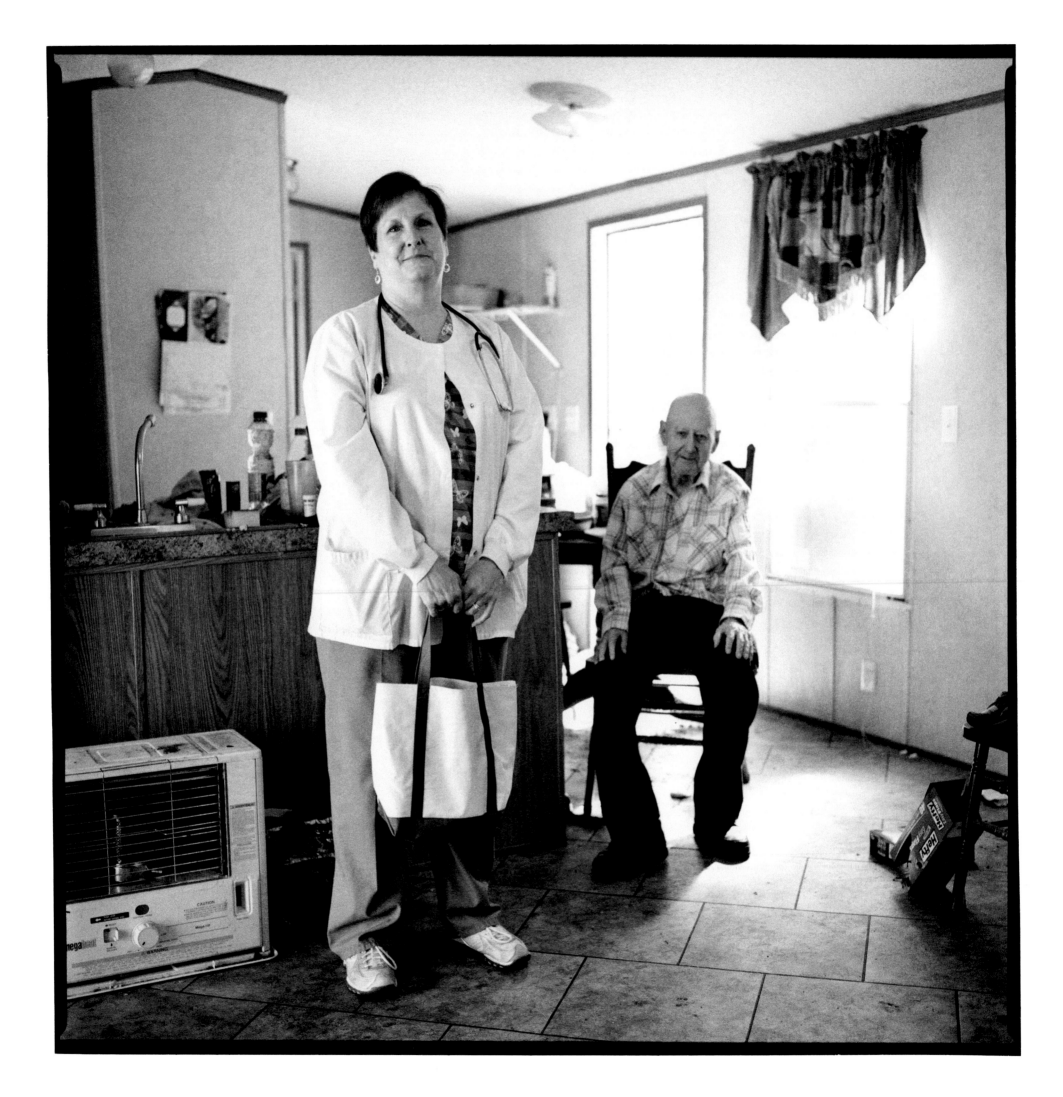

I went to one home where I drove through weeds taller than my Jeep and pulled into an open area where several small trailers were parked. When I stepped out of my car, a swarm of children came running over and took me to the house. The oldest was about eight, and she had this naked two-year-old in her arms. While I was weighing the child, I asked why they weren't in school, and the eight-year-old told me that her mother was still sleeping. The infant was supposed to be on special formula, and the girl said she had already fed her.

The father came in and stood watching me as I checked the infant's vitals. He didn't want me to be there and let the eight-year-old answer all my questions. It was clear that this young girl was responsible for all the kids, including a nine-month-old baby. I never met the mother the whole time I was taking care of those children.

Once we were treating this other elderly woman who had been in and out of the hospital several times, and we were sent to her house, which was a trailer with cracks between the walls. It was pitiful. She lived there with her husband and two little children, on a mattress on the floor. There were animals in the house and feces on the floor. The lady was on the mattress without any sheets, just ragged quilts covering her. The children were so dirty that you could not tell what color they were. They had a fear of social workers. The lady was supposed to receive daily dressing changes, but we would come back a couple of times a week, and there were no dressing changes. We can only do so much.

When I first started in this job, I had a lot of paperwork that had to be signed, but not a lot that had to be transmitted to state and federal. As the years went on, we saw a lot of change as home health care became more utilized. During the Clinton Era, when they made major medical reforms, we saw a lot of pay cuts to home health care, and also an increase in the paperwork. They wanted to look at comparisons between patients and agencies to make sure we were meeting certain guidelines. As time passed, we've seen a lot more budget cuts and a lot more requirements for paperwork. Medicare now requires a tremendous amount of paperwork. We have nurses who are assigned completely to paperwork, with no patient care. I spend 80 percent of my time doing paperwork and working with insurance; the bulk of mine is Medicaid.

Medicaid is a very stringent program in terms of income. We find that we can only take care of a married couple if they have a monthly income of no more than $2,000. They have to sign an estate-recovery paper, so that Medicaid can take their home and property after their death to recoup the money. Most of these people have worked really hard and have very little, but they want to leave whatever they have to their children.

Sometimes our hands are tied because of what insurance will cover. Our resources are very limited. You can't afford to provide services if you can't get paid. Over the past two decades, I've seen that a lot of budget cuts are made on the backs of the people who can least afford it—the elderly and the disabled.

SHARON KOZACHIK

THE JOHNS HOPKINS UNIVERSITY SCHOOL OF NURSING, BALTIMORE, MARYLAND

Sharon Kozachik, PhD, RN, was born in Charlotte, Michigan, and is the youngest of five children. She was inspired to become a nurse by her Aunt Ellen, a nurse supervisor on the maternal child unit at Sparrow Hospital, and by the TV show Julia, *which starred Diahann Carroll as a nurse. A research scientist studying pain and sleep disturbances, Sharon teaches a required course in the undergraduate nursing program at the Johns Hopkins University School of Nursing and encourages her students to become interested in research.*

I am an assistant professor in the Acute and Chronic Care Department in the School of Nursing at Johns Hopkins University.

I graduated from Lansing Community College with an RN associate's degree, which was all you needed back then to sit for the nursing boards. When I took the boards, in the mid-1980s, it was with paper and a pencil, and it took two days. Now it's computer-generated and takes about one hour.

I started working as a nurse in psychiatry, with patients who were chronically mentally ill and didn't have good health insurance; they were covered either by Medicaid or bare-bones private insurance. After a few years I got bored, so I went to work at the Michigan Reformatory, a prison in Ionia, where I did ambulatory and emergency care for four years. I learned a whole new set of skills and worked with young, violent offenders between the ages of fifteen and thirty. At the time I was also going to school for my bachelor's degree, and that inspired some of the inmates to get their GEDs.

I believe that a nurse is not just there to administer to patients; we also serve as role models. Nursing has always been an occupation that's highly trusted by the public, and I take that trust to heart. I always want to be a good role model and provide the very best of myself and the best care.

I also believe that being a nurse means you have to challenge yourself and to continually grow and evolve. After four years in the prison and completing my bachelor's degree, I went back to working in mental health and got my master's in gerontological nursing. On my first day of class at Michigan State University I met Dr. Barbara Given, my professor. She was so enthusiastic about research that it was contagious; she inspired me to become a researcher. Today, I have my PhD, and I teach research in our undergraduate program.

As a bedside nurse, I could touch one life at a time, but as a researcher, I can impact the health of countless thousands of people. As a scientist, I study pain and sleep disturbance in the context of cancer and cancer treatment. We have discovered that there seems to be a long-term, adverse effect on pain when people don't sleep well. I would love to see more physicians address poor sleep because it is so important.

I teach my students simple, common courtesy things that everyone can to do protect the sleep of the patient: carry a flashlight at night and never turn on the overhead lights if it's not essential; turn the IV pump away from the patient so the blinking lights don't disturb their sleep; be quiet (with the tile floors in the hospital, every little sound carries); don't talk loudly; and turn off your cell phones when you are on the unit at night.

When I was a nurse, we hand-calculated everything and often mixed our own drugs. Now everything comes pre-mixed, and technology has changed the way we do things. I love technology, but I trust it about as far as I can chew it up and spit it out. I always admonish the students not to trust technology because it is fallible. You can't give up critical thinking because you have a machine.

We have students here with prior degrees in all kinds of subjects: fashion design, liberal arts, musical theater, financial planning, and the classics. I hear two prevailing reasons why they come to nursing: one is that they are looking for a recession-proof profession, and the other is that they once helped care for a loved one who was sick.

I love helping students learn, and I think when you love what you do, you can excite students. I have to say we teach some exceptionally bright nursing students here. I have the best job in the world, and I get paid to do what I love doing. How lucky am I?

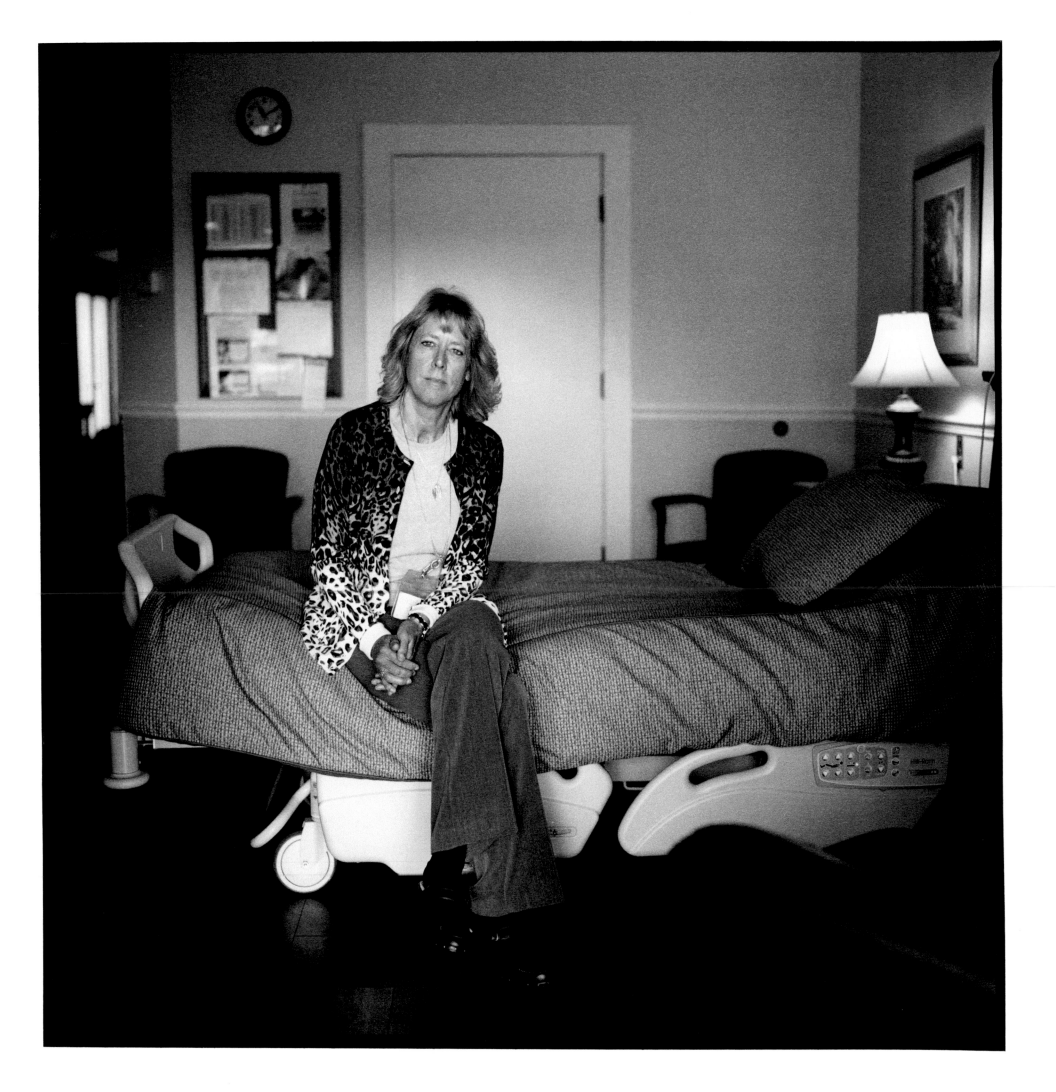

JENNIE GABLER

TIDEWELL HOSPICE, SARASOTA, FLORIDA

I am an RN case manager for the Sarasota home team for Tidewell Hospice.

The turning point in my life that made me decide to get my nursing degree and to pursue a career as a hospice nurse was when my father passed. In 1990, my father was diagnosed with prostate cancer. He had surgery and radiation and did well for about nine years. His last year of life, when he became symptomatic, I tried to convince him to seek hospice. He and my mother refused. Three weeks before my father passed, my mother called and asked if I could come. The day I arrived we called hospice, and their care began. My dad had a nurse visiting and nursing assistants bathing him. He would joke and flirt with them. When it came time for me to take my nine-year-old daughter back home to school, my dad said, "I know you can't stay, but it sure would be nice if you could." I sent my daughter home on a flight by herself and stayed until my father passed a week later.

I went into nursing specifically to become a hospice nurse. I've always believed in the hospice philosophy.

Almost every day someone says to me, "I don't know how you can deal with death every day." The simple truth is that I just wanted to make a difference, and I felt this was what I wanted to do for others.

There are very few really memorable moments in a lifetime—birth, graduation, wedding, and death. These are the things you remember. I try to facilitate a death that creates a good memory.

You can't learn hospice nursing in school. It has to be something that's in you. I feel that it was my calling.

To me, the philosophy of hospice is to provide comfort and dignity at the end of life for both the patient and the family. For the patient, this means allowing them to make choices for as long as they can and to live the highest quality of life within their limitations.

The loss of independence is huge for anyone. No one wants to feel like a burden, especially to their loved ones. It's very difficult when the patient becomes dependent on the caregiver. Sometimes the wife wants to care for the patient, but she doesn't have the physical strength to do so. That's a huge challenge. The family— the husband, wife, daughter, or son—should be the emotional support, not the nurse.

Hospice care does bring the family together. As a nurse case manager, I can help gather the resources and guide the family. I tell the family not to wait until the patient is taking his last breath. This is when the family needs to pull together and be there for each other. I frequently get the family to come together as a hospice team, and those cases are the best ones. It is very rewarding when you can help facilitate that.

Jennie Gabler, RN, BSN, CHPN, was born in Highland Park, Michigan, and grew up with five siblings in Hazel Park, near Detroit. As a single parent of two kids, she had to postpone her dreams of being a nurse. After her father died in hospice care, she went to nursing school and was forty five years old when she graduated. She worked on the cardiac floor as a student but then achieved her goal of becoming a hospice nurse. She graduated from the State College of Florida with a BSN and hopes to care for the impoverished in a third-world country one day.

NANCY BLANCK

VILLA LORETTO NURSING HOME, MT. CALVARY, WISCONSIN

Nancy Blanck, BSN, RN, was born on a farm in Fond du Lac, Wisconsin, one of five daughters. She graduated from Marian University in 1972 and has worked in several different nursing fields. She started in a hospital, did staff nursing, and then worked in a small home-care agency for eighteen years. Since then, she has worked in a nursing-home setting at Villa Loretto. Nancy has been a nurse for forty years and still gets goose bumps when she puts a smile on the face of someone who is dealing with pain.

I am an RN and staff nurse at Villa Loretto in Mt. Calvary. We have fifty residents here, mostly between the ages of seventy-five and ninety. Most of them can no longer take care of themselves because of Alzheimer's, dementia, or some physical disease. They need help with feeding and managing their medical needs. We are keeping residents alive a lot longer, so there are more complications as far as the progression of different diseases.

When I was about ten years old, my grandmother got sick and I stayed with her in the hospital. After that, I said to my mother, "I want to be a nurse." I'm not sure where that came from, but I guess I just admired the nurses who took care of my grandmother.

After I graduated, I moved with my husband to Idaho, where I worked on an orthopedic floor in a hospital for several years. Then I was an infirmary nurse at the University of Idaho in Moscow. We moved back to Wisconsin, and I worked in a hospital for eight years. From there on I did home care for eighteen years. I started working at a nursing home in Holstein about ten years ago, and then came here to Villa Loretto two years ago.

I like working in long-term care because you really get to know the residents. In a hospital, the patients are in and out too quickly to form relationships. Of course, when I first started in nursing, people stayed a lot longer in the hospital than they do now. Anyway, I find this a much friendlier place to work.

In the past, people came to nursing homes mainly to die, but now we do a lot of rehabilitation. We have found that people who come to nursing homes are much sicker than they used to be and have a lot more medical needs. Some are on antibiotics or need IV fluids or even chemo. We are doing that more frequently in nursing homes than in the past. I think it's partly because it is cheaper to do it here than in a hospital setting.

Years ago, the staff was maybe half RNs and half LPNs. The rest were CNAs or nursing assistants. Now I think we have an RN on every shift, day and night. The job has definitely gotten more technical, and LPNs don't quite have the background to do some of the tasks required.

It is not hard for me to see people die. My whole idea of death has changed, particularly in the past two years that I've been here. The residents with Alzheimer's or dementia, well, it's not fun for any of them, and I think they are more than willing to let go. We make sure they are not in any pain and that they are comfortable, and we try to help the families deal with the situation. Personally, I think we do far more tests than are necessary. I understand that the family may not want to let go, but the important thing is to put the quality of life of the resident first. I think if the family members lived on the floor for a week with their loved one, they'd understand that there's nothing more that can be done. We try to develop a real relationship with the family so we can be helpful when the time comes.

I truly love my job. I am also an animal lover, and we all enjoy the farm. We just got some angora rabbits, and there are always dogs and cats around. The residents love to talk about the animals, especially in the summertime, when the new babies come. It's a really nice thing for them. I particularly love the fainting goats. They're called that because when they get scared, they fall right over.

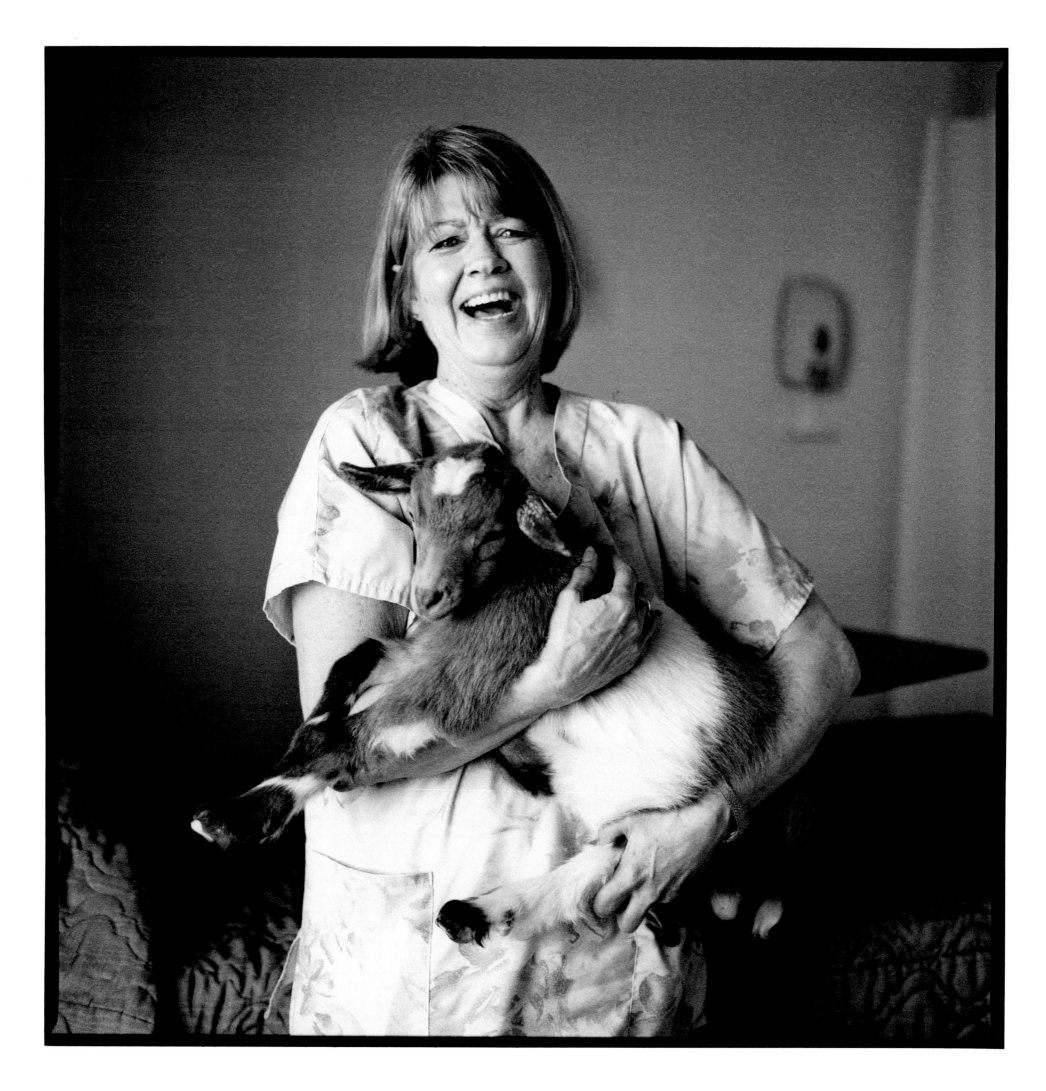

JOHN BARBE

TIDEWELL HOSPICE, BRADENTON, FLORIDA

I am a registered nurse, and I work at the Tidewell Hospice House in Bradenton, Florida.

At first I thought I wanted to work in pediatrics, but then my son was born, and I didn't think I could handle pediatrics, so I came back to hospice, which is really my first love. I like working here because I get to spend time with the patients. In a hospital you are running around giving out meds and don't have time to actually connect with the patients. I've met some really interesting people, especially some of the World War II vets, and there aren't too many of them left. They have amazing stories to tell, and I am honored to care for them. It's very rewarding to go home at the end of the day and know that you've helped someone at this point in their life.

I like working nights because it gives me more time with my family. At night, not so much is going on in terms of administration or politics, and there is more intimate one-on-one time with the patients and their families. Also, there aren't so many visitors coming in and out, so it's a homier atmosphere.

Some patients we only take care of for a few days, some for months. There was one young gentleman who was in his mid-teens and just wanted to play video games and go hang out. He had his mind, but his body didn't function anymore, and he needed help with almost everything. But it was so cool because I could take him out in his power wheelchair. We'd go for a walk down the street, and it would make his week. It's very special to be able to do something like that for someone.

I remember one lady who didn't talk to anyone and didn't seem to have any friends or family. I went into her room one morning and said, "Hey, Sunshine, how are you today?" She opened her eyes and started talking to me. Everyone on the floor was amazed that I got her to talk, but it turns out she had a brother who used to call her Sunshine, and that resonated with her. I assisted in her care for the next three weeks. It was just one of those things. The patients come and go, and you can't grab onto all of them, but sometimes you can connect with one of them.

Here we see every kind of religious and spiritual belief. I see people who have believed their entire lives, and they die with their beliefs intact. I see other people who haven't believed in anything their whole darn life. I see some people who really want to believe. Everyone is different, but they all go through a gamut of emotions at the end. And, at the very end, it's the same for everyone, no matter if you believe or not. Everybody's a book with many different chapters, but at the end you close the book, and it's done.

We are all going to get to the same place—no matter how much money you have—and the only thing that matters is what you have done with your time in between.

When I am out in the community and get asked what I do for a living, I say that I work at Tidewell Hospice, and there's complete silence. You can hear the crickets chirping. It doesn't matter because I love what I do; I can't stay away from this place.

John Barbe, RN, was born in Bradenton, Florida, and has lived in Manatee County for his entire life. He has an older sister, and their father died when John was only five years old. He became interested in hospice work when he first started nursing. His mother is a CNA and always encouraged John to follow in her footsteps.

JOANNE STAHA

NYU LANGONE MEDICAL CENTER, NEW YORK, NEW YORK

Joanne Staha, RN, BS, OCN, grew up in Chesapeake, Virginia, with her two sisters and a brother. She graduated with a bachelor's degree from Virginia Tech and then received an associate's degree in nursing from Marymount University. She began her nursing career in 2000 at Virginia Hospital Center and is currently working as an infusion nurse at the NYU Langone Clinical Cancer Center, where she administers chemotherapy infusions and provides education and emotional support to her patients.

I am a chemotherapy infusion nurse at NYU. I've been a nurse for twelve years, and I've been here for the last seven years. Originally I went to Virginia Tech for finance, but I had a hard time. My professor once said to me, "You just don't get it." I didn't, but I got my degree in finance anyway. I started working as a medical assistant to a plastic surgeon who was willing to train me.

I loved working with his breast-cancer patients and decided to go to PA (physician assistant) school, but I didn't get in. Nursing seemed an easier route into the medical field, and it proved to be easy for me.

When I got out of school, I went to a local hospital and worked on their oncology unit. Then I did some hospice care, but after the second year I burned out. I was done believing there was a higher power up there that took care of us because it was so unfair to see these young people die. My mom reeled me back in. "You can't ask why," she told me. "It's just the way it's supposed to be."

Right around then, I met a travel nurse and thought her job was fascinating. Travel nursing works like this: you sign up with a company and pick a location where you want to go; they find a job for you. My first assignment was in Denver; I was there for six months. I worked in California and Virginia, and then I came to this cancer center in New York City, where I always wanted to live. I loved the job, the people who work here, and my patients. As an outpatient nurse, things are a little different than inpatient. You don't work nights or holidays, but you do work weekends.

My patients are all so strong and uncomplaining. It's a wonderful population of people. I had one young woman with sarcoma. She didn't deserve what she went through. She showed me how to be strong. She passed away a few years ago, at thirty-five, and hardly a day goes by that I don't think of her.

I try to give hope to my patients, especially the ones who are back for a second or third treatment. I have one patient who has gone through many different kinds of chemotherapy. She didn't know how she was going to keep trying. I said, "You don't have to do it if you don't want. But if you don't try, how will you know?" My whole thought process is that you don't know if it is going to work unless you try it.

Typically I see five to seven patients a day. They have varying types of treatment. Some are IVs, and others are injections. Some are in and out in five minutes; others take six hours. No matter what condition the patient is in, I try my best never to let that person know I might be crying on the inside or feeling just tortured because of what they're going through. That's not what they need.

People are very anxious when they come here for chemotherapy. Where I excel is making them feel relaxed. I do tend to stay calm, even in an emergency. It's something I've observed in myself. I don't mean to be boastful, but I think I do a good job, and I am proud that my patients like me.

I think we get to see a side of people no one else does. These patients may have to put on a front with their family and friends. Or they are hiding their condition from their coworkers. We get to see the vulnerable side that they hide from others. This is the one place where patients can let it all hang out. They're at their most vulnerable, and we are here to help. As a nurse, you have to be strong to handle it.

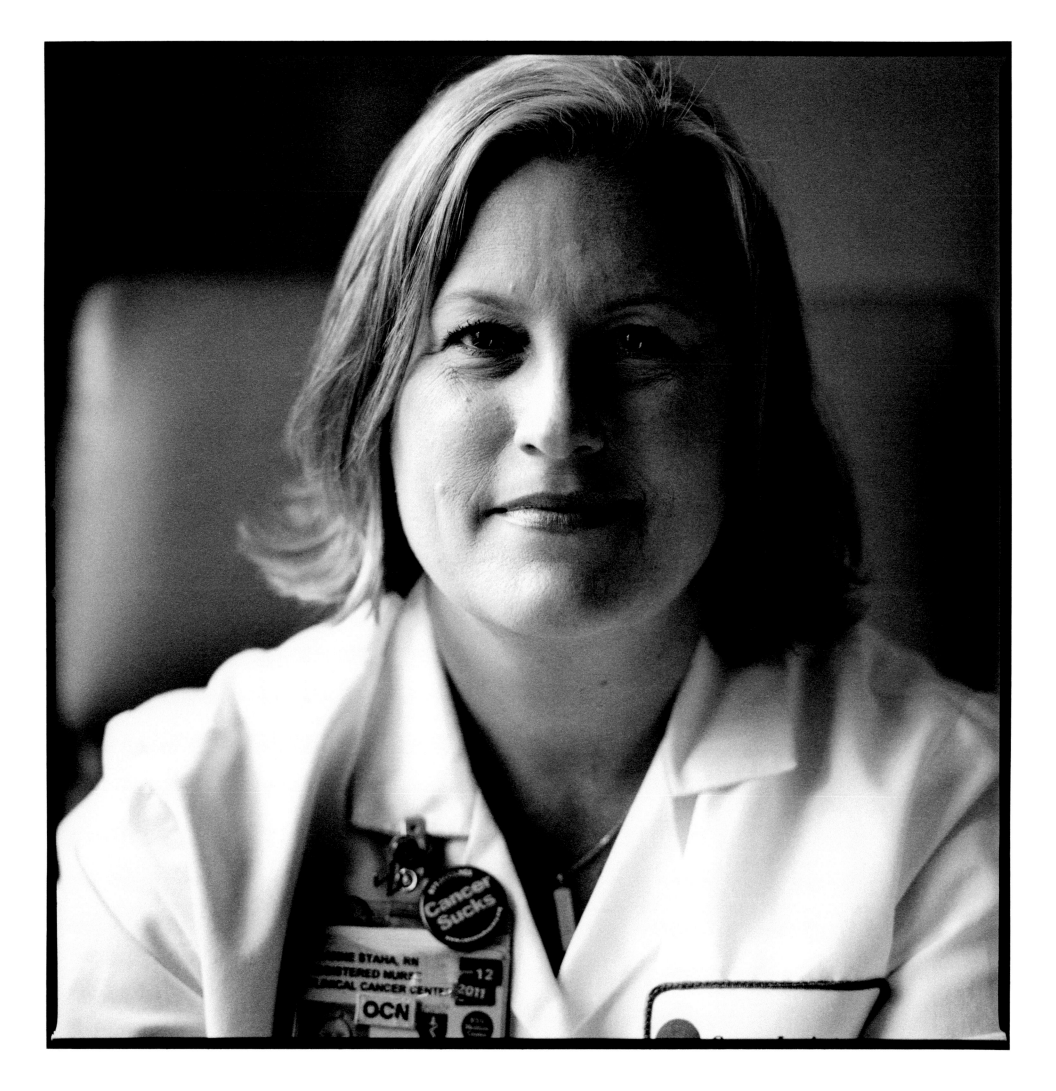

KEITHEN D. POTTS

INTERIM LSU PUBLIC HOSPITAL, NEW ORLEANS, LOUISIANA

I am a nurse manager at the Interim LSU Public Hospital and function under Nursing Administration. I oversee the day-to-day operations of the dialysis and sexual assault/crisis intervention units, write and review policies for the Division of Patient Care Services, and function as the research credentialing coordinator for our facility.

During my weekend visits home from college, I helped my grandmother take care of my great-grandmother, who suffered from Alzheimer's disease. My grandmother said I was a born caregiver and had the patience to deal with people, especially the elderly. At the nursing home where my great-grandmother later lived, I learned all the tricks of the trade from some outstanding "old-school" nursing assistants and nuns. I've been a nurse since 1998.

What I learned from taking care of my great-grandmother was to talk to the patient. When a nursing assistant would approach her and try to do something, my great-grandmother would smack her because she thought it was disrespectful to touch a person or reach under their clothing without first explaining what you were about to do. I learned from that experience how important it is to communicate with your patients.

I was working in the trauma ICU at LSU when Hurricane Katrina hit. LSU is a Level One trauma center. We came in like it was another normal day, even though we were on "code gray," which means we were preparing for the long haul during an approaching storm. I reported to work on Sunday; none of us realized what was going to happen.

After the initial storm, the flooding left us in a really bad situation, and from then on it was horrible. We're on the twelfth floor, and we could see out to the Superdome. There was no electricity in the Superdome, so all these people started trudging through the water to get to the hospital. I guess they figured we could provide some resources. Guards were posted at the doors to prevent anyone from coming in. We could barely manage the care of the very sick patients, much less the general public.

People in the hospital just started to lose it. They were hysterical. Some people just snapped and started hearing or seeing things. And then the rumor mill started. People didn't know what had happened to their loved ones.

Everyone talks about the police and the firemen, but not about the nurses—those of us who had to take care of patients through it all. We had to accommodate the people on ventilation when we had no electricity. We had to bathe the patients and change their dressings. We were there until Friday—five days in the sweltering heat. I am proud to say we only lost one patient during the storm. He had incurred injuries from a motor-vehicle accident and was in multiple-system organ failure. I think it was inevitable that he wasn't going to make it. I am very proud of our team and what we accomplished.

It was two weeks before I got back to my house, and it was still partially under water. I thought I'd need a truck for my things, but there was nothing left to salvage except some jewelry and my favorite pair of shoes. I moved to Chicago for four months, and a woman there asked, "Was it really as bad as we saw on TV?" I couldn't believe she was serious. Didn't she see the bodies in the street? It was, in fact, far worse than anything shown on TV. After that question, I refused to talk about Katrina.

I learned a lot about myself during the storm. I learned how strong I was as a person. My faith in God is what saw me through. My faith was tested, but I was able to keep standing. Katrina made me a stronger person. I try not to let things bother me the way they did before the storm. I really learned to take it day by day and appreciate my life and the people around me.

Keithen D. Potts, RN, BSN, was born in Monroe, Louisiana, the eldest of three kids, and moved west when he was a toddler. He lived in Nevada until he was sixteen years old. In 1993 he graduated from Louisiana Tech University in Ruston, Louisiana, with a degree in biological sciences and, in 1998, from Dillard University with a bachelor of science in nursing. He is currently a nurse manager handling operations in the dialysis and sexual assault/crisis interventions units.

TONIA FAUST

LOUISIANA STATE PENITENTIARY, ANGOLA, LOUISIANA

Tonia Faust, CCNM, RN, was born in Monroe, Louisiana, and moved to St. Francisville, about twenty-five miles from Angola, when she was five years old and her parents divorced. Her mother worked at Louisiana State Penitentiary for seventeen years. After high school, Tonia went to Northeast Louisiana State, in Monroe, where she enrolled in the nursing program, and then transferred to LSU at Alexandria, earning her nursing degree in 1997. She worked at the Occupational Medical Center in Baton Rouge and St. Francisville Country Manor Nursing Home Facility before getting her current job at the Angola penitentiary in 2001.

I am a registered nurse and the hospice-program coordinator at Louisiana State Penitentiary (LSP), the only maximum-security facility in the state. We have a death row. Everyone expects that it is a dark, dank place, but it's really quite beautifully landscaped. The cells are nicer than you'd expect.

I've always got my guard up, but I feel safe here. The security is right at your side all the time. A lot of people want to know how I can take care of people who have committed horrific crimes. I tell them that the people here have been incarcerated for the crimes they committed, and 97 percent of them will never get out of the prison system. I'm not here to judge them. My job is to take care of the health aspects of their incarceration.

The inmates in hospice care have six months or less to live. When I am working with a patient, my thoughts are in the present. I don't look at their rap sheets, and I don't know what the majority of my patients have done to be here. I don't want to know. I know they've done something bad, but my job is to take care of a human being as if they were a family member. I don't treat these patients any differently than I would a patient out on the street.

I've been at LSP for eleven years, but only recently got assigned to the hospice unit. What makes this program unique is that we have twenty-six inmate volunteers in the program, who do this work for no compensation at all. They have their regular jobs, and then they come here during their recreational or downtime—either daily, every other day, or if it's a vigil, then 24/7. They go through a forty-hour educational program and then work under a mentor with one of our patients through death. For the most part, the dying inmates have someone with them all the time; no one dies alone. I mean, that is a luxury that most of us outside this prison won't have.

It's truly exceptional to see these older, sometimes huge men sitting at the bedside of a dying inmate, reading or feeding them ice cream. The guys stay the entire time, and once the patient passes, they bathe and dress them for the morgue. Sometimes we even cry together. Then, when the body is gone, the volunteer will ask if he can go sit with someone else. You don't see this kind of compassion on the streets.

We raise money from charity rodeos and selling raffles to get supplies and equipment that the state isn't able to purchase for us. Mostly these are little things—M&Ms or grapes—that the patients request and we all take for granted. Last year, I think we had fifteen deaths, and the average age of the deceased was fifty-one. The majority of our hospice patients die from cancer. In terms of our volunteers, the majority of our inmates are lifers, and many of them came here at a young age, so they know they'll probably wind up here at some point. A lot of them say that coming here to help the dying is a calling for them; they just felt like they needed to contribute something.

We've become a model hospice program and get a lot of requests from facilities in other states wanting to know the details of our program. Recently, some research showed that our anxiety- and pain-management medications were a lot lower than in other facilities, which shows how well this program is working.

This job is emotionally draining, but very rewarding. I go home at night knowing I made an impact on someone's life. I feel blessed to be in this program.

BRENDAN HUNT

MONTEFIORE MEDICAL CENTER, BRONX, NEW YORK

Brendan Hunt, BSN, RN, CNOR, PCC, was born and raised in the Bronx, New York, along with his identical-twin brother and three other siblings. He graduated from Lehman College in the Bronx, with a bachelor's degree in science and a focus on nursing. He started his nursing career as a part-time nurse's aide at Montefiore before being hired for a full-time position. He worked the units for two years before transferring to the operating room. He has been a nurse for fifteen years, thirteen of those in the OR.

I am the patient-care coordinator for plastic surgery and otorhinolaryngology in the operating room at the Weiler Division of Montefiore Medical Center in New York.

I became a nurse after developing an interest in how the human body works. My inspiration came from my mother, who was diagnosed with multiple sclerosis when I was growing up. This led to an interest in learning how to help those in need. Over time my mother became progressively weaker, which was evident as she used to walk around the house holding onto the walls for assistance. Despite her challenges, Mom still made the effort to attend our Little League games, even if it meant not getting out of the car. As her condition progressed, she subsequently became wheelchair-bound. As children, we didn't really think about it—that was the condition Mom was in and her physical deficiencies never interfered with her being a mother. Mom's capacity to love and nurture outweighed the physical challenges. Besides, her mental sharpness and clarity always kept us in check. It never felt like we were missing out on anything.

I have an identical-twin brother who is five minutes younger than me. Even though we had the same background and grew up in the same environment, our individualities were allowed to flourish, and he went into advertising while I gravitated to nursing. It's just something that developed in me, even though I didn't think that many males became nurses. I had friends going into the field, and I am so glad they convinced me to do the same.

I think I am blessed with a lot of patience. I don't get rattled too easily, and I have a caring nature, which seems to thrive in the field of nursing. Every day I meet people whom I can help. I enjoy the caring aspect of the work and want to be supportive of the patients and their families. I take solace in knowing that in some small way, that through being part of a unique nursing specialty, I continuously contribute to improving the health of others.

As a patient-care coordinator in the operating room, my role is multifaceted. I have days where I have direct patient care. I help facilitate the entire process with the surgeon, assistants, anesthesiologist, and the scrub technologist, making sure that each patient's needs are uniquely met. My role also includes teaching and mentoring new staff members, inventory management for my surgical specialties, and being a role model and resource for the staff, peers, and nursing management. On my non-patient care days I work as the OR team leader, who directs the operating schedule for the day. It is a unique experience that allows for interdisciplinary collaboration among nursing, anesthesia, and surgery. Team leading requires extreme flexibility, making quick decisions, and mobilizing people and the resources needed to adequately care for surgical patients.

To be right on the edge of all the new technology, and everything that's happening around us, is an incredible feeling. It's amazing work, and I'm grateful that someone pointed me in this direction, because the possibilities and different avenues that you can take within nursing are *endless*.

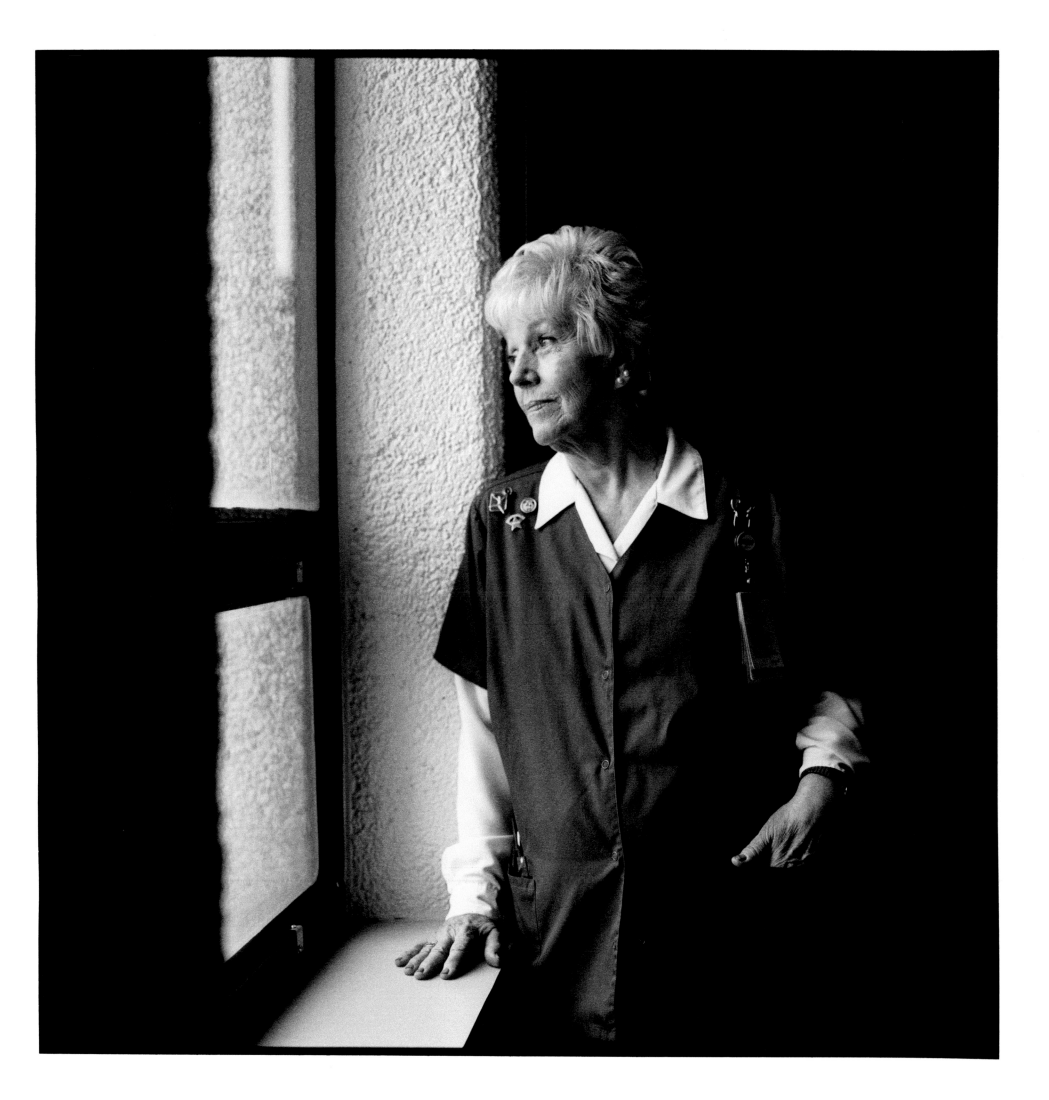

GOLDIE BAKER HUGUENEL

INTERIM LSU PUBLIC HOSPITAL, NEW ORLEANS, LOUISIANA

I work in the University Hospital, or Interim LSU Public Hospital, in New Orleans.

I was born in New Orleans and have always lived here. I've been married for more than fifty-five years, have two wonderful sons and daughters-in-law, five incredible grandchildren, and one precious great-grandchild. I live in the suburbs, in Metairie, but I call New Orleans my home.

I am probably the oldest nurse around here. I decided I wanted to be a nurse when I was four years old, and no one could change my mind. I used to put Band-Aids on my dolls and work on my brother and sisters when they scraped themselves.

When I was seventeen, I got a scholarship to Mercy Hospital, but I didn't want to go there. My family almost had a fit when I turned down the scholarship. Since I was a little girl I knew I wanted to go to the Charity Hospital School of Nursing in New Orleans. I graduated in 1956, more than fifty years ago, and went straight to work at Charity. I've never worked anywhere else.

Most of my hands-on nursing was in pediatrics. I was staff nurse, head nurse, supervisor, and then director of the whole pediatric area. After that, I was in administration. I retired and for six years traveled as a tour director all over the country and Canada. Then the hospital called and asked if I'd come back to the emergency room, which I did because I love emergency nursing. My job is to be a liaison between patients and the families working with the nurses. When someone dies, I do the calling to console the family. I went on to become certified as a bereavement facilitator and took some more courses for an advanced certification.

Then Hurricane Katrina hit, and she was mean. She closed us up at Charity. Dealing with Katrina was like dealing with the death of the city. Some things die and never come back. My high school and my church never came back. There are a lot of things in New Orleans that will never return. What I remember most about being in the hospital during Katrina was that not one nurse would leave until each and every patient had been evacuated. The patients in the ICU on the twelfth floor were carried down on spine boards in the hot, dark, slippery stairwells, and everyone did a hero's job of it. There was no panic, no one screaming to get out or anything like that. It was amazing.

About a year later, University Hospital opened, and I came back part-time to work again as a patient liaison. I am the bereavement facilitator for the hospital, not only for the patients and families, but also for nurses, doctors, staff, and anyone who needs my help. Everyone here can sometimes have really bad grief and stress issues, and I have some debriefing time with them.

I follow up with families after the death of their loved ones. I send them personal condolence cards and call the families to help them with bereavement issues. Sometimes they just want to talk; other times I recommend relevant support groups. There's a church on St. Charles Avenue that prays every Sunday for any person, and their family, who died in New Orleans the previous week. It brings comfort to some people. The other day I called a woman who had lost her forty-year-old son, and she could not believe I called. She said she had been terribly depressed, unable to get out of bed, and her family kept telling her she needed to move on, but she couldn't. She said she was down on her hands and knees screaming to God to send her a sign, and that is when the phone rang. "You were the sign," she told me. "God got you to call." She was going to call her daughters and take them out to lunch that day.

I was just calling to check up on her, but she insisted it was divine intervention; that kind of blew my mind.

Goldie Baker Huguenel, RN, NCBF, can trace her family roots back six generations in her native New Orleans. She has spent more than forty-five years working at Charity Hospital, until it was closed after being decimated by Hurricane Katrina. She now works as a bereavement facilitator for the Interim LSU Public Hospital, where she helps patients, families, and staff members to deal with grief and stress.

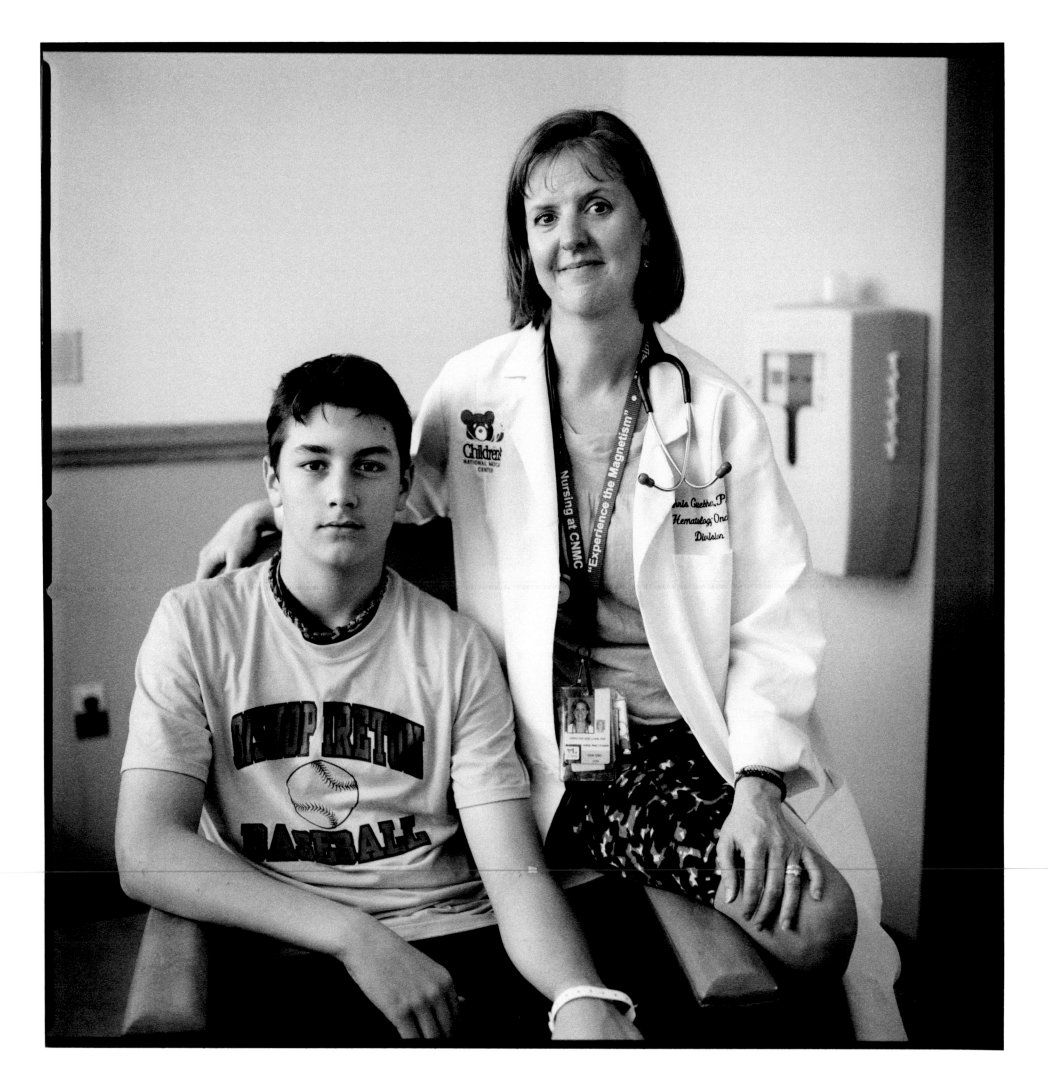

CHRIS GUELCHER

CHILDREN'S NATIONAL MEDICAL CENTER, WASHINGTON, D.C.

I am a pediatric nurse-practitioner at Children's National Medical Center in Washington, D.C.

I always wanted to be a nurse. When I was a kid, I liked medical play. I spent one summer reading *Gray's Anatomy* and educating my family about muscles and bones. My babysitter was a nurse and actually still works at the VA hospital.

When I went to nursing school, I had an open mind. I didn't know that I wanted to work with kids, which I actually thought would be intimidating. Then on rotation I had a boy with leukemia and fell in love with being part of his care. So, for the past twenty-three years, I've worked in pediatric hematology and oncology. Truthfully, I'd much rather work with children than adults. Sick kids are amazingly resilient; they can be getting chemotherapy, missing school, and still be playing and laughing.

I've had different roles over the years. I was on inpatient units and transitioned to outpatient nursing. Then I went back to graduate school and have been a nurse-practitioner for the last fifteen years.

I've seen some big changes in treatment over the past decade. Back then, we didn't have the anti-nausea or anti-vomiting medicines we have now. I can remember giving chemotherapy, and we just snowed the kids. They were asleep the whole time because if they were awake, they were nauseous and getting sick. Now, with the advent of new medications, the kids are up playing in the playroom and tolerating their therapy much better. This has made a huge difference.

Now I work with kids who have hemophilia. (There are about twenty thousand in the country.) We have about three hundred kids with various bleeding disorders. I have classes here for the families, and we teach them how to do their own infusions at home. Some of them have gone their whole life without meeting anyone else with a bleeding disorder. The kids get to meet other kids with hemophilia, while they practice giving injections. The older kids come back to mentor the younger ones, and parents with experience teach the new parents. It's remarkable.

I met Jimmy when he was an infant. There was a family history of hemophilia, so his mom knew he had a 50 percent chance of having the disorder. She was savvy enough to bring Jimmy in for testing, and we have been treating him ever since. His life has been remarkably normal, which is a testament to his parents who incorporated his hemophilia into his life without making it the focus.

I'm happy to say that because of the resources of the hemophilia treatment centers, we're able to educate families. A big part of my job is being an advocate in the community and educating local emergency rooms and pediatricians about the disorder. Kids with hemophilia don't bleed faster; they bleed longer. They aren't going to die from a scraped knee or paper cut. You can see everyone relax when you say that.

As a nurse-practitioner, I get to be independent, and it gives me flexibility to see patients, teach, and go out into the community.

I have two children myself—thirteen- and eleven-year-old girls. They know how much I love my job. I think it is a real gift to enjoy what you do for a living.

Chris Guelcher, MS, PNP-BC, grew up in Silver Spring, Maryland, with her sister; received an undergraduate degree at Georgetown University; and went to graduate school at the University of Maryland. She did her senior practicum in 1989 at Children's National Medical Center in D.C. After graduation she moved to Chicago and worked at Children's Memorial and then later at Mott's Children Hospital in Ann Arbor. When her husband finished law school, they returned to D.C., and she has been working at Children's National Medical Center ever since. Today, she coordinates one of 132 federally funded centers for the treatment of hemostasis and thrombosis, caring for 350 patients with various bleeding disorders, including hemophilia and von Willebrand disease. Chris is shown (opposite) with her patient Jimmy.

NURY ASTRID CUBILLOS

VA SAN DIEGO HEALTHCARE SYSTEM, SAN DIEGO, CALIFORNIA

Nury Astrid Cubillos, RN, MSN, was born in Bogotá, Colombia, in South America. She came to the United States when she was fourteen years old. She graduated with honors from the Community College of Aurora and obtained her BSN with honors at Regis University in Colorado, and her MSN/ED with honors from the University of Phoenix in May 2012. She joined the US Navy Reserves in 1996. She has been a nurse for eleven years in the emergency/trauma department and has toured in Asia.

I work in the emergency room at the VA hospital. I've been here for fourteen years.

I always wanted to be a nurse. Several people in my family were military nurses, and I was always proud to see them in uniform. I wanted to join the Army and did three years of ROTC in high school, but when I went to join up, I was two inches too short to meet Army requirements. So I went to college. Ten years later, they waived the height requirement, but I passed right by the Army and joined the Navy. Nothing against the Army, but I'm so glad I joined the Navy. I had the opportunity to see and do many more things.

I have been recalled three times for active duty. I have been to many different states in the US, and I did a tour of Asia on the USS *Mercy* for six months. We traveled to different locations on a humanitarian mission doing patient care and surgeries on civilians. We provided medical care to people who had never been to a doctor or a dentist.

My last deployment was at NMCSD Balboa as an emergency nurse. I cared for wounded warriors anywhere from forty-eight hours to a month after they were injured. One of my patients was an operating-room nurse who was wounded very badly in Afghanistan when their compound was attacked while they were in surgery. She was struck in the neck by shrapnel fragments and only survived because the surgeon wasn't hit. When she came out of the anesthesia, she began assisting others. She became my hero. I told her, "We'll get through this together." The rest of the day I kept giving thanks to God.

Working at Balboa can be very stressful, but it can be very satisfying to see sick people recover. We are on call twenty-four hours, seven days a week. I love my work because it is my passion in life. Helping a sick or wounded person makes me feel good.

Being a nurse is a lot more than taking care of pain with medication. It is about being there, listening to the patient, providing a smile, or telling an uplifting story. Technology is wonderful, but it is not the cure for everything. We must still hold on to the spiritual side of being a nurse.

Part of being a nurse is listening to the veterans tell their stories; it's a big part of the healing. Sometimes all they want is for you to listen. I have learned so much from their stories. Sometimes I wish I could find the words to make them feel better or help cure what they've been through. So I just listen, and I pray that God will give me strength to help when someone is in pain or having a difficult time. Every day you learn just by listening, looking, and getting involved.

Nursing is always nursing, but working with veterans is different. I am blessed to work with veterans because I am one myself. It's a different culture, a different population. Sometimes civilians don't understand. A lot of veterans come home and don't have jobs or are homeless. Employers should welcome vets with open arms. They served their country and kept us free and safe. It's our responsibility to give them jobs and take care of them when they come home.

I have a strong faith in God. One of the reasons is because I lost my seventeen-year-old daughter in a car accident a week before 9/11. I asked God, "Why?" And then 9/11 happened, and I said, "I understand why you took her. You needed a lot of angels to help with so much disaster." Now, every time we lose a patient, I say to God, "Here is another angel coming Your way."

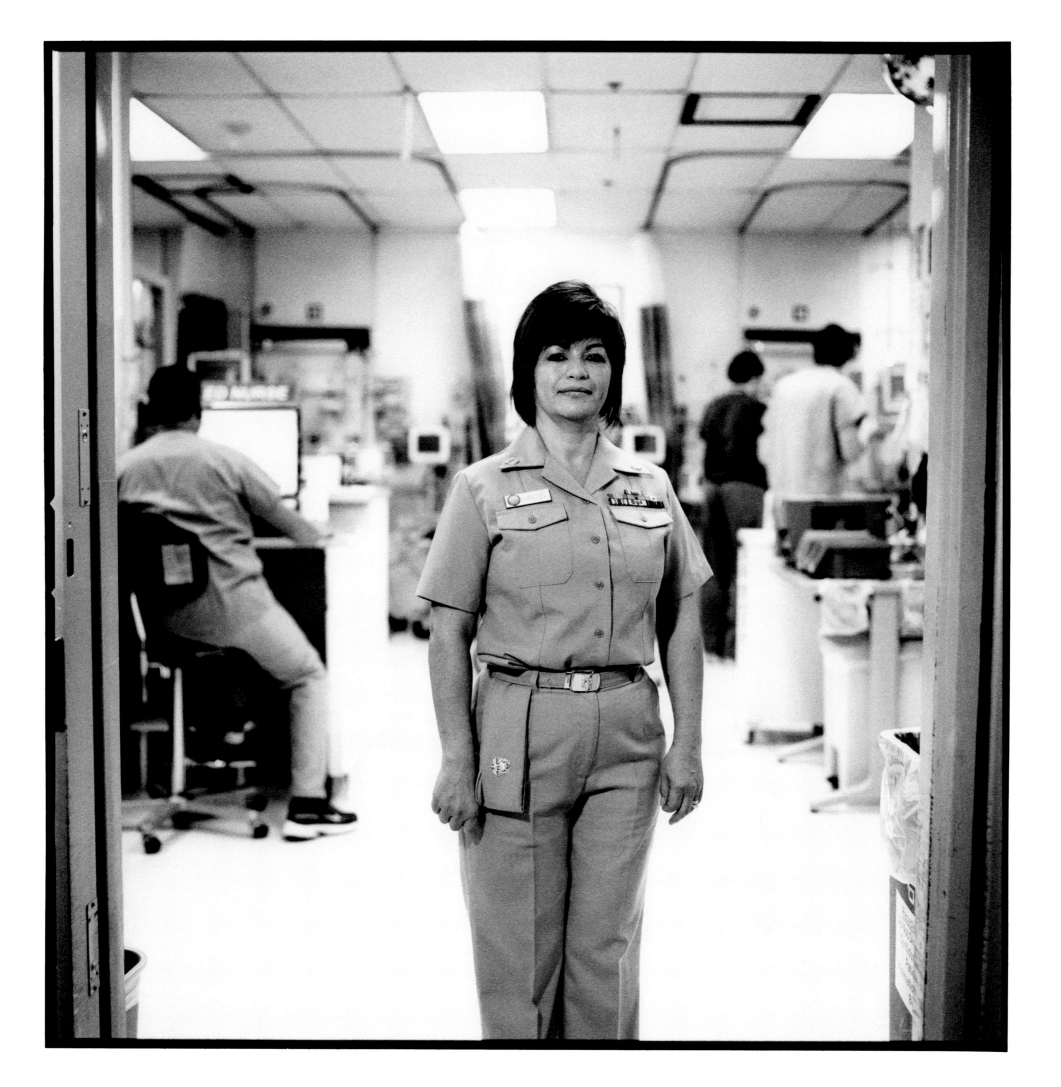

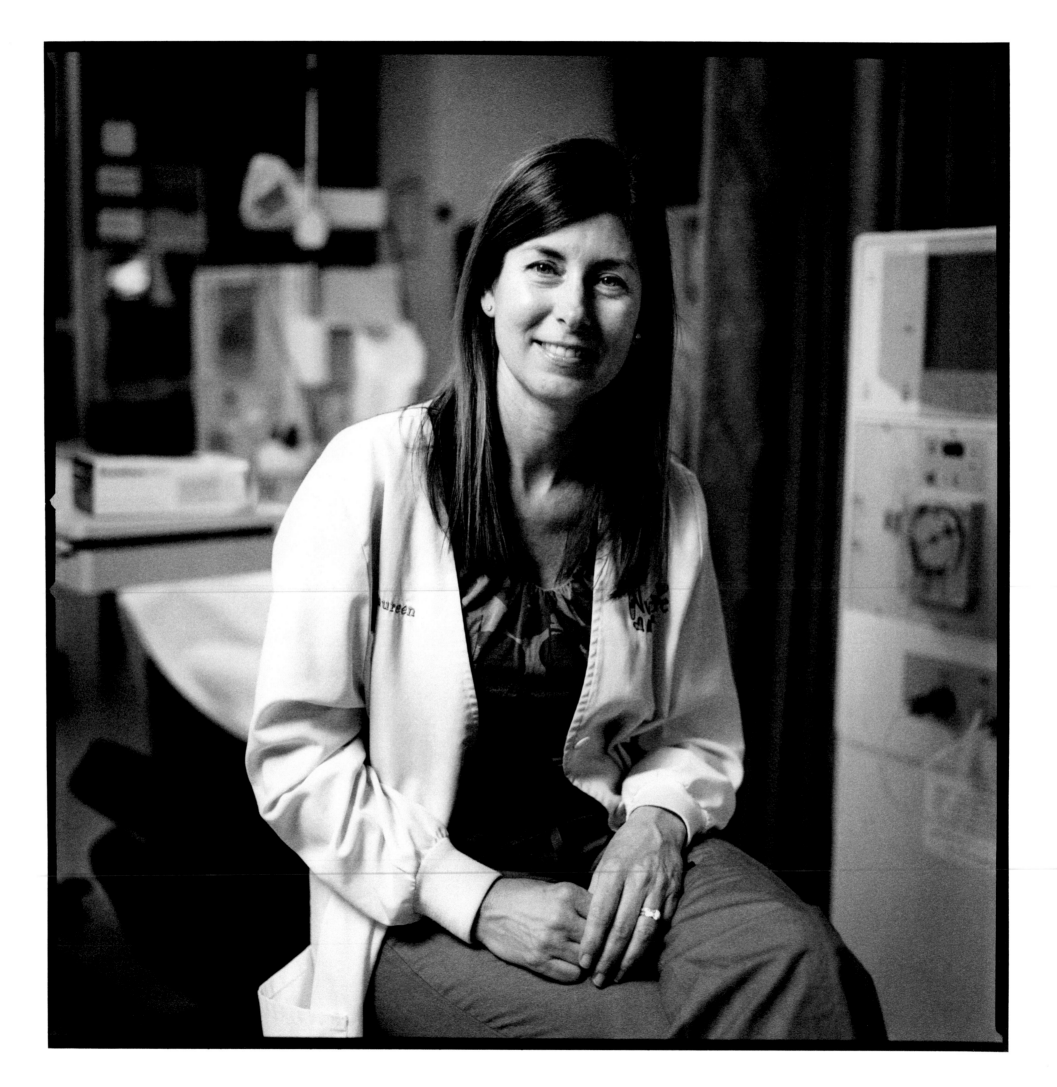

MAUREEN EISELE

MONTEFIORE MEDICAL CENTER, BRONX, NEW YORK

I've been a nurse at Montefiore Medical Center for twenty-seven years. Right now, I am working in pediatric dialysis with kids who have kidney disease. Basically, we do hemodialysis, but we have some patients on peritoneal dialysis. We do some high-tech therapies in the ICU with continuous renal replacement therapy, and we help the nurses give those therapies. I also work with Montefiore at the children's kidney center at Frost Valley YMCA summer camp.

The kidneys were never my favorite organs; I liked the heart and lungs. But then I started doing dialysis and really enjoyed it. I always loved the technical stuff. I think I like dialysis because it is highly technical with the monitors, drugs, drips, and mathematical equations. I like the science part of it.

I was really young when I started—I went from high school straight into nursing. And because I was so young, I didn't really understand some of the stuff I was seeing. I was able to be very distant from my patients. The older I get, the harder it is to maintain that distance. I work with families, particularly mothers, who just break my heart.

When you work in intensive care, your patients are mostly sedated, but in dialysis there's a lot more patient interaction, and we talk a lot about family-centered care. It's our only option here. These kids don't look sick; they are very resilient. But, in fact, they are very sick, and we have to teach the parents how to use the machines. We're constantly on the phone with the families, and we see them a lot. They're the ones really taking care of the patients.

Some people are appreciative of what you do, and others are just always telling you that you are wrong. You have to take it all with a grain of salt. Everyone has their own way of coping. If you can laugh a couple of times a day, no matter what you're going through, it's a good day.

Our kids maintain a high quality of life, and they seem to bounce back from everything. The technology keeps improving. Ten or twenty years ago, these kids wouldn't survive their illnesses. Dialysis really started in the late 1970s, and then there was a committee who decided if you were entitled to it. They weren't going to give it to just anyone, only to people who contributed to society. Kids were out of the question. Now, of course, anyone who needs it can get it, and the focus is more on kidney transplant, not on dialysis.

About twelve years ago I got involved in this dialysis camp in the Catskills. The camp was started thirty years ago by a family from Montclair, New Jersey. Their daughter had kidney disease, but at that time couldn't get dialysis. The girl died at fifteen, and her parents wanted to establish a foundation in her name to keep her memory alive. They discovered a summer camp in Claryville, New York, that agreed to take sick kids, and worked with Montefiore to set it up. Today, they have a state-of-the-art facility within this camp atmosphere.

I came to Frost Valley to work for two weeks and stayed for ten years. This is the only camp in the country that mainstreams the children with kidney disease. In addition to helping the kids, the camp has become a model for other camps. Hearts in the Valley, for example, was founded for cardiac kids.

It really is a fantastic experience for the kids. When they're at home, their whole life revolves around the disease. At the camp, the treatment for the disease revolves around their life at camp.

Maureen Eisele, MA, BSN, RN, CNN, was born in Manhattan and grew up in Pearl River, New York, with her parents and younger sister. As a kid, she was fascinated with anatomy and physiology. In high school, she attended Rockland County BOCES for two years and was a LPN at seventeen when she graduated. She went to work on a medical/surgical unit while attending community college for an AAS degree in nursing. She went to work at Montefiore in 1984, after earning her BSN from Dominican College, and has been employed there ever since.

SANDRA RANDALL

VILLA LORETTO NURSING HOME, MT. CALVARY, WISCONSIN

Sandra Randall, BSN, RN, NHA, MS, was born in Fond du Lac, Wisconsin, and grew up in the area with four siblings. She has a BSN in nursing and an MS in organizational leadership and quality. She started working at Waupun Memorial Hospital as a graduate nurse in 1975 and, after fourteen years, was senior vice-president of patient services. She has been a nurse for thirty-seven years. Sandra is photographed with Linda Koenigs and Darlene Tenpas, LPNs at Villa Loretto who wear traditional nursing uniforms once a week for the residents.

I am the administrator for the Villa Loretto nursing home. We're a fifty-bed, skilled nursing facility, and we have a twenty-bed, residential-care apartment complex. My job is to keep everything moving as best as I can throughout each day. Since I became a nurse, I've never been bored with any job I've ever had, and I've never caught up. No day is ever the same.

I did everything late. I married, had my children, and then decided I wanted to be a nurse. At the time, Marian College did not accept married women, so I had to wait until that policy changed. When it did, I called and spoke with the dean of nursing. I didn't have any chemistry credits from high school, so I had to go back to school for a year—ten years after I graduated! They charged me eighteen dollars for tuition. I was in class with juniors. At the end of the year they invited me to the prom.

After high school I enrolled in Marian. Once again I was the oldest person in class. Even though I had three kids at the time, I wanted to finish college in four years. The dean told me I'd never do it, but I did. I graduated in 1975. I personally feel I had a wonderful education.

Our clientele here in Villa Loretto are older people who are no longer able to live at home or have needs that require a nursing staff. We have some rehabilitation patients recovering from hip or knee surgery. The assisted-living folks need about twenty-eight hours of nursing care a week; that's how we are licensed in this state. These people just need a little assistance with activities such as meal planning, medication, or laundry.

Villa Loretto was founded by the Sister Servants of Christ the King in 1965, and it's still owned by them. It's rare to be our size and still be independent. It's a struggle every day, but that's why I'm here.

We're in a farming community, and the residents are familiar with animals, so we have lots of animals here including llamas, pygmy goats, and other exotic species. Our residents love getting outside with the animals. Sister Stephen also does foster care under a contract with the social services department in Fond du Lac.

Visitors come here all the time to see the animals, walk the property, and take a tour. We get bus tours from Milwaukee and even Texas. We take them on a hay wagon and serve lunch, for a fee, of course. We're on 120 acres and have ponds, so there are lots of migrating birds.

One of the things we hope to accomplish in the future is to do targeted work with dementia patients on the farm. We can use this facility to help more families who are dealing with that problem. My personal goal is to ensure that this place is able to continue our work and the legacy of the sisters into the future.

I've always prided myself on being a nurse, even if I no longer do bedside care. I still think I can make a difference with the direction and the vision of the work we do, which is a holistic approach to nursing. I just read an article that said nurses are the most trusted professionals out there. I shared this with the nurses to say that we need to appreciate what we do every day. I like to remind them that we should be really proud of our work.

Nursing is getting better all the time as it continues to change and grow. I wish we had more solutions to the national health-care problems, but I'm convinced that if we hold true to our traditional nursing values, we can make a huge, huge difference.

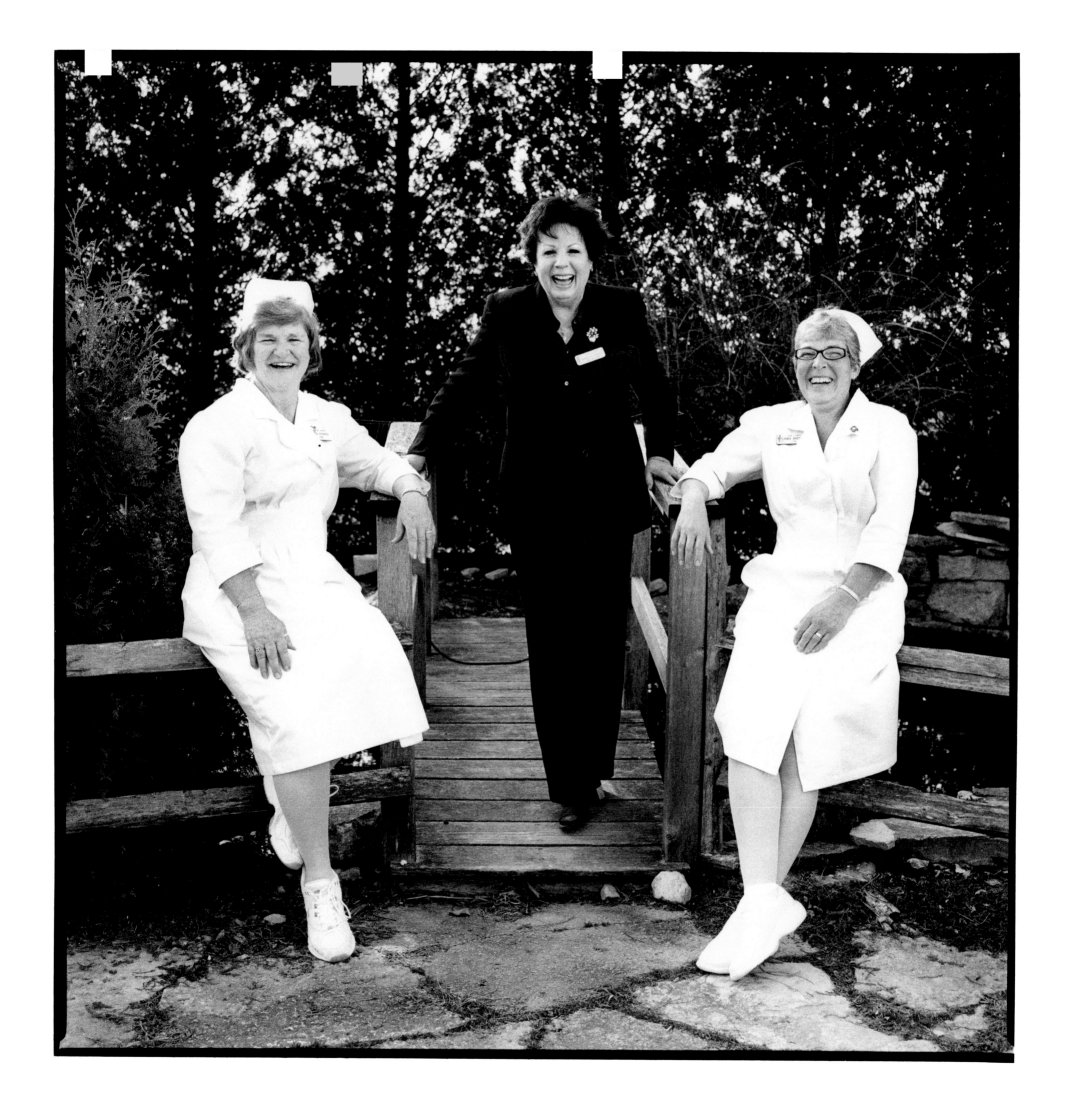

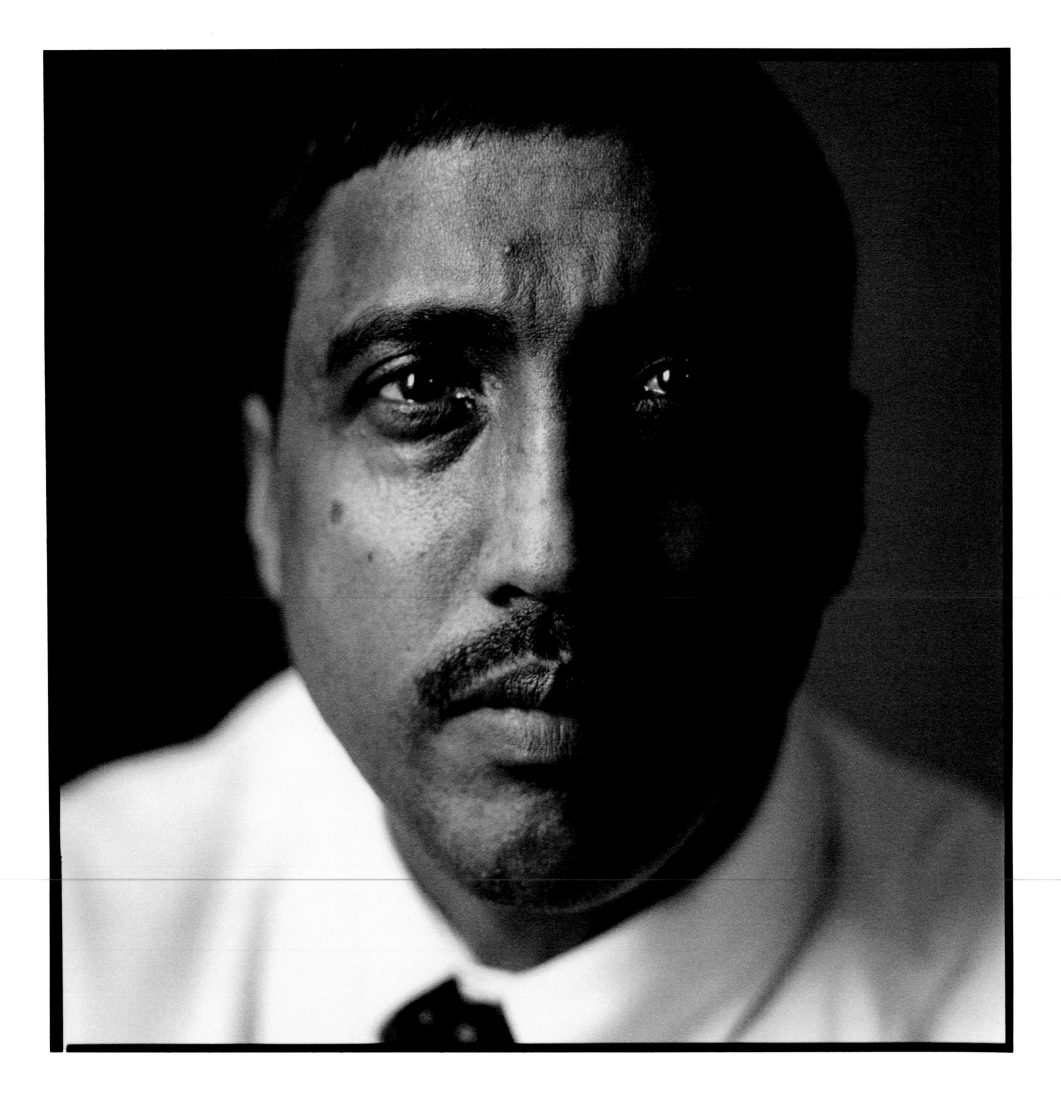

MOHAMED YASIN

MONTEFIORE MEDICAL CENTER, BRONX, NEW YORK

I work at Montefiore Medical Center in the Bronx. I became a nurse in 1991. In 1998, my manager helped to promote me to nurse manager. I am a Bronx person. I went to school at Lehman College, and I was living near here so Montefiore seemed like the best choice for me. I love coming to my job. Since I started here, I moved out of the Bronx so now I travel sixty-eight miles a day to get to this hospital.

I was born in Guyana, a little country in South America between Brazil and Venezuela. We were very poor and lived on a farm. Local folks used to come to my dad because he could heal them. He said there was something spiritual about him that folks believed could help them. He had these unique moments where he would talk really softly and blow a whiff of air on the person, ever so gently. Folks believed that was healing. I liked that about my dad and thought it made him powerful. When you're poor, things like that are very important. My mother never went to school, and my father only reached the fifth grade, but education was very important to them.

I was always in the top of my class, but I was also sick a lot as a child. I had breathing problems. I remember being in the hospital, with my parents waiting outside. I always wanted them to come into my room and be with me. I also remember the nurses who gave me injections. With some nurses, it really hurt, but then other nurses gave me injections that didn't hurt. Now I understand that it was the attitude of the nurses that made a difference, but at the time I couldn't explain it. I was just going by which ones hurt and which ones didn't.

I had a brother who came here as a student and then stayed. He was a mentor to me when I arrived. He worked with the elderly in a nursing home and shared these positive stories that inspired me.

The hardest moments for me are when I feel like I missed something. Sometimes I get that dreadful feeling that I wasn't there for my patient. I am always questioning myself, and it bothers me when I feel I am not in control. I feel responsible while the patients are under my watch. I know I can't control everything, but it is bothersome.

I like my current role as a nurse manager because there's greater opportunity to mentor, support, and guide the new nurses. I try to explain that it's not the glass of water that you give, it's how you give it that will make it tasty for the patient. As I grow older, I feel the need to pass on some of the knowledge I've acquired. As a nurse manager, I am able to do that, to make an impact.

I come from another culture. All we knew was farming and the value of education. Nothing else. We were always serving. My elder brother and sister are both teachers. I became the first nurse in my family, and now five of my siblings are nurses. My parents are really proud of us.

Mohamed Yasin, MSN/MPH, RN, NE-BC, grew up in Guyana, South America, in a very poor village with nine brothers and sisters. Before nursing, he worked for the Guyana National Travel Agency, the United Artists Capri Theatre in the Bronx, and the Morris Park Nursing Home. Currently, as a nurse manager at Montefiore, he manages the clinical and administrative functions of the nursing unit on a twenty-four-hour basis. He has been a nurse for twenty-one years.

AFTERWORD / RHONDA COLLINS

Rhonda Collins, MSN, RN, earned a master's degree in nursing administration after spending fourteen years as a staff nurse. She is currently completing a doctorate in nursing practice in executive leadership. In 2011, she went to work for Fresenius Kabi, USA, as vice-president and business manager of medical devices.

I am a nurse, first and foremost. I spent more than twenty years working in a hospital, beginning as a staff nurse in labor and delivery. I worked my way up to executive leadership and eventually made the decision to transition into the world of medical devices, which is the technology that nurses use at the bedside in caring for their patients. I now work for a company that makes and sells IV-infusion pumps to hospitals. I am responsible for the medical-device business in the United States. I made this decision because I felt that the medical-device industry didn't completely understand the complications nurses experience trying to integrate technology at the patient's bedside.

My personal story is both profoundly normal and distinctly unique. I tell it in the hope that it explains the path that brought me to where I am and to the making of this book. I am the daughter of a Baptist minister and was raised in a very conservative home. It was the 1970s, when mini-skirts and short shorts were in fashion, but I was not allowed, like my friends, to wear mini skirts or short shorts. We didn't have Christmas in our home; we celebrated by giving money to the church instead of giving gifts to each other. It was a very cloistered life, and I felt like I had to fit into a very defined mold to please my father. I was afraid of doing anything that might anger my parents and, like most children, wanted my parents approval. I still play the piano, and I played for the church growing up. My father was proud of that, so I started college as a music major with a music scholarship.

I married in my sophomore year in college and had a baby a year later, and my second child was born two years after that. After six or seven years, I looked at my life and said, "I've got to do something more." I had always been interested in service-oriented work because I found there to be a spiritual component to service. I went into nursing because I thought, well, I like caring for and being around people—I'm comfortable with that. Also, it just seemed like a profession where I could make a living.

My husband was a mechanic, and we lived paycheck to paycheck in a little house in Texarkana, Texas. School was a challenge because I had two little children and we were broke. Music and church were still a significant influence in my life, and I continued to sing in the choir at my church. I frequently sat next to a woman who was married to a physician in our community. One evening we struck up a conversation, and she asked me what I did for work. I told her I wanted to go to nursing school but had to wait until that goal was financially feasible. A few days later she called and said her husband was going to pay for my nursing school. He wanted to do it because he believed in supporting people in the community going into health care. I went back to college and was quickly enthralled by my classes. The science courses were hard, and I had to hire a tutor for chemistry, but I knew immediately I had found my calling. I received my associate's degree in nursing and started working the night shift in labor and delivery.

I never met the man who provided the means for my education and never wrote a five-hundred-word essay on why I wanted to be a nurse, but he provided for everything—my tuition, books, and uniforms. He would deposit money in an account at a local college. I never knew how much was in the account at any time, but my tuition would always be covered. I sent him a thank-you note, and he wrote back to say the only thing he wanted in return was for me to be the best nurse I could be. I found out he passed away last year, and I never learned if he knew I had become VP of nursing in one of the most reputable hospitals in the country. I would have wanted him to know that I couldn't have done this on my own and that I had spent my career working hard to be the very best nurse I could possibly be.

I think his wife saw in me a desire to do something great. Honestly, at that time, I lived a small life in this little East-Texas town, but I had a fire in my belly to be somebody, to go somewhere and do something. I didn't know how I was going to grow to become a woman of substance. I knew I wanted it to happen, but I didn't have the resources until this couple came along and changed everything. This experience taught me that we are all required to hold out a hand and help others stand up. Every time I take a job or hire a new employee, I am looking for someone who can take my place. It's my job to take care of my profession, and I take that responsibility very seriously.

When I first started in nursing, I loved the experience of being with the patient and the family and helping to make a difference. All of us find our place in nursing, and I ultimately found my home in labor and delivery, where good things happened more frequently than bad things. Bringing a baby into this world is an experience like no other. In nursing we see people at their very worst and their very best, and our compassion and skills ease them through their life-changing experiences.

I remember the elation that came from hearing a baby cry for the first time. This was back in the day when the doctor would hand the baby to me, not the mother. This was before the advent of HIV, so we'd take the babies and use our bare hands to rub off the blood and mucus—not even wearing gloves! It's crazy to think about that now.

I remember one birth where we were told the mom was in the elevator and the baby was coming really fast. The elevator doors opened, and she was having the baby right there. We delivered her baby in the elevator and then rolled her into the delivery room. The woman had her hands over her face and kept talking about how embarrassed she was. I said, "Why? Women would give anything to give birth this easily. A couple of years ago a woman had her baby out on the lawn; she never even made it into the hospital." She looked at me and said, "That was me!"

Of course there were tragic situations also. There were patients who were victims of molestation or rape. There were families in turmoil who were adding another child to the mix. And then there were the babies who weren't born whole or were too premature to survive. There was the heartbreak of having to tell the parents and the devastation of watching the babies die.

The worst thing that happened to me as a nurse occurred one morning when we were really busy. Back then nurses mixed their own drugs. I made a critical error in programming an IV infusion for a patient, and she had to have an emergency C-section. The baby was fine, but, because of me, the mom had an unnecessary procedure that she hadn't wanted. It was a horrible moment, one I will never forget as long as I live. Later in my career, when I was vice-president of women's services, I would have to talk with these young nurses who wanted to leave nursing because they'd made some kind of error with medication. I knew there had to be a better way, that education and skill sometimes wasn't enough to protect all of us. That was the trajectory that landed me in this industry. I passionately believed that when we designed technology for nurses to use, we had to have nurses intimately involved in the design and function of that technology.

I saw it as my responsibility, as a nurse, to pioneer a better way for our profession. I decided to go back to school. I earned my bachelor's degree while working full time. I drove 198 miles each way to class, two days a week. I was putting seven thousand miles on my car each month. I took a year and focused on completing my master's degree. I moved to Dallas/Fort Worth and became director of labor and delivery at Baylor University Medical Center, and was subsequently named vice-president.

One day I was talking to a salesman about how he could improve his IV pump. I was telling him why his product didn't work in the patient-care environment. Three weeks later, I made the decision to go work for his company. The next thing I knew, I was walking into the corporate world for the first time. Or as some of my nursing colleagues like to say, I went over to the dark side.

I'll never forget when I saw the GM and the vice-president of sales having an intense discussion in the hall. There was lots of yelling and slamming of doors. When I asked what was happening, I was told that we weren't going to make our numbers (our financial forecast) that quarter. I said, "You know, where I come from, we only act like that if we cut off the wrong leg."

I believe we can create technology that always begins with the end in mind—the patient. I have an extraordinary opportunity to build a nurse-centric business because, at the end of the day, 98 percent of the end users of IV pumps are nurses. At Fresenius Kabi, we're focused on finding innovative ways to educate the nurses, such as avatar training in which nurses practice in simulated environments, much like the way pilots learn to fly a plane. We are creating think groups to fully understand the behaviors that drive clinical practice at the bedside before we design technology to enhance that practice. We don't believe our job is to *change* nursing practice, our job is to *enhance* nursing practice. By starting with the patient first, and the caregiver second, we then focus on moving the bedside to the technology, rather than starting with the technology and forcing it to the bedside.

Year after year, nursing is rated "the most trusted profession," but I don't think most people understand what it takes to be a nurse. Few people recognize the education, hours, and commitment required to become a nurse or the huge diversity of the profession.

At some point in our lives every single one of us is going to be a patient under a nurse's care. We rarely leave this life without that experience. The overwhelming majority of health-care providers are nurses, and the vast majority in this great, beautiful, diverse landscape of nursing are committed individuals who are too busy to beat their own drum. Health-care reform is changing everything. Patients are being sent home unwell. We nurses have a very complicated environment within which to work. The time is now to make medication safety more intuitive, user-friendly, and focused on the end result—the health of the patient. I truly believe that if we have nurses lend their brain trust and real experience to the design and use of the technology we create, we can affect positive change and make hospitals safer and better places.

Today I work for Fresenius Kabi USA because it is a company focused on the nurse and focused on the patient. We are inspired every day by nurses, and we wanted to do something extraordinary to demonstrate and celebrate our commitment.

This book is a step in that direction. Within these pages, we have captured the stories of seventy-five nurses from hospitals all across the United States. In this project—and all that will grow from it—we have begun to create a place for nurses to share their voices, to learn from each other, and to celebrate one another. This is the purpose of *The American Nurse*: to shine a light on nurses in this country, to tell their stories frankly and honestly, and to see them at work, doing what they love.

It is astonishing that, with three million nurses in America, this story hasn't been told before. However invisible they may seem to be, nurses are an enormous force. It is time for us all to see them clearly, hear their voices, and listen.

ACKNOWLEDGMENTS

I would like to thank my much-loved husband, Jacques, for always making me feel as though I enrich our lives with my work. He is my best friend and my encouragement. His sense of simple elegance inspires me, and his generous guidance with design helps me see things more clearly. He is always available to lend his gifted art-director's eye to my work, and I am grateful for that. I miss a lot of things when I travel—social events, school plays, walking the dog—and yet our treasured daughter, Mercer, always makes me feel good about my work. I realize that when Jacques and I are both away, it offers the opportunity for her to host the occasional party—so there is an upside—but she pitches in enormously when I'm gone, and I'm lucky to be able to depend on them both. We are a great team, and I know exactly with whom I would want to be stranded on an island. I am lucky beyond words. I cherish my entire family and draw great strength from them.

I want to thank Chris Fitzgerald and Michael Christman of Opts Ideas. When I went through breast cancer, Michael continued to work with me on projects, never caring if I had hair or not and always dealing with me as though I was perfectly normal and could work at a normal pace. It was healing to be treated in such a way during that time. Heaven knows that I was learning so much about myself, and a lot of it led me right here, to making this book. Chris Fitzgerald is the person who brought everyone together to make this project happen. He has been tireless in his mission to tell the nurses' stories and shed light on a profession that has long been under-represented. I am grateful to him for the enormous trust he placed in me to get it right. He made invaluable suggestions that got the creative wheels turning. He encouraged me to go deeper into the hospitals and photograph nurses surrounded by the tools of their trade. Chris, along with his colleague Sophia Larroque, fought tirelessly for this book, and it wouldn't be here, in this form, without them. Sophia kept us all together in spite of my dropping off the face of the earth to uncover these stories. Chris's partner at Opts Ideas, Lisa Holland, keeps everything moving forward quietly and elegantly behind the scenes. I'm grateful to her for her support.

Rhonda Collins is some kind of force. Her personal story of becoming a nurse is rich and moving, and had enormous influence on why and how we did this project. Rhonda wants to celebrate nurses and give something back to the community that she is a part of. Working at Fresenius-Kabi, she has the opportunity to take what she has learned as a nurse and make real changes in the hospital environment. The fact that Fresenius-Kabi was willing to support this vision and this book tells us what kind of company it is. It has been my great privilege to have the chance to work with them. Rhonda had a vision, she put herself on the line to make it happen, and I am in awe of her force and conviction. She always stood by her word, and I would walk through fire with her.

Lisa Frank produced the American Nurse Project. Lisa went on each trip and stood beside me as I photographed the subjects and conducted the interviews, but her work began long before we were on the road. Her smile has opened doors and paved the way for us in many corners of the world as we have traveled together for the 100 People Foundation. I always say that I want to leave a positive wake behind us as we travel and meet people. Lisa has brought that to a new level. She also brought her own great ideas to this project and accepted each wild idea that I had with open arms and made it happen. She's a meticulous and funny partner, we have seen much together and she has become my dear friend. I should also point out that her charming fiancé was a darn good sport about all of the travel too. Max Schwartz directed his legal talents to making sure that we were always doing the right thing and that everyone was protected. Max's mother, Nella Shapiro, deserves my thanks as well. She opened the doors for us at the Montefiore Medical Center in the Bronx and helped us begin this project on the right foot, caring about the right things and focusing on the issues that matter. Candace Thompson brought humor, fearlessness, and an entertaining vocabulary to our production team and this project. Her capable and persuasive personality got us into places we would not otherwise have gone. And my thanks to the talented Sofia Verzbolovskis, a photographer in her own right, who has helped us stay organized and in contact with all of the nurses—which is no small feat.

Jaka Vinšek started this project as a photo assistant, and ended it as a friend and colleague. He is a talented artist, and I was lucky to have his magic on these trips. I cannot imagine that he will be an assistant for long—his career is unfolding as I write this. You will never meet two people who are better travelers than Lisa and Jaka. Always ready for anything, enchanted by the nurses, game for working long hours and then getting in the car to travel to the next destination. Good sports through and through, and exactly the kind of energy that's brilliant to have with you on a project like this.

As soon as we met the first nurse, I knew that this book had to be made available to the public. I immediately thought of Lena Tabori. Lena is a legend in the publishing world, and I had always wanted to work with her. She published *I Dream a World*, which is one of my favorite books. It has been an honor to create this book with her. She has encouraged me to stay true to myself in so many ways. I have also enormously enjoyed the chance to work with Clark Wakabayashi, the president of Welcome Enterprises and the designer of this book. His insights, suggestions, and designs have created a book I am very proud of. In a true small-world moment, Clark and Gregory Wakabayashi, the art director at Welcome, are the sons of the great photographer Hiro, who hired me when I first arrived to NYC in 1979. Although I had studied photography and communications at Syracuse University, my education began in Hiro's studio. There, I learned to be true to myself in my work—and that was the biggest lesson of all. At Welcome Books, I also met Emily Green, who hopes to someday find her way to nursing, and the energetic Andy Reynolds, who is committed to getting the word out. This book has been in the best hands ever.

Linda Sunshine edited *The American Nurse*. She took hours and hours of what were sometimes meandering conversations, and found the words that would resonate with all of us. I would often read her edit of the interview in amazement that she could capture in that limited copy what I had felt at the end of a long conversation. What a gift she has for pulling out what is meaningful for us to read and learn from.

I decided to shoot the photographs for this book using my trusty medium-format Hasselblad camera and B&W Tri-X film. That camera forces a kind of thoughtfulness and formality for me, and I wanted that to help me capture and honor the nurses. Almost all the photographs were taken with natural light. I wanted the photos to be true, so we did not use Photoshop to alter any image, and all are printed full frame.

It was important to find a lab that could embrace this approach and make beautiful prints. picturehouse + thesmalldarkroom is such a place. They took care of the entire project from processing all of the film to creating the prints, and ultimately the scans for the book. Jessica Palazzo, whose mother is a nurse, printed every single nurse with love. I am grateful to her for seeing into the soul of the project and pulling out these amazing prints. Anna Tucker kept things organized, which was no small task, and made us feel welcome every time we walked through her door. BJ DeLorenzo and Conan Thai made beautiful scans of the prints, and at the end of the day, the photos ring true.

The American Nurse Project is about giving a voice to nurses, so it is part book and part website. Bob Gourley worked with me tirelessly on the website to find a way to present the nurses that would be both beautiful and easy to navigate. This helped inform the book; as I was choosing images and reading the words, I was able to refer back to the nurses' interviews because of the work that Bob did, and that was hugely helpful.

Isabel Sadurni, my partner from the 100 People Foundation, edited all of the video interviews on the website. She listened to every single word from every single interview from 103 nurses. She got so deep into the material that she knew what I was looking for and found the jewels of the interviews without guidance. Both her grandmother and her mother are nurses, so the profession runs deep in her family. The compassion that Isabel brought to this project was immeasurable.

I want to thank everyone at the hospitals and facilities that helped us capture these images and stories. We disrupted many days and inconvenienced many nurses. In particular I'd like to thank Helene Guss and Tracey McGlinchey from the Montefiore Medical Center; Gary Stephenson, Dianne Haley, and Karen Haller from The Johns Hopkins Hospital; David Glaser from Tidewell Hospice; Jerry Algozar from the Callen-Lorde Community Health Center; and Stacey Stanek from Central Wyoming College.

And now to the nurses, thank you to each and every one of you who stopped what you were doing and took the time to sit for my camera and talk to me. You are a national treasure, and I hope this project helps focus attention on you and the wisdom that you have gained doing the amazing work that you do. You are cherished.

—Carolyn Jones

The American Nurse: Photographs and Interviews
By Carolyn Jones

Producer: Lisa Frank
Photo Assistant: Jaka Vinšek
Production Coordinator: Candace Thompson
Production Assistant: Sofia Verzbolovskis

Project concept in collaboration with
Opts Ideas
www.optsideas.com

Chris Fitzgerald
Michael Christman
Lisa Holland
Sophia Larroque

Welcome Books
Publisher: Lena Tabori
President & Designer: H. Clark Wakabayashi
Editor: Linda Sunshine
Copyeditor: Frank Rehor
Editorial Assistant: Jacquelyn Lam

Prints and high-resolution scans by
picturehouse + thesmalldarkroom
Prints by Jessica Palazzo

Published in 2012 by Welcome Books ®
An imprint of Welcome Enterprises, Inc.
6 West 18th Street, New York, NY, 10011
(212) 989-3200; fax (212) 989-3205
www.welcomebooks.com

Text and photographs copyright © 2012 by Carolyn Jones

Pages 6, 7, and 9: photographs by Jaka Vinšek
Page 8: photograph by Lisa Frank

All rights reserved. No part of this book may be reproduced or utilized in any form or by any means, electronic or mechanical, including photocopying, recording, or by any information storage or retrieval system, without permission in writing from the publisher.

Library of Congress Cataloging-in-Publication Data on file

ISBN 978-1-59962-121-0

FIRST EDITION
10 9 8 7 6 5 4 3 2
Printed in the United States of America

For further information about this book please visit online:
www.welcomebooks.com/americannurse

For further information about the American Nurse Project
please visit online:
www.americannurseproject.com